IMAGES
of America

BURKE'S GARDEN

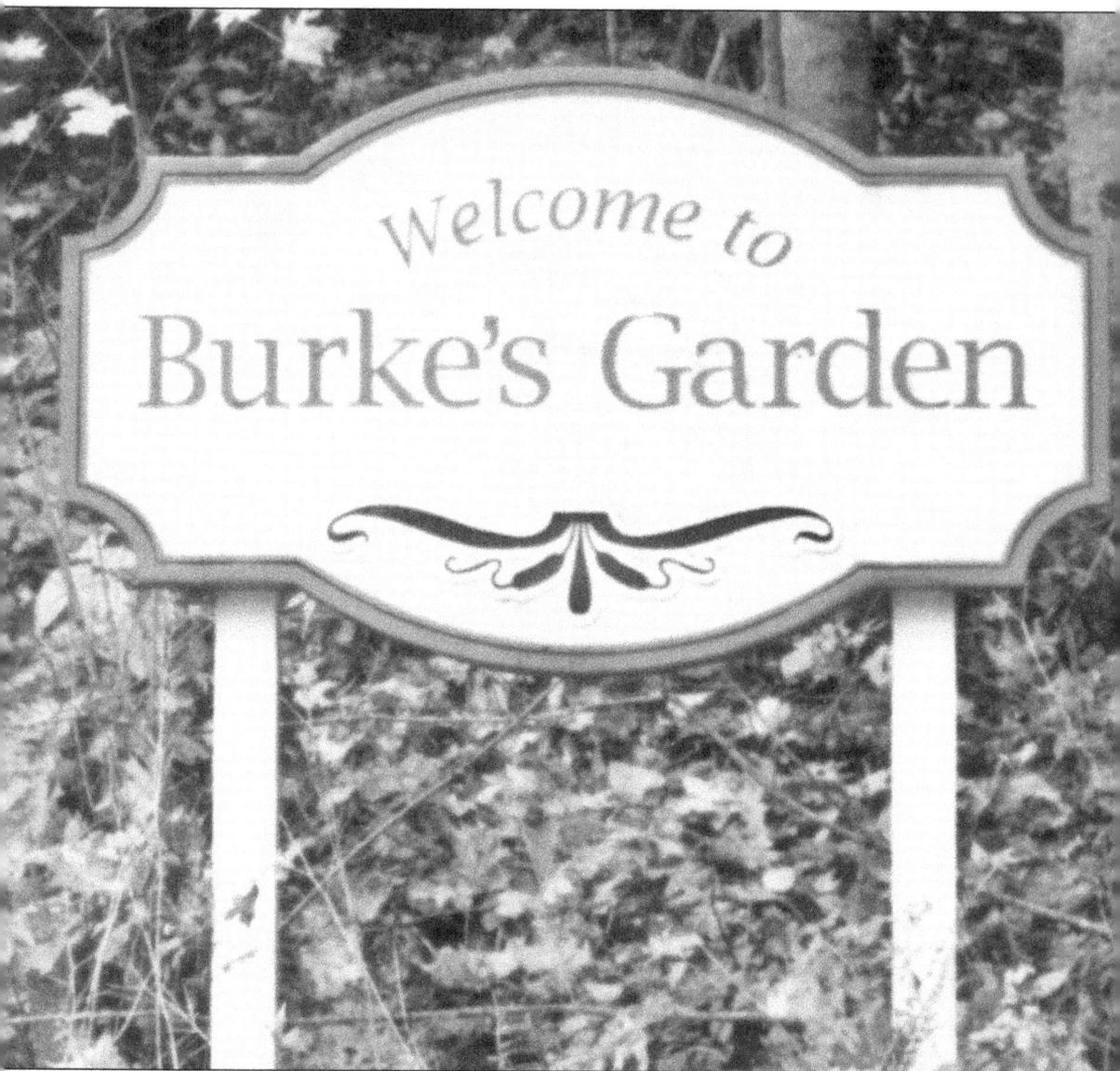

Erected by the Burke's Garden Community Association, this unique symbol welcomes visitors to an equally unique community in Southwest Virginia's Tazewell County. Burke's Garden, a natural bowl-shaped valley, stretches approximately 5 miles north to south and 10 miles east to west. At 3,074 feet above sea level, it is Virginia's highest valley and also the highest valley east of the Rocky Mountains. According to geologists at Virginia Tech, this geographical phenomenon was created by millions of years of water seepage through a dome of soft, probably sandstone, rock rimmed by a harder limestone perimeter. (Courtesy of the Mullins files.)

ON THE COVER: At an earlier time, Burke's Garden residents greet one another as they depart the Burke's Garden Academy. The academy, which opened at the dawn of the 20th century, was one of the premier schools of the region. The fine arts, for example, were not ignored in this farming community. In fact, the school included an impressive music department to supplement its academic disciplines. (Courtesy of A. S. Greever.)

IMAGES
of America

BURKE'S GARDEN

Louise B. Leslie and
Dr. Terry W. Mullins

ARCADIA
PUBLISHING

Published by Arcadia Publishing
Charleston, South Carolina

Library of Congress Catalog Card Number: 2007927679

For all general information contact Arcadia Publishing at:
Telephone 843-853-2070
Fax 843-853-0044
E-mail sales@arcadiapublishing.com
For customer service and orders:
Toll-Free 1-888-313-2665

Visit us on the Internet at www.arcadiapublishing.com

To Pearl Rhudy Leslie

My mother, Pearl Rhudy Leslie, was born in Burke's Garden in 1895. She left the community for college, teaching jobs, and marriage, but Burke's Garden never left her. Many times she talked about looking at Beartown from her bedroom window every day when she was a child. The mountains seemed to live inside her for almost 90 years. For her last five years as an educator in Tazewell schools, she requested to teach in the Burke's Garden High School to "pay back what Burke's Garden had given [her]." I dedicate this book to my mother and to my ancestors, who knew this was a good place to live.

—Louise Leslie

To John Henry Mullins Jr.

My father, John Henry Mullins Jr., was born in Burke's Garden in 1922. His family left the valley several years later and moved to the Pisgah community near Tazewell. Always very proud of his Burke's Garden roots, he often visited the Garden to enjoy the beauty and splendor of the place of his birth. After serving in the European theater during World War II, he returned to Tazewell County to raise his family. I dedicate this book to my father and other Garden ancestors, who more than a century ago recognized the unique attraction of this paradise.

—Terry Mullins

CONTENTS

ACKNOWLEDGMENTS

We extend special thanks to the Burke's Garden Community Association members who provided images or contacted others who contributed photographs of early homes and family members. Hundreds of images have been donated. We regret that some have been left out because of the space limitation requirements of the publisher. Every photograph, nevertheless, tells a different story about the people who first settled in Burke's Garden, and each story is valuable. We deeply appreciate the interest shown in this project and the cooperation of every person who has added to the final product.

Contributors include the following: Edgar P. Greever, Faye Cuddy, Juanita Boling, Elizabeth Bowman, Harry Tibbs, Mary K. Lotts, Mary Ann Vaughan, Marie Sheets, Francis Felty Smith, Betty R. Felty, Tommy Coleman, Rebecca Hubbard, Pam Moss, the Moss scrapbook, Ruth Tarter, Bryan Warden, Community Club scrapbooks, Marvin Meek, Colleen Cox, Betty Vanhoozier, Bobby Short, Ben Lineberry, Gary Howell, Fred Lawless, Melvin Grubb, the Historic Crab Orchard Museum, Alex Chamberlain, the *Garden Gate*, the Hoge family, Margaret Catherine Rhudy, Ruth Snapp, Merle Howell, Jim Bob Davis, Helen Boling, George H. Litz, Nancy Wilson Neal, Mary Elizabeth McGinnis, Elizabeth Fox Martin, G. Michael Alford, Jack Cox, Vivian Litz Merhoff, Georgia Havens, Rita Howell, Eunice Cooper, Betty Jean Felty, Rita Etter, Ernie Wilson, J. C. McCann, Mary Lambert, Ida Greever's *Sketches of Early Burke's Garden*, and Mildred Lineberry's *Memoirs of Burke's Garden and Tazewell County*.

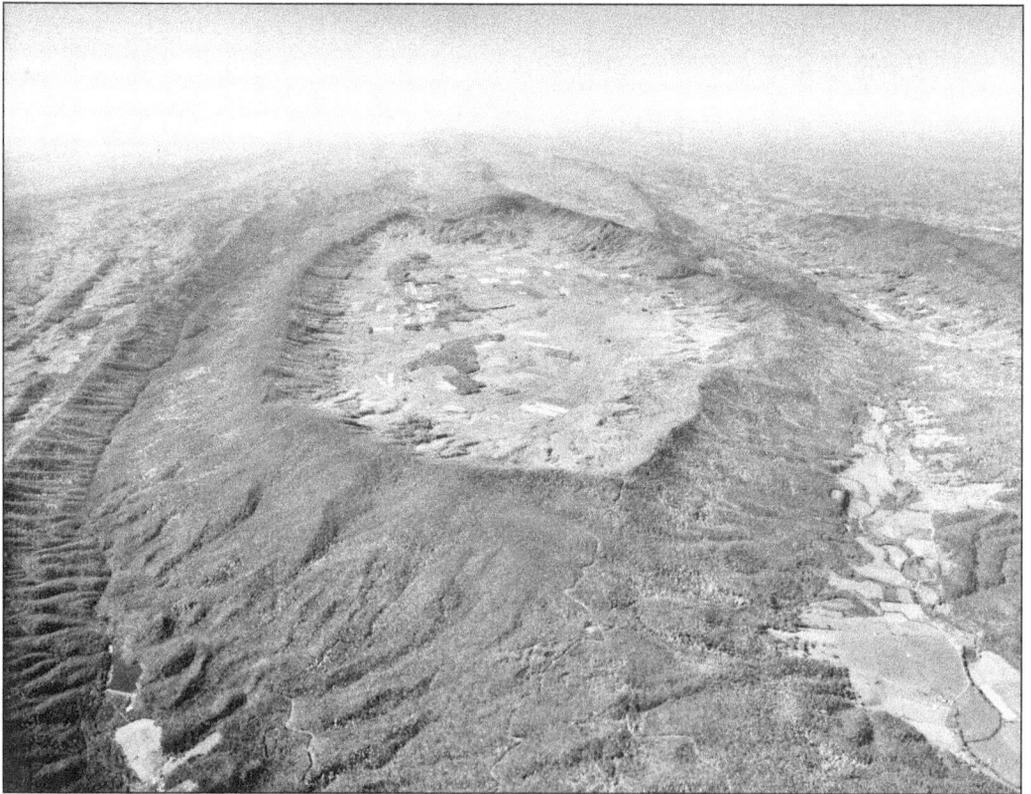

This well-known aerial photograph, taken by Melvin Grubb of Bluefield, explains the rare basin better than words. (Courtesy of Melvin Grubb.)

INTRODUCTION

Read the different descriptions of Burke's Garden—from James Burke's proverbial "Garden of Eden" when he first saw the land to the recent words of a newspaper reporter, "A Haven from Hubbub"—and you realize these fertile fields surrounded by high mountains have brought praise from a variety of sources for more than two centuries. The road signs have proclaimed Burke's Garden the "Garden Spot of the World." In addition, an impressed visitor recently wrote, "Seasons come and go, many dangers take place in the world, but that land stays safe, like in the hollow of God's hand." The bowl-shaped valley in which Burke's Garden lies is a formation that is not likely found in any other location. The valley, completely surrounded by mountains, has been mistaken as a volcano, a meteor crater, and even a dried lake bed. In reality, at one time it was a huge dome-shaped mountain with an elevation of 6,500 feet. The sandstone mountain eroded, leaving the harder surrounding limestone configuration that became today's Garden Mountain. Due to its distinctive geology, Burke's Garden has been visited and studied by experts in a variety of disciplines.

This book about the fabled land hidden away in Tazewell County before the modern inventions of automobiles, television, and air travel deals in great part with the people who have inhabited Burke's Garden since the 1700s. Most of the current natives of Burke's Garden can trace their ancestors to the discovery of this beautiful haven more than 200 years ago. Some came for religious freedom, others for the possibilities of a better life in a rich land, and still others as an escape from the fast pace of modern life. When they came, they stayed. Once Burke's Garden is experienced, it is indeed hard to leave.

Jim and Louise Hoge sum up the area's charms as follows: "In its time Burke's Garden has been an ocean floor, a towering peak, a great hunting area, a home for Indians, a flourishing farming community. But time is not yet finished with us. Who knows what we may yet become?" In fact, a century ago, Burke's Garden was a self-contained community. It was possible to spend a lifetime in the valley without crossing the mountains to the outside world. The valley included stores, churches, schools, postal services, and a confident view of the world that was surprisingly not isolated but far-reaching. As in most early farm communities, neighbors helped neighbors and families formed close-knit bonds. The beauty of the land and its unique formation seemed to seep into the lives of the lifelong residents.

In this book, most images of the early homes, businesses, and people of Burke's Garden emphasize the community prior to the second half of the 20th century. The active Burke's Garden Community Association is responsible for collecting most of the photographs, with a few exceptions. We hope the readers will enjoy this look at a place still believed to be greener, higher, prettier, and different than any other location in the southern Appalachians.

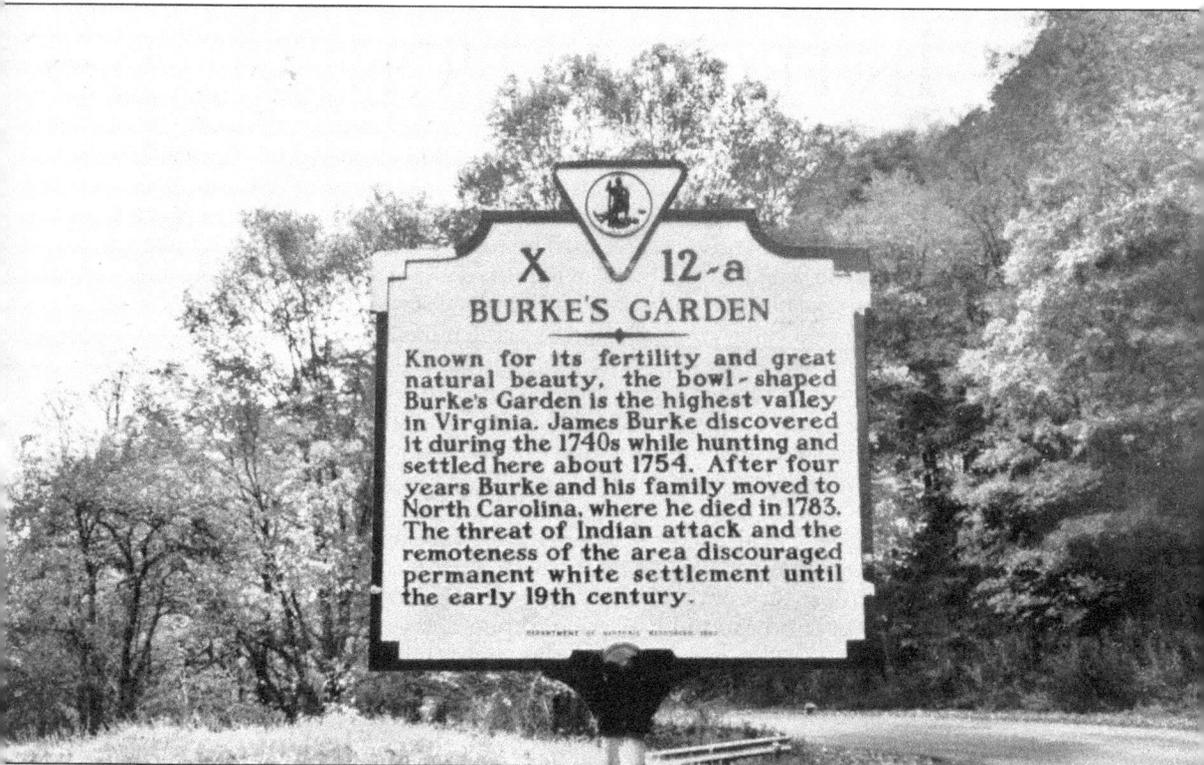

X 12-a

BURKE'S GARDEN

Known for its fertility and great natural beauty, the bowl-shaped Burke's Garden is the highest valley in Virginia. James Burke discovered it during the 1740s while hunting and settled here about 1754. After four years Burke and his family moved to North Carolina, where he died in 1783. The threat of Indian attack and the remoteness of the area discouraged permanent white settlement until the early 19th century.

DEPARTMENT OF HISTORIC RESOURCES 1992

This Virginia historical marker denotes Burke's Garden as the state's highest valley. At 3,074 feet above sea level, it is completely surrounded by Garden Mountain, which is the northeastern-most extension of the Clinch Mountain Range. Burke's Garden has been named to the Virginia Landmark's Register and the National Register of Historic Places as part of the Burke's Garden Rural Historic District. The Garden marks the start of a 13-mile bicycle loop, the Heart of Appalachia Bike Trail, which encircles the community. (Courtesy of the Mullins files.)

One

GRACEFUL GRANDEUR

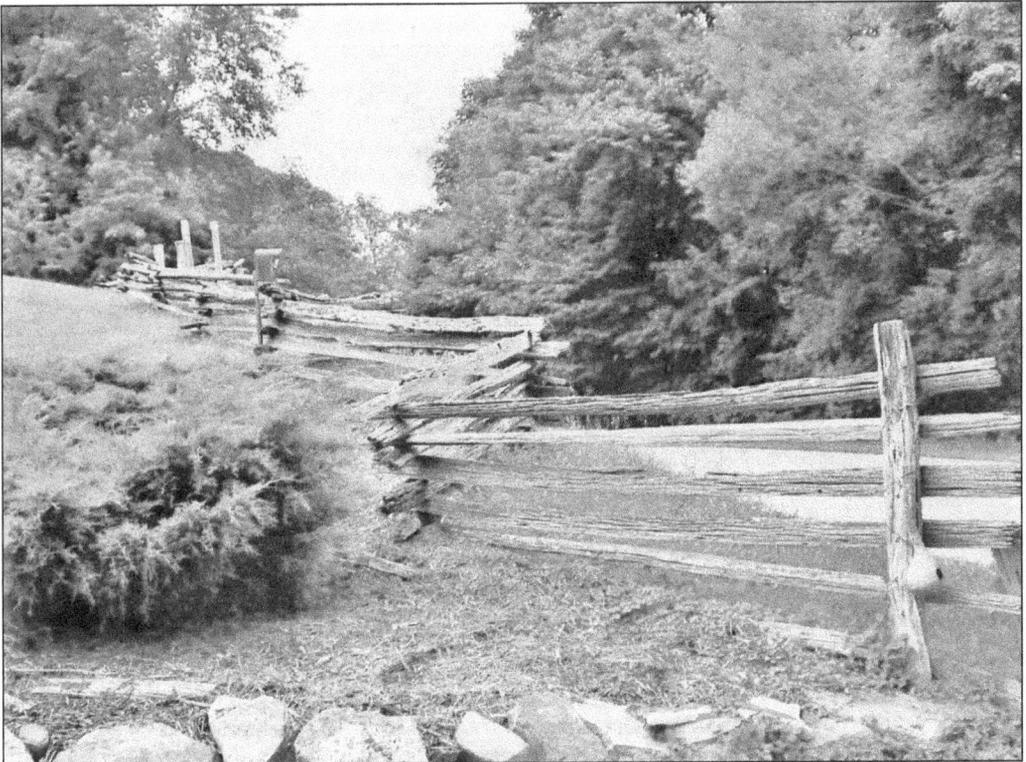

Wooden rail fences are common in Burke's Garden neighborhoods. A reminder of a simpler time, this rail fence on the Glenn Riddle Jr. property adds another type of unique charm to the rural community. (Courtesy of G. Michael Alford.)

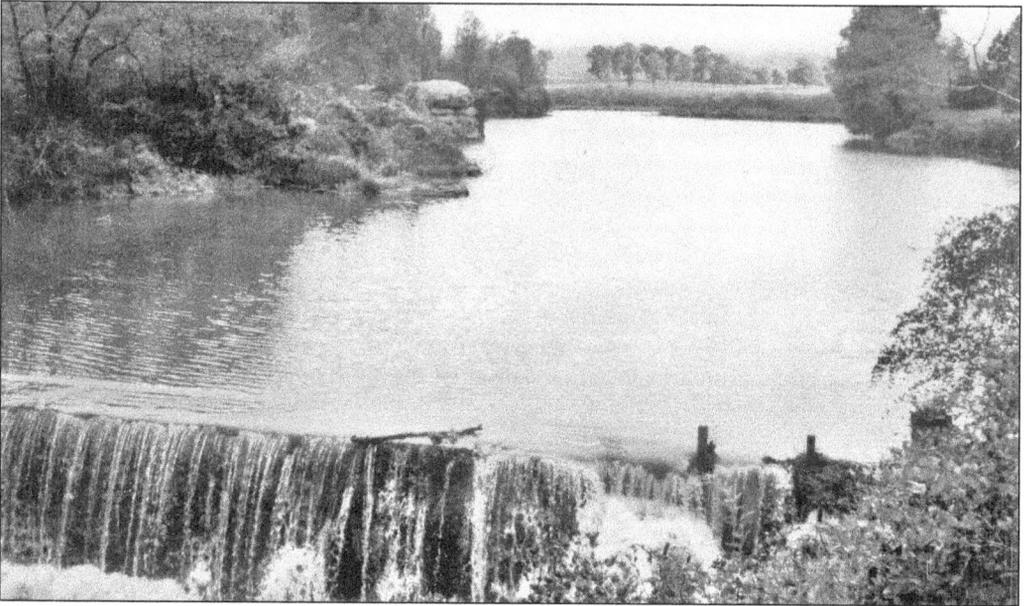

The long view of Burke's Garden, showing the Mill Dam, is one of the most photographed scenes in the area. The bridge stands close to the former Gose Mill, an active mill in the early days of settlement. The Gose family was among the prominent families who first came to the rich farmlands. (Courtesy of G. Michael Alford.)

Only one natural opening exists in the massive Garden Mountain Range encircling the valley. Through this notch, all the water from the Garden drains to the Wolf Creek and eventually to the New and Ohio Rivers. The only paved road into the Garden also passes through the Gap and then crosses Rich Mountain on its way to Tazewell, the county seat. This road was originally known as the Fancy Gap to Tazewell Courthouse Turnpike. On the opposite side of the Garden, the Appalachian Trail follows the summit of the Garden Mountain for about 10 miles along the southern edge of the valley. (Courtesy of the Mullins files.)

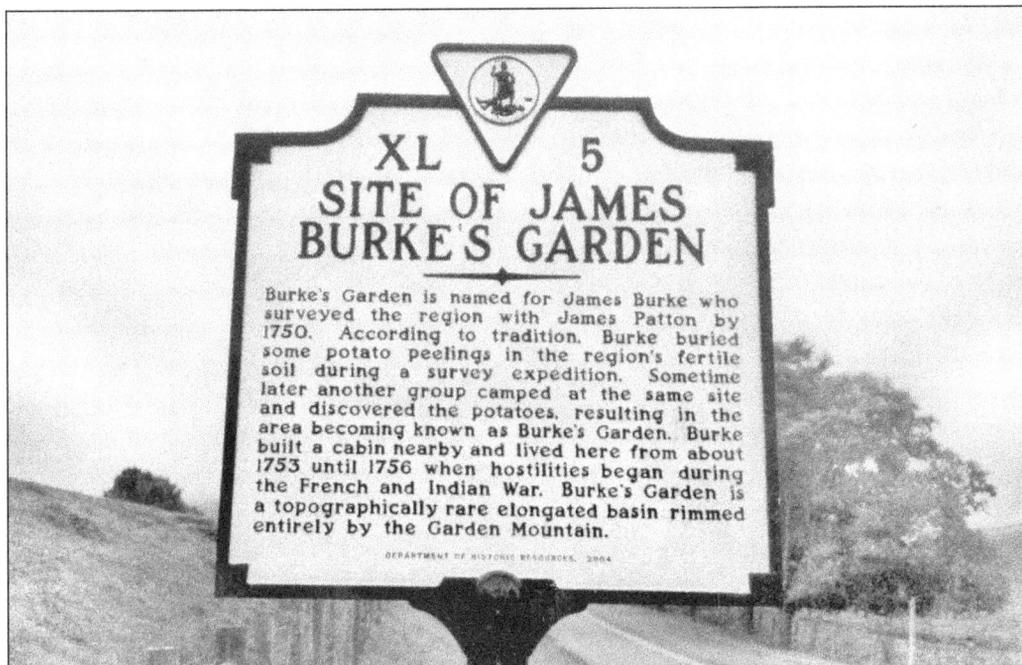

Burke's Garden was first surveyed in 1748 by a team of men working for local landowner James Patton. Legend states that one of the men, James Burke, threw out potato peelings while cooking. When the party returned to the area a year later, the men found potatoes growing at the same location. As a result, the valley was dubbed Burke's Garden. Burke built a cabin and lived in the valley for a few years in the 1750s. (Courtesy of the Mullins files.)

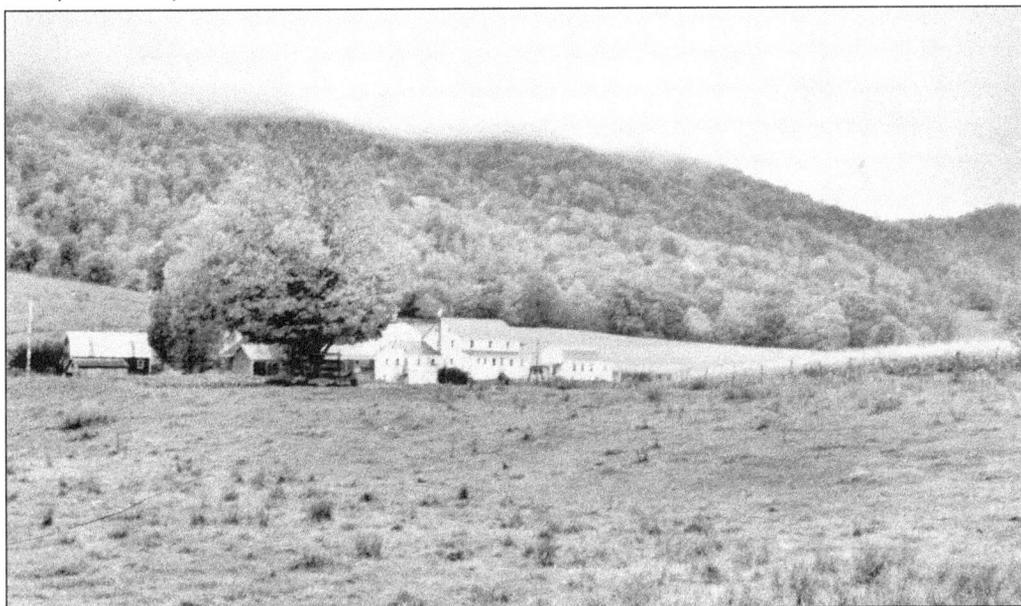

Members of the Amish community settled in Burke's Garden in more recent times, bringing a different aspect of farming and home life to the valley. Their homes, schools, and farming techniques were characteristic of their traditional Amish beliefs and simple way of life. (Courtesy of the Mullins files.)

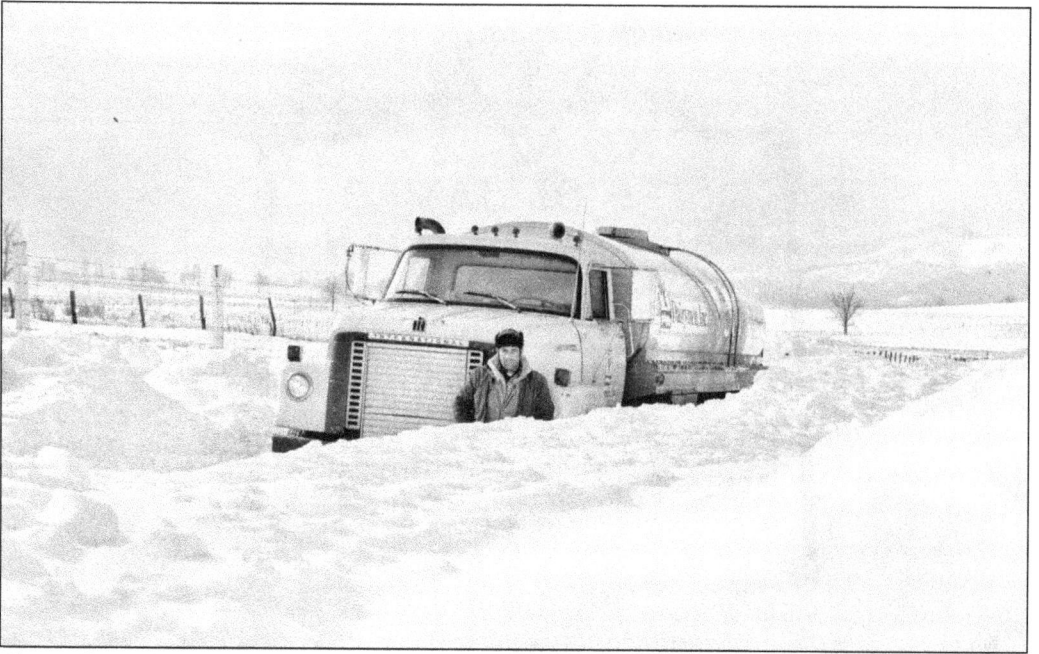

The milk truck makes its rounds regardless of the weather. On a typical winter day in January, activities do not stop; they just slow down for a few drifts. (Courtesy of Ross Gillespie.)

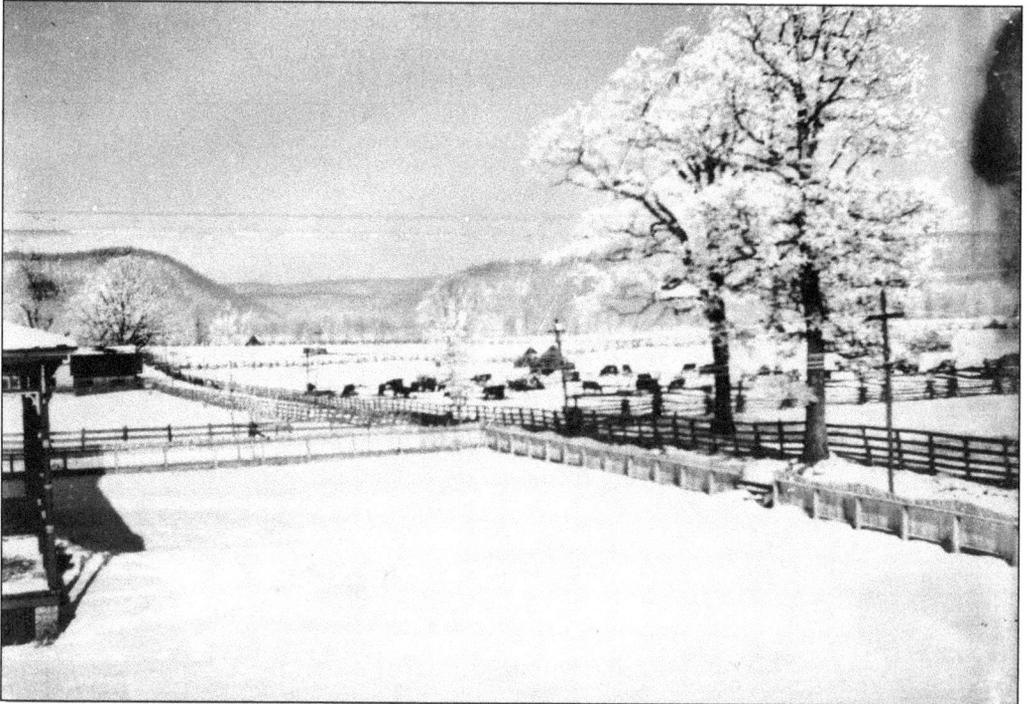

This winter view, looking north toward the Gap, illustrates the unique formation of the flat fields surrounded by the towering mountains. In fact, Garden Mountain looms from 500 to 1,000 feet above the elevation of the valley below. The Garden can truly be called "God's Thumbprint." (Courtesy of A. S. Greever.)

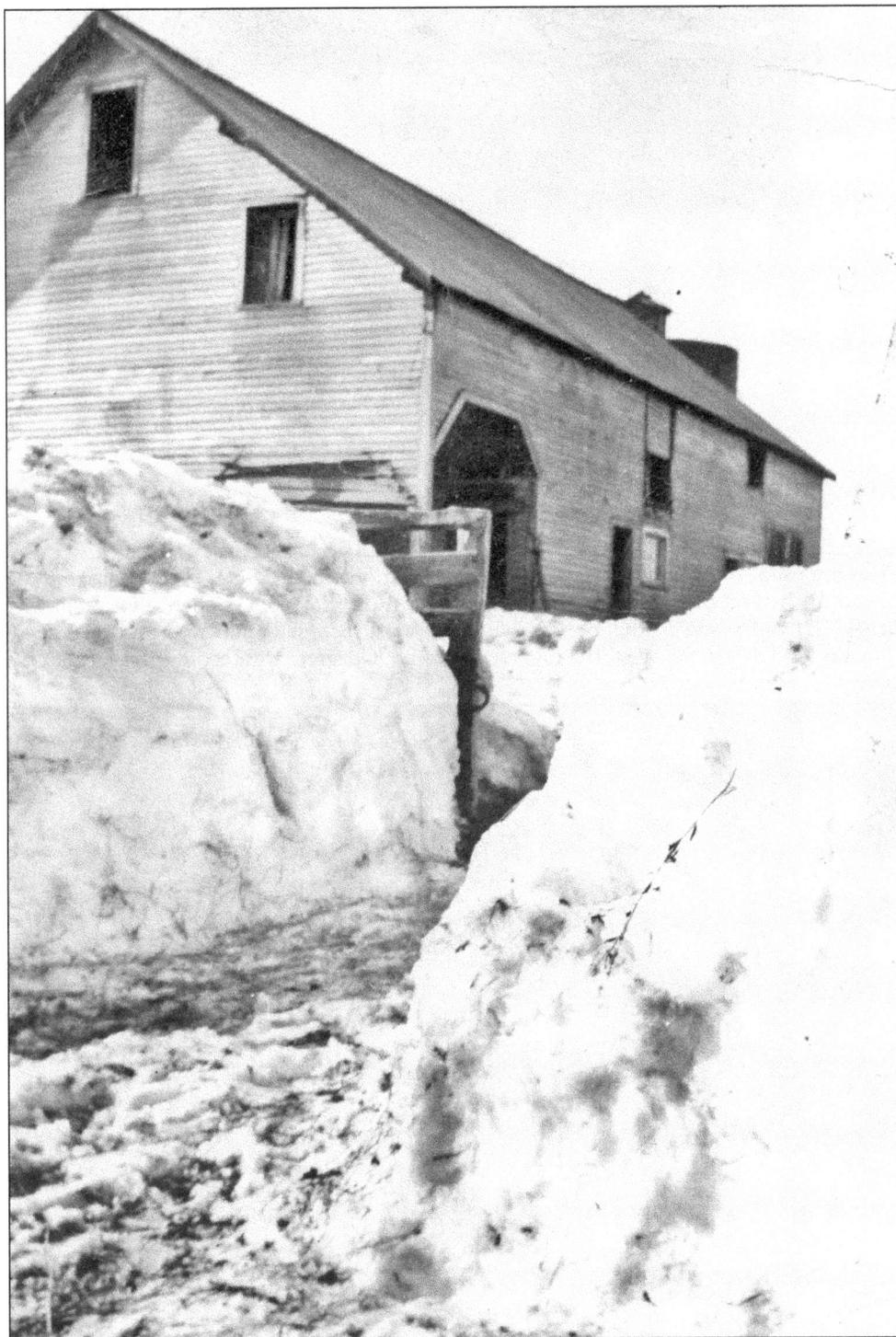

Heavy snowdrifts do not stop the farm work at the Heninger–Lula Dutton barn. It is not unusual for snow to be piled higher than trucks in a Burke's Garden winter. Often the coldest temperatures in Virginia are recorded in this mountain basin. (Courtesy of Faye Cuddy.)

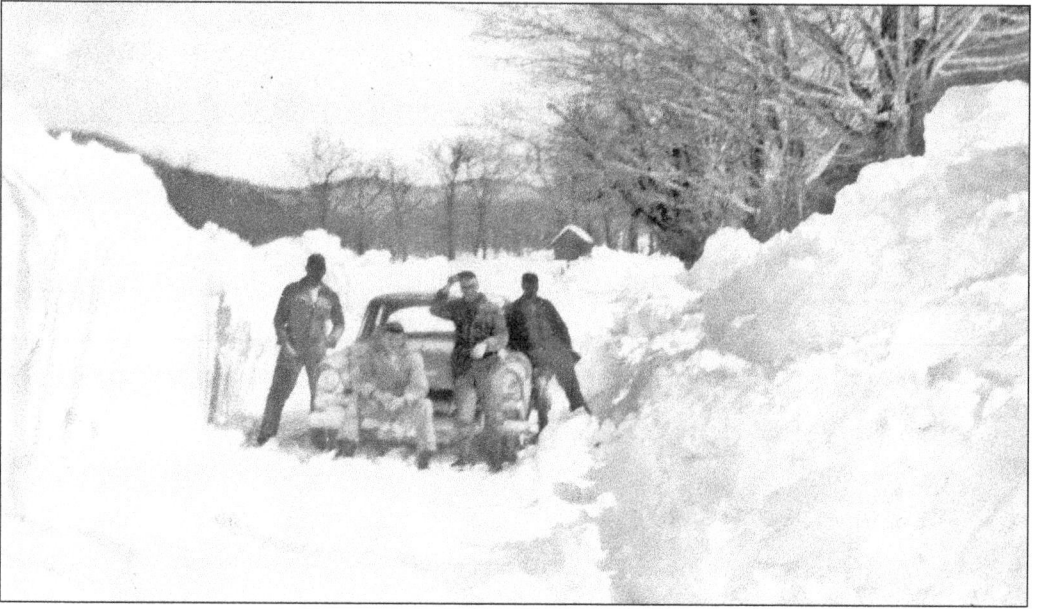

Natives are used to the most extreme weather conditions in the state. This photograph was taken during a 1960 snowstorm, when the Beartown Road proved a challenge for, from left to right, "Phil, Du, Pa, and Andy." Burke's Garden's lowest recorded temperature was -26 degrees on January 27, 1987. In contrast, the highest record of 96 degrees was recorded on July 16, 1954. (Courtesy of Marvin Meek.)

The Thomas Perry Goodwin house was almost covered with deep snow in February 1966. It drifted to the porch ceiling and roof. In the winter, livestock and people have reportedly been able to walk across high fences on top of the snowdrifts. (Courtesy of Ben Lineberry.)

14

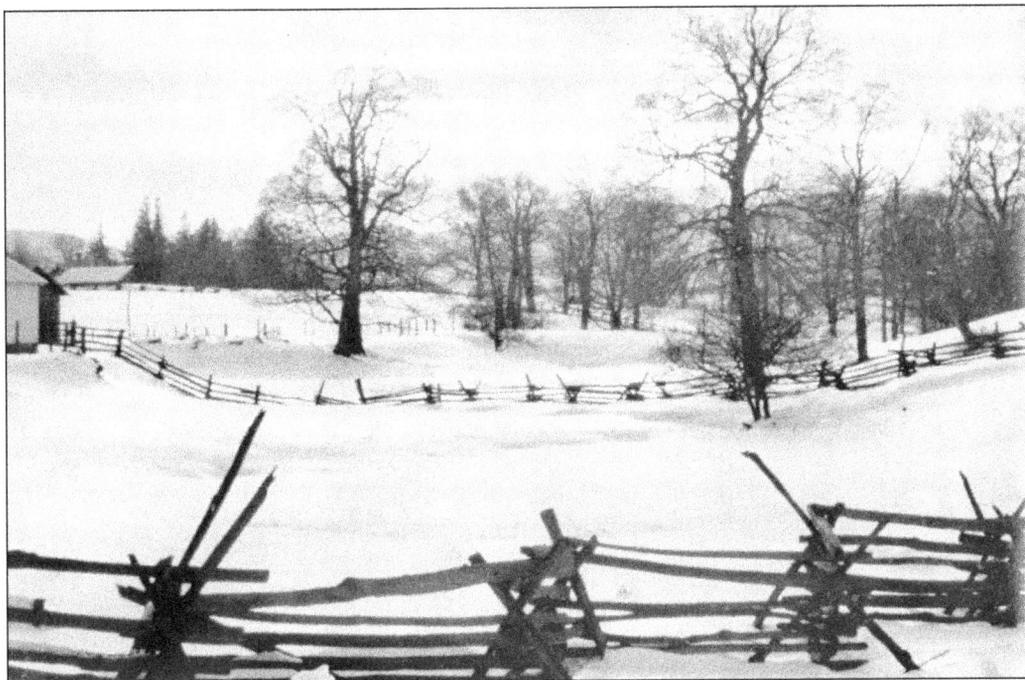

The rail fences around the rich meadows add a unique beauty to the Burke's Garden landscape. At one time, there were many "stake and rider" fences, built with safeguards against roving livestock and harsh weather conditions. (Courtesy of the Moss scrapbook.)

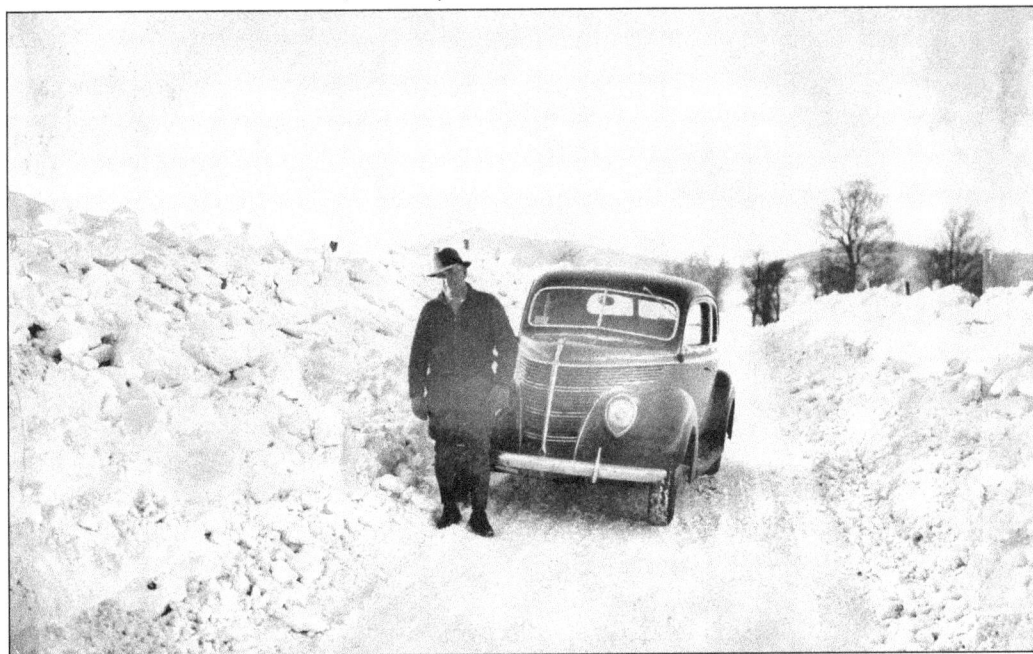

Elmer Rhudy believed the creed of the U.S. Post Office, which states that "neither snow nor rain nor storm nor dark of night" will stop the mail. He delivered the Burke's Garden mail in snowstorms like the one shown here. During his 48-year career, he made more than 13,000 trips around the Garden. (Courtesy of the Burke's Garden Community Association scrapbook.)

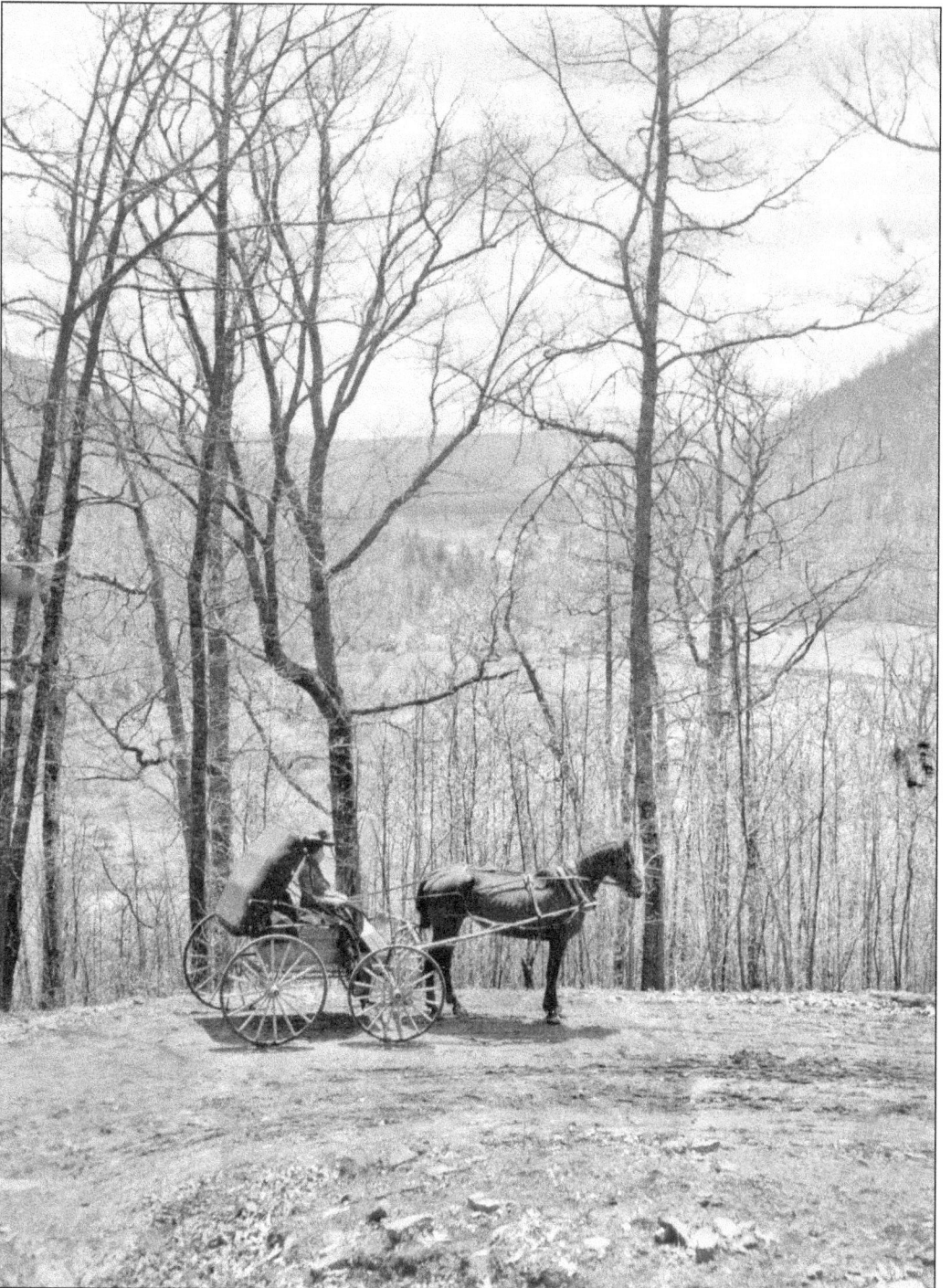

Looking south through the Gap, this view adds to Burke's Garden's worldwide reputation for scenic beauty. The horse and buggy wind down the north side of Clinch Mountain, approaching the only natural entrance to Burke's Garden from Little Creek Valley. (Photograph by A. S. Greever.)

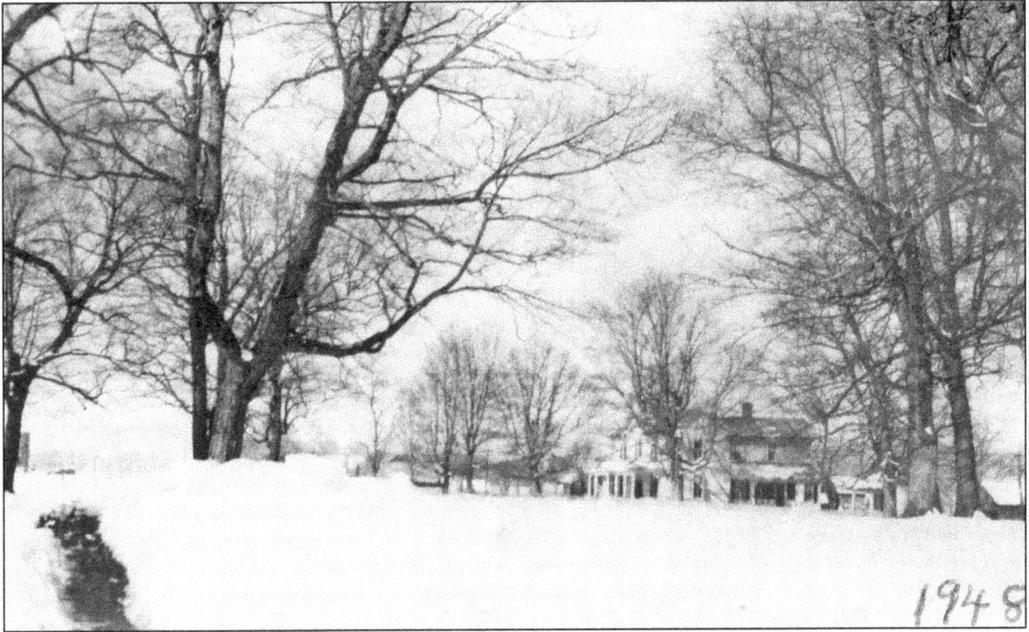

The heavy snow in the winter of 1948 was a reminder that Burke's Garden often sets the record for snowfalls in the commonwealth of Virginia. For example, Burke's Garden recorded 97 inches of snow during the 1995–1996 season. The Will and Sarah Moss house looks beautiful in its white setting. (Courtesy of Ben Lineberry.)

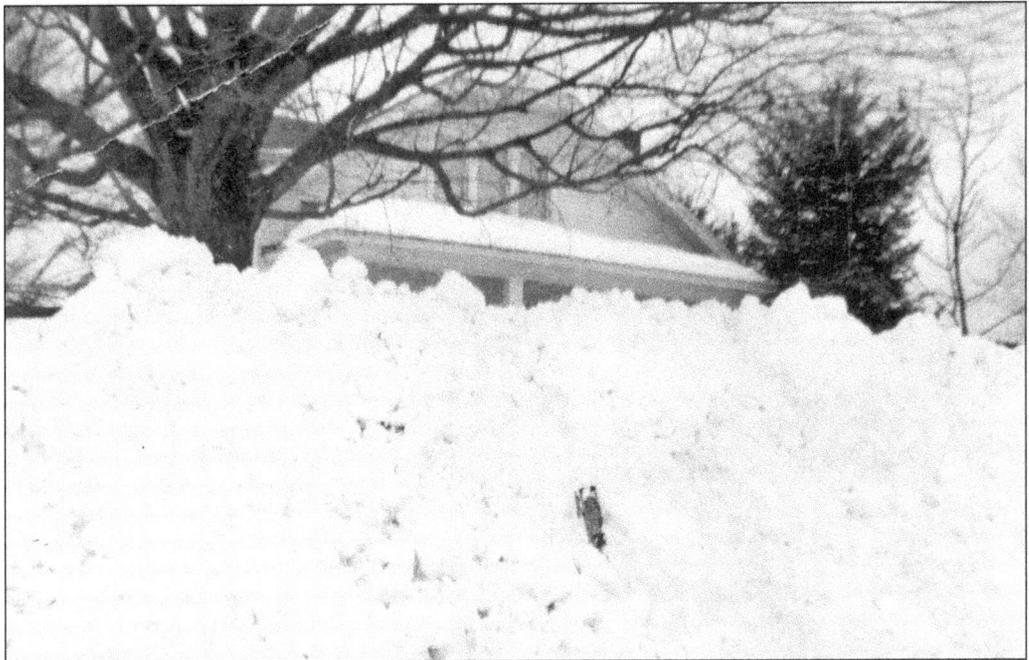

Snowfalls in Burke's Garden come in record proportions. This photograph of the Sam Meredith home exemplifies why snow depths are often measured in feet rather than inches in Virginia's highest valley. The most snowfall recorded in one season was 112 inches during the Burke's Garden winter of 1977–1978. (Courtesy of Margaret Rhudy.)

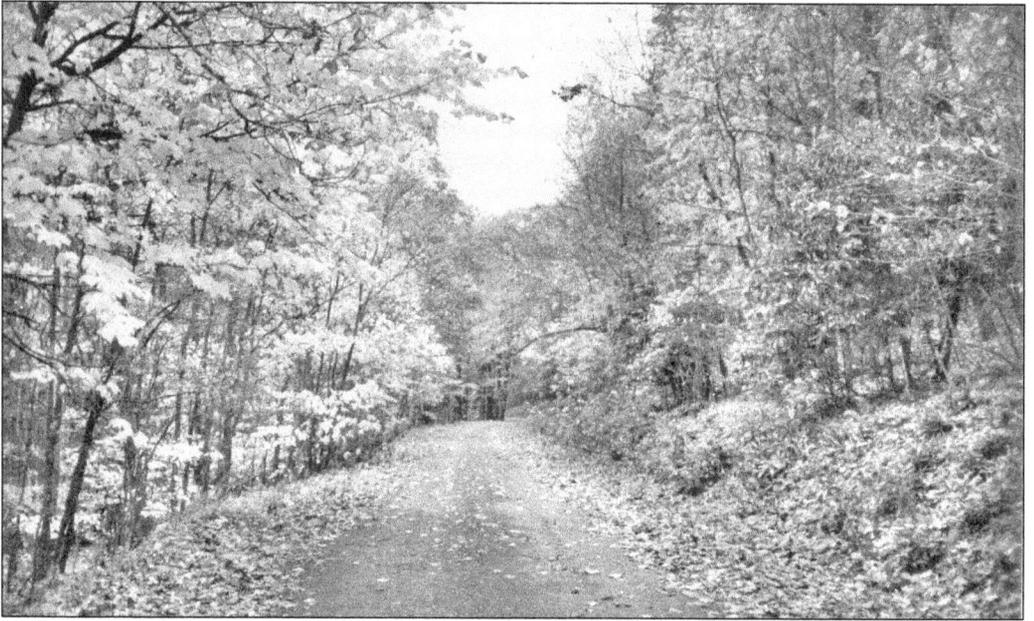

The country roads stretching to the different farms of Burke's Garden are beautiful in every changing season. Because of its history, roads, and surrounding scenery, the valley has been designated a Rural Historic District. Local legend states that George Washington Vanderbilt came to Burke's Garden trying to buy land for a castle in the late 1800s. He surveyed his possible new property and stayed in the Moss home in 1880. The Burke's Gardeners would not sell, however, so Vanderbilt constructed his Biltmore mansion in the late 1880s and early 1890s near Asheville, North Carolina, instead. The majority of the farmland in Burke's Garden has been owned by the same families for generations. (Courtesy of the Mullins files.)

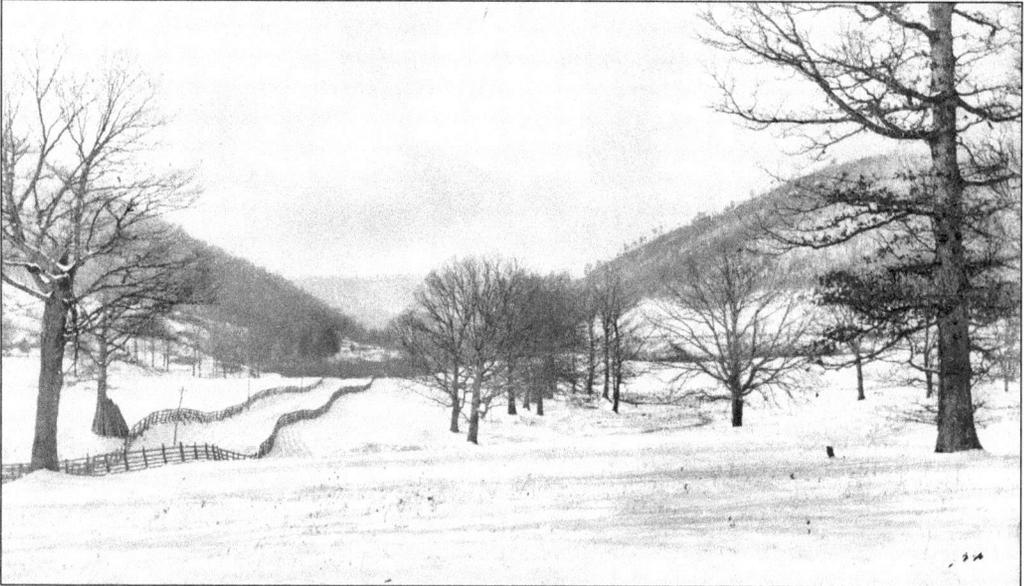

This winter scene, looking north across Burke's Garden toward the Gap, needs a poet's power of description. The photograph was taken on a day close to Christmas when the snow hid all imperfection. (Courtesy of A. S. Greever.)

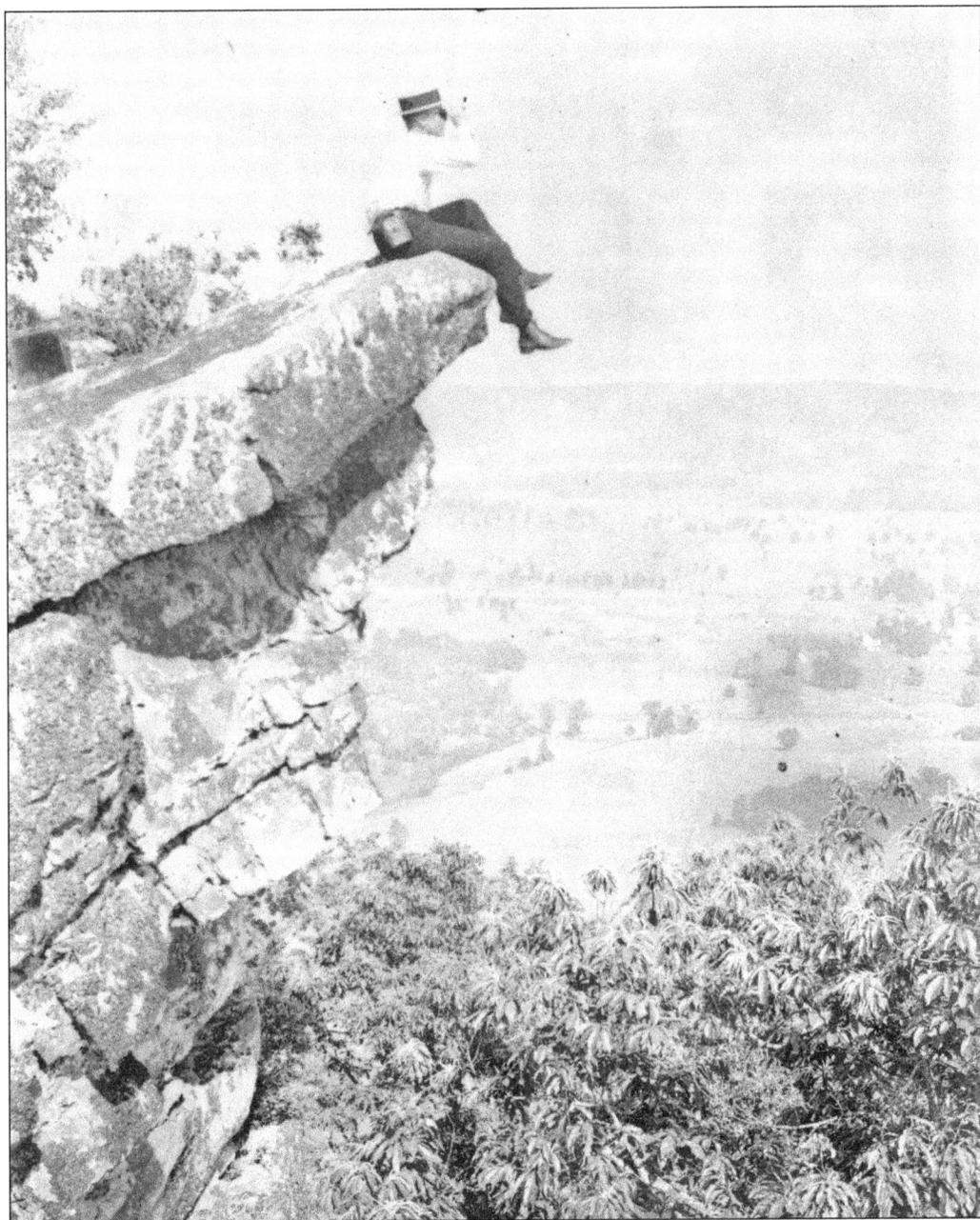

Sitting on the Moss-Rhudy property, Raven Rock is a high point on the Garden Mountain rim that allows one a scene unequaled in the mountains of Virginia. Intrepid hiker Boyd Coyner enjoys a bird's-eye view of the majestic Burke's Garden valley from this unique vantage point. (Photograph by A. S. Greever.)

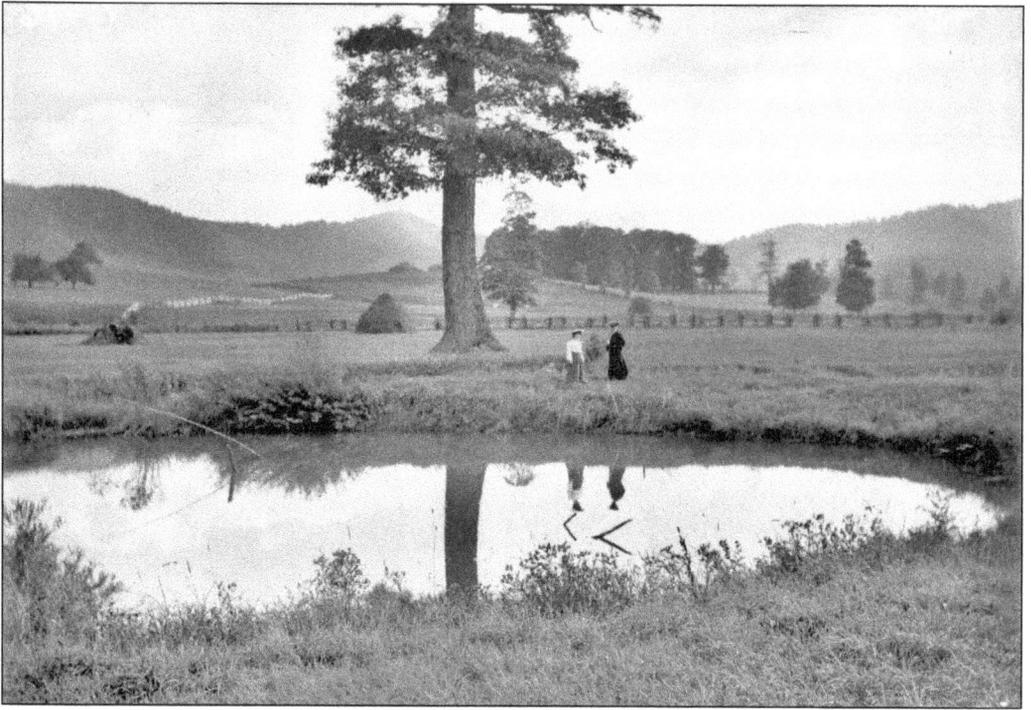

Blue Spring, one of the largest in the state, pours out 3,900 gallons a minute. Burke's Garden includes three springs—Blue, Station, and Fish—which are all said to be bottomless. Blue Spring is part of the present-day Moore farm. (Courtesy of A. S. Greever.)

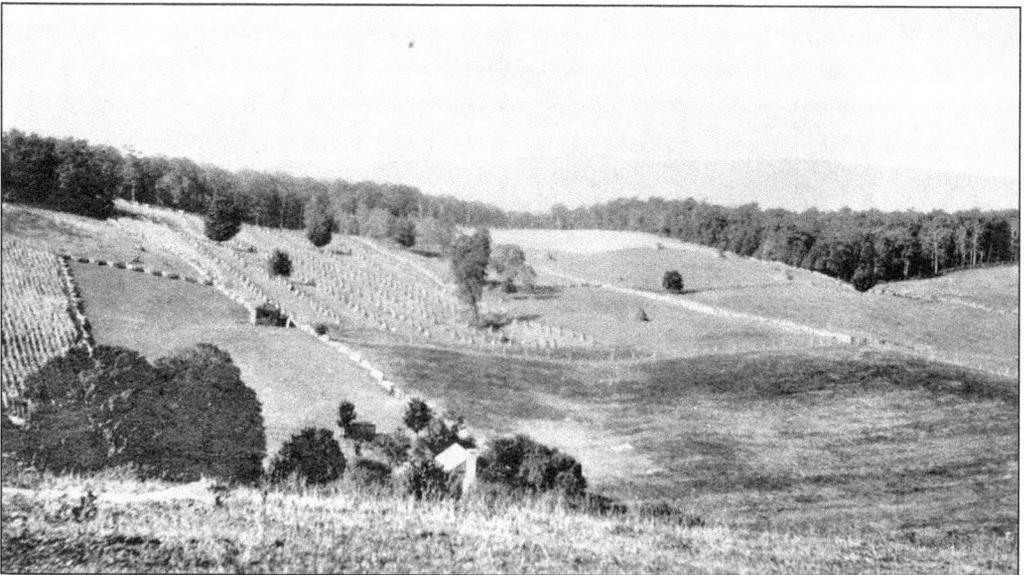

In the midst of Burke's Garden's rich fields are the Marvin Eagle house and orchard. Marvin Eagle was a World War I veteran, one of many residents who served in that war. This photograph was taken from Eagle Hill. (Courtesy of Ruth Snapp.)

20

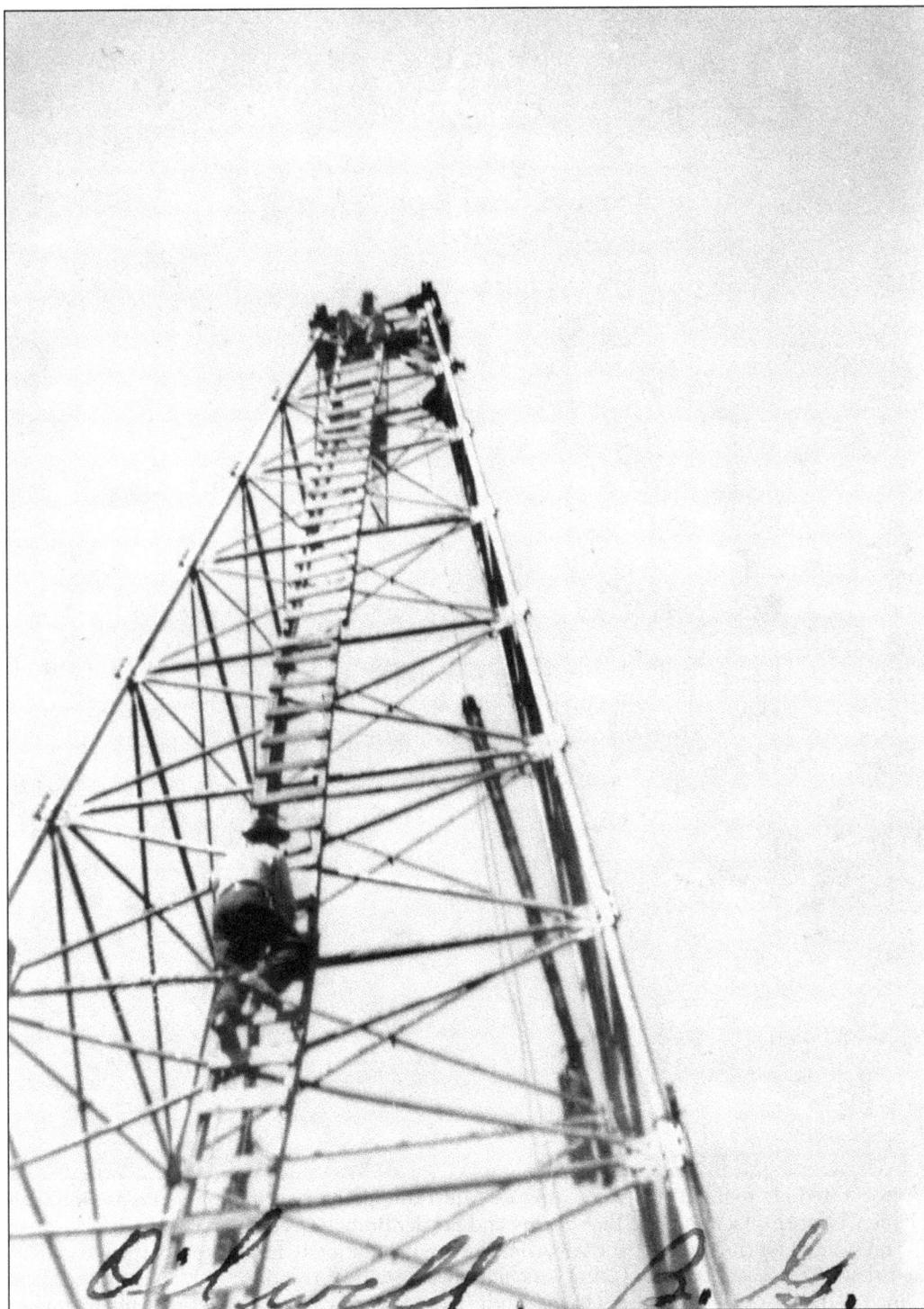

An oil well was drilled on the Jim Hoge farm in 1948. When the oil rig was being closed down and the water boiled out for the last time, there was reportedly enough water left in the well to supply a large city. (Courtesy of Harry Tibbs.)

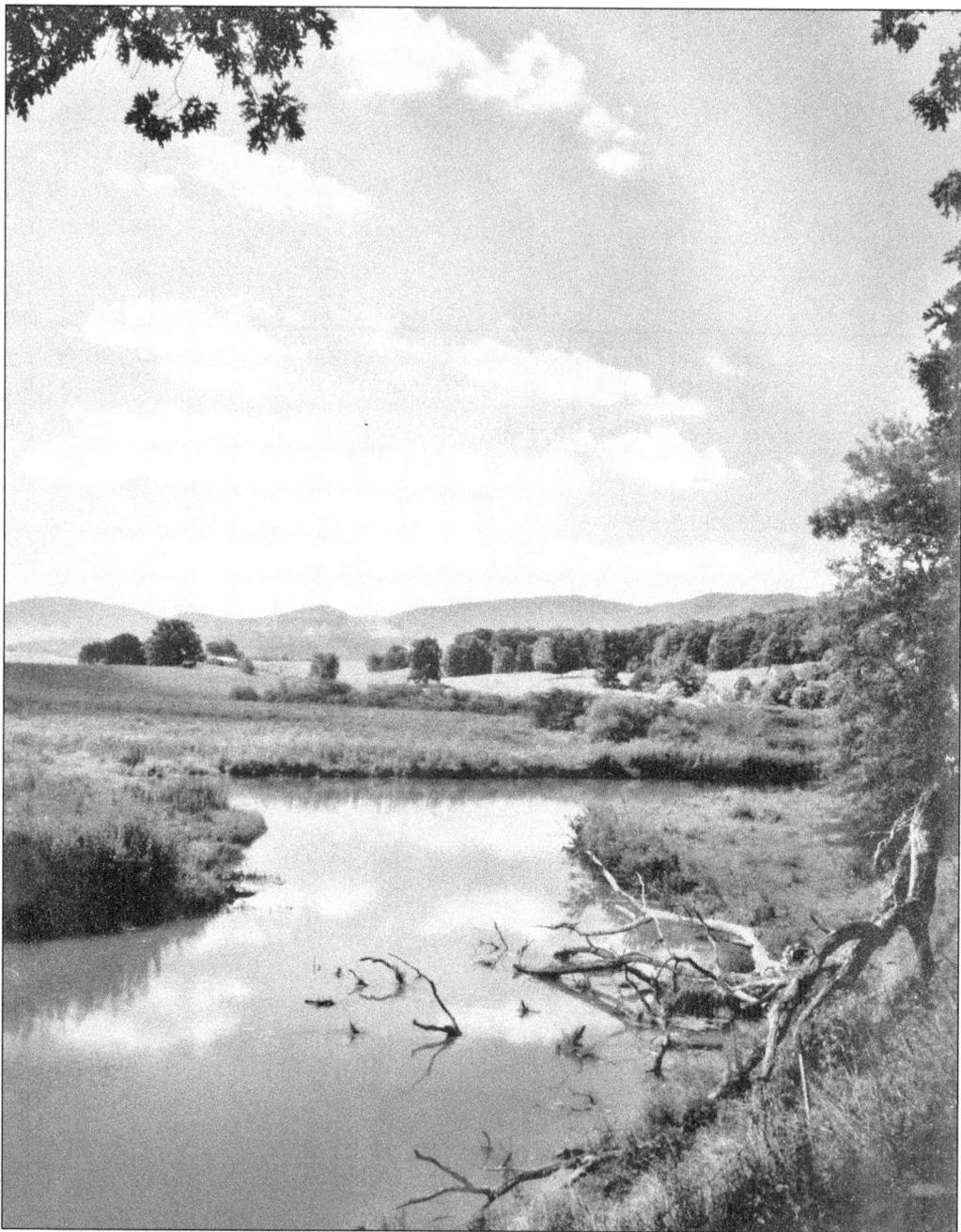

Visitors often photograph this scene at Gose Mill Dam giving a surrounding glimpse into the Garden. Near this location, the Blue Spring and Snyder Branch Creeks join to form Wolf Creek, the only outlet for the waters that rise in the Garden. In addition to headwaters of the New River that flow to the east, Tazewell County includes headwaters of the Big Sandy to the north, the Clinch to the west, and the Holston to the south. This view was captured by Tazewell photographer Bryan Warden. (Courtesy of Bryan Warden.)

Two

EARLY FOLK

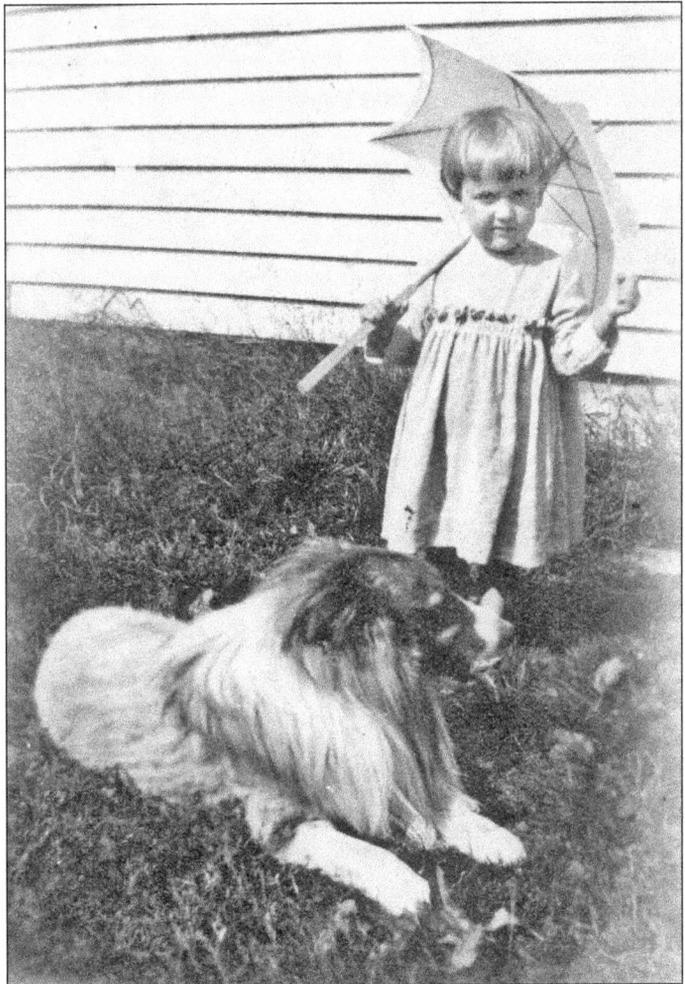

Young Mona Davis, the daughter of Leon and Donie Davis, must have felt safe with her favorite parasol and her canine friend close by on a bright Burke's Garden day. She later married J. P. Buchanan and had two children: Phil and Mary Ann Buchanan (Vaughn). (Courtesy of Ruth Tarter.)

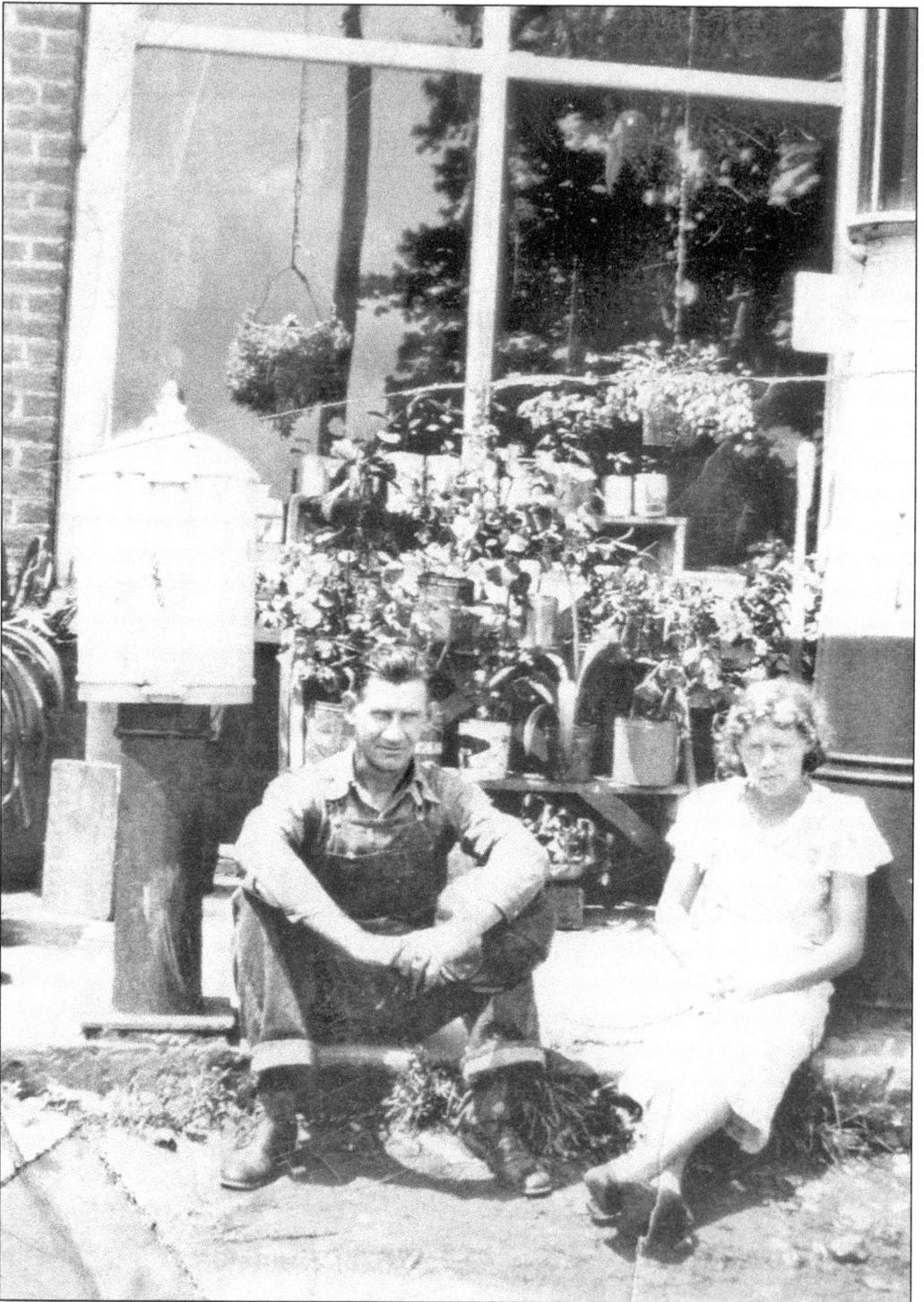

Ray Brewster and Ruth Lambert Tabor relax in front of the Perry Goodwin Store in the late 1930s or early 1940s. The popular shop became a mainstay for Burke's Garden families, who were able to find almost everything there. (Courtesy of Betty Vanhoozier.)

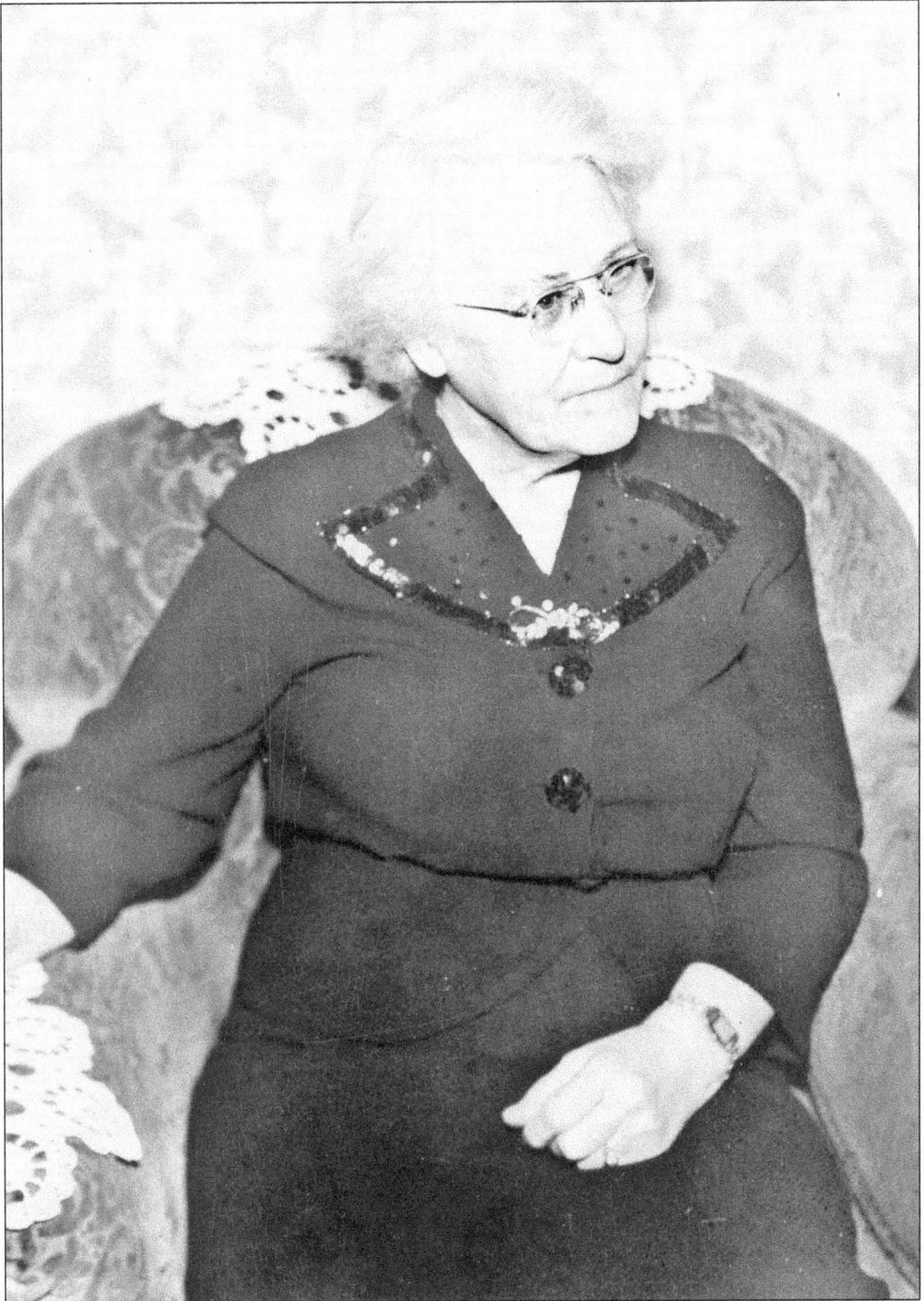

Mattie May Felty Short played an important role at the Short Store. As with many women in Burke's Garden, she ran a home, assisted with her family's business, and still had time to donate to the community and church. She was the wife of Tilden H. Short. (Courtesy of Bobby Short.)

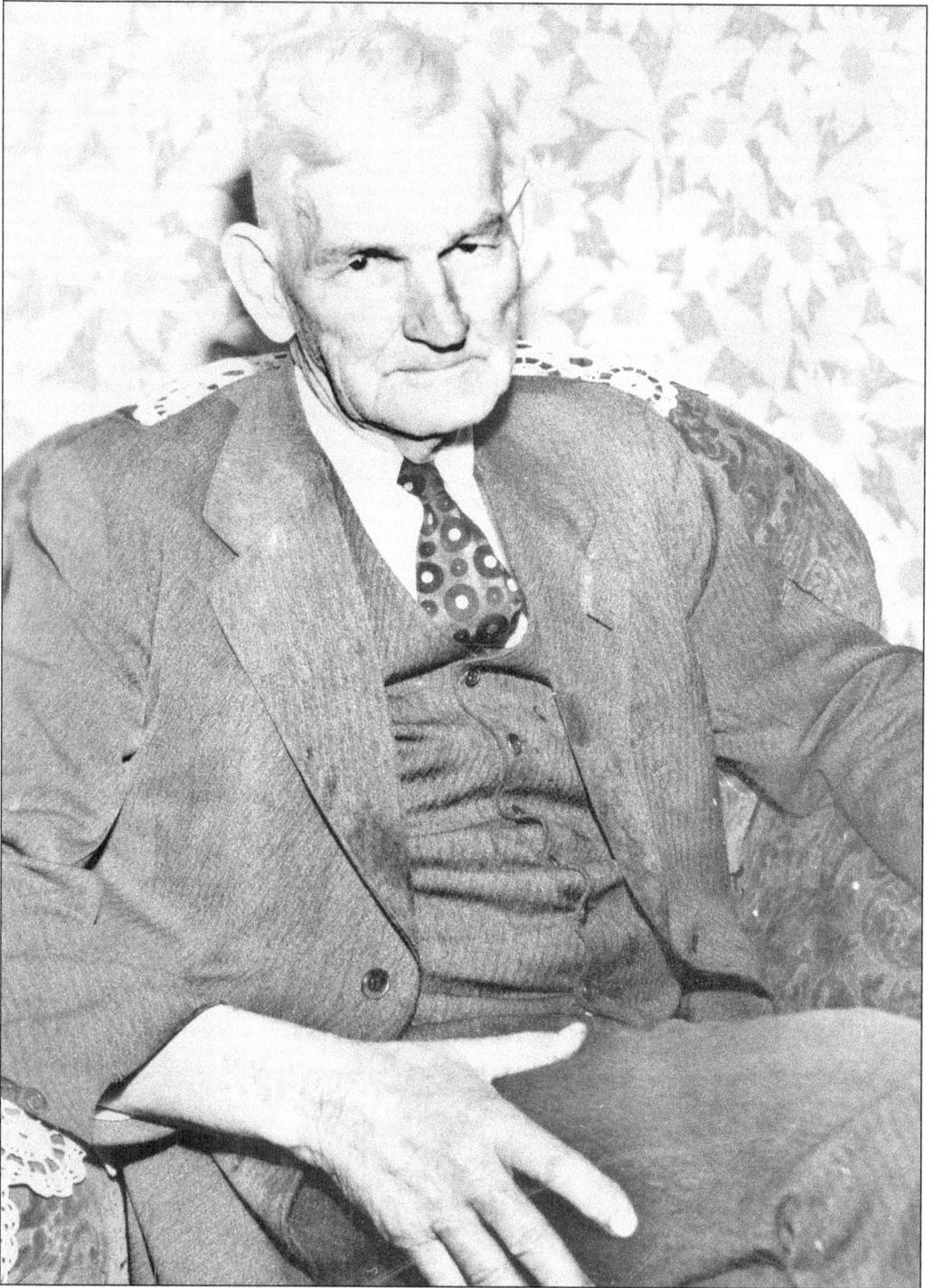

Tilden Hendrick Short operated a thriving store in Burke's Garden for many years. The Garden was well supplied with stores, churches, schools, and postal service through much of the last two centuries, making it a self-contained community. The Short Store was one of these important services. (Courtesy of Bobby Short.)

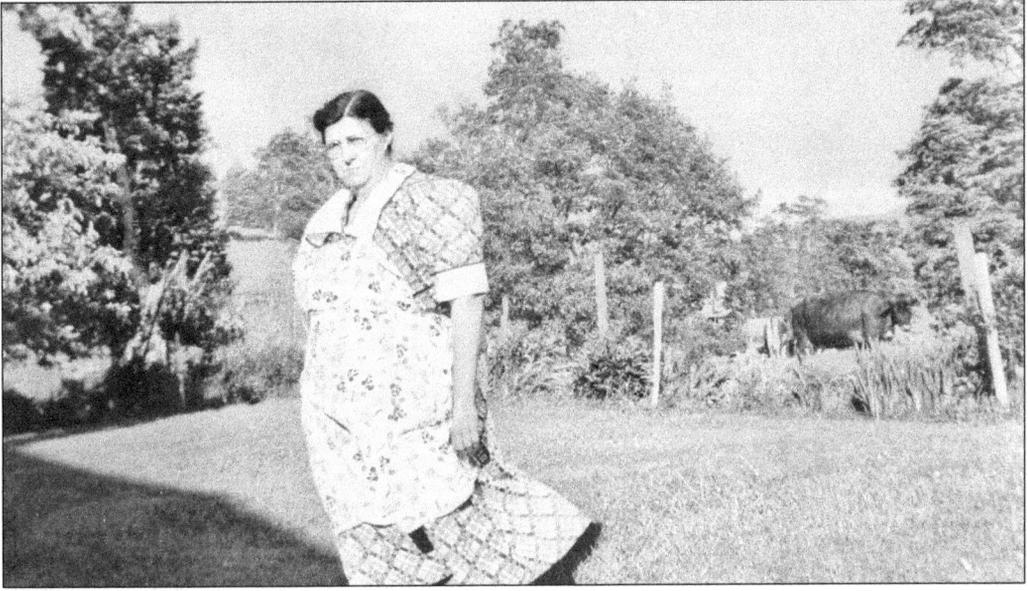

Nellie B. Rhudy (1896–1960), the wife of Jacob Leach Rhudy, was a homemaker and a supporter of her community. Her daughter Colleen Rhudy Cox is the well-known postmaster of Burke's Garden, presiding over one of the smallest post offices in the nation. (Courtesy of Colleen Cox.)

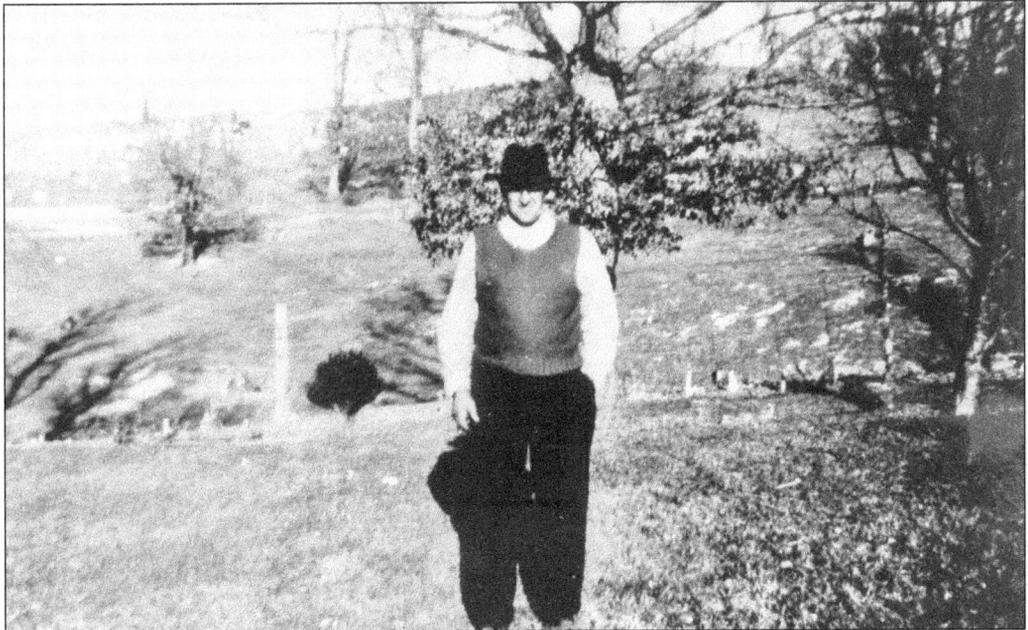

Jacob Leach Rhudy and his family lived on the original Rhudy land in the middle of the Garden bowl. The Rhudy family surname is more common in Virginia than in any other state. Jacob died in 1969 at the age of 75. (Courtesy of Colleen Cox.)

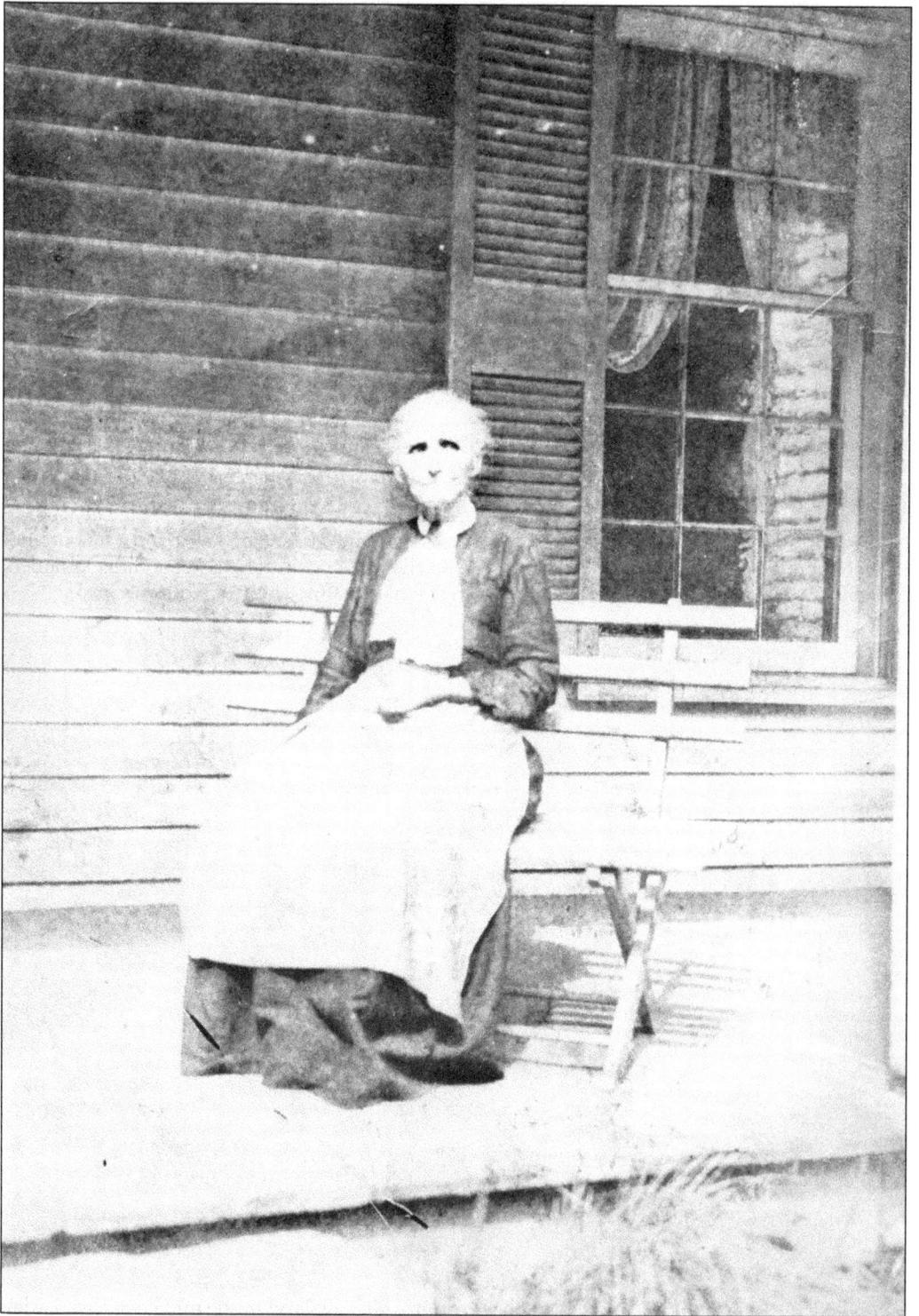

Mary Elizabeth Kelly married Henry Branstetter Groseclose, bringing together two pioneer families. Note Mary's clothing, typical of the time. (Courtesy of Ben Lineberry.)

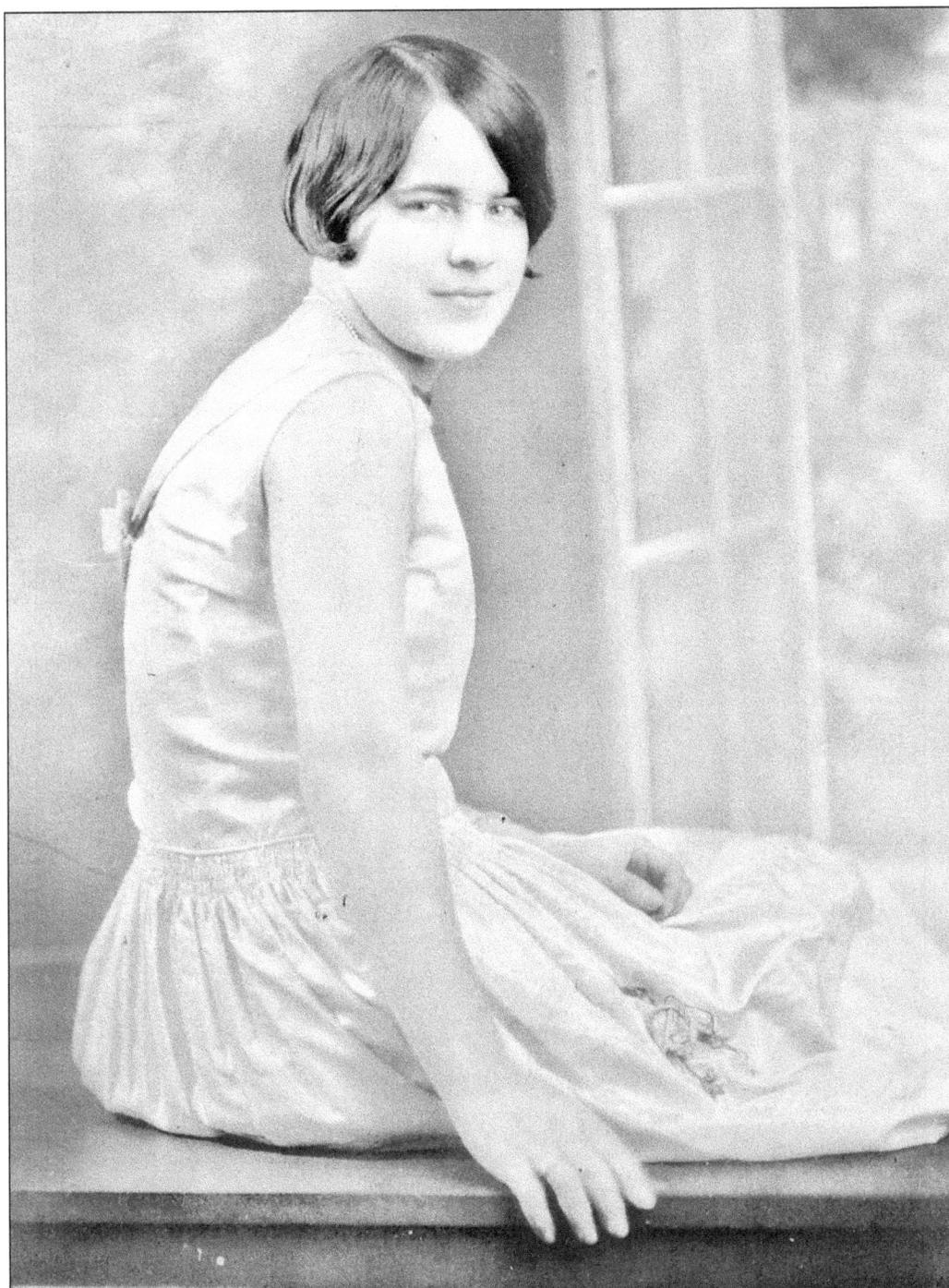

Mildred Brenda Meek (1909–2005) was born in Burke's Garden, the daughter of James Robert and Josephine Brenda Groseclose Meek. After graduating from Burke's Garden High School, she earned her college degree from Sullins in 1929. She and Harry H. Lineberry married in 1929 and, after living in Honaker for three years, returned to farm in Burke's Garden. Their two sons are Ben and Bill. (Courtesy of Ben Lineberry.)

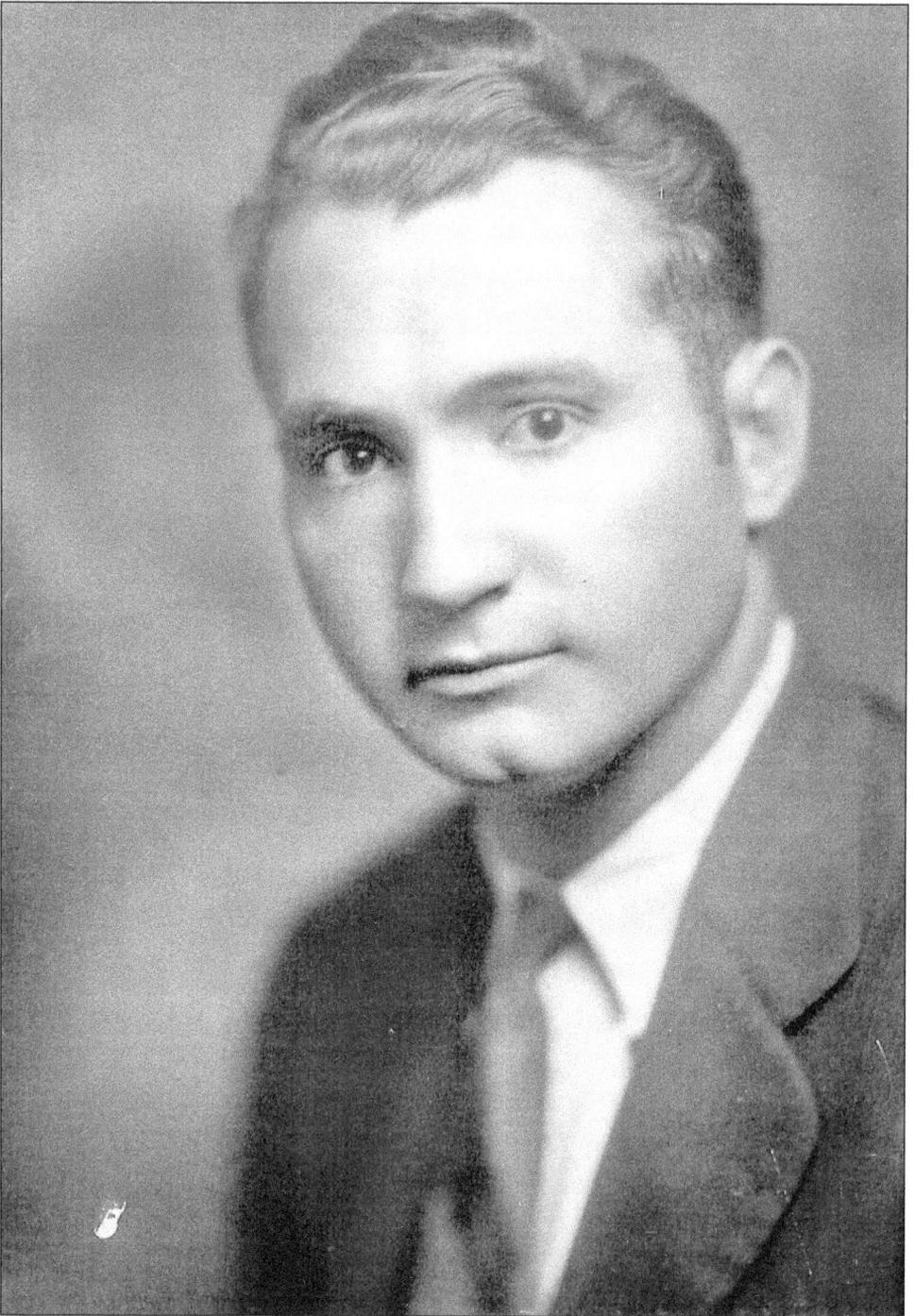

Harry Holland Lineberry (1903–1974), a native of Carroll County, came to Burke's Garden as the first vocational agriculture teacher. He also became the first teacher in this field at Tazewell, Honaker, and Cleveland High Schools. He had graduated from Virginia Tech in 1926 with a degree in agriculture education. During college, he earned athletic letters in wrestling and football. (Courtesy of Ben Lineberry.)

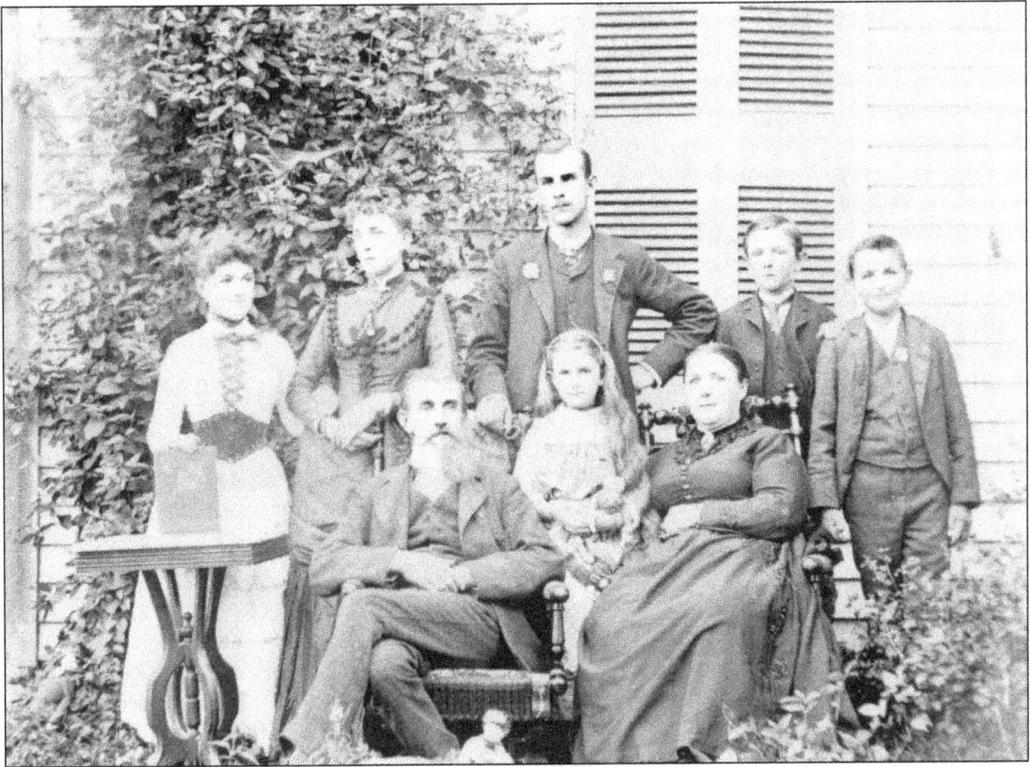

The Groseclose family gathers for a formal portrait at their home, likely in the mid-1800s. Pictured from left to right are the following: (first row) Henry Branstetter Groseclose, Fannie Gilmer Groseclose, and Mary Elizabeth Kelly Groseclose; (second row) Martha Matilda Groseclose, Josephine Brenda Groseclose, John Kelly Groseclose, Frank Farrier Groseclose, and James Henry Groseclose. (Courtesy of Ben Lineberry.)

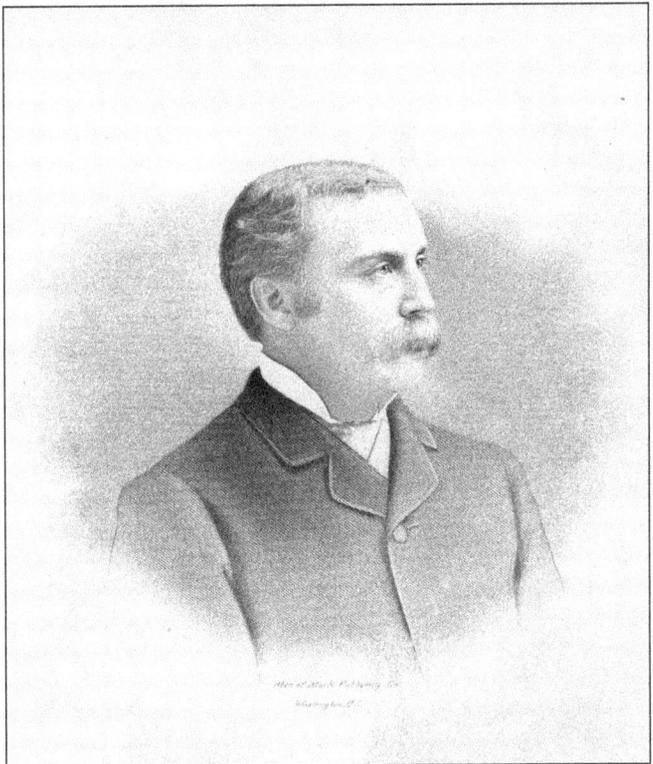

R. M. Lawson's reputation as a gentleman and a farmer of ability is recognized years after his death. His respect for the land in this fertile basin, and his understanding of the people who settled in this "Garden Spot," serve as a model for other landowners. (Courtesy of the Oak Grove Farm scrapbook.)

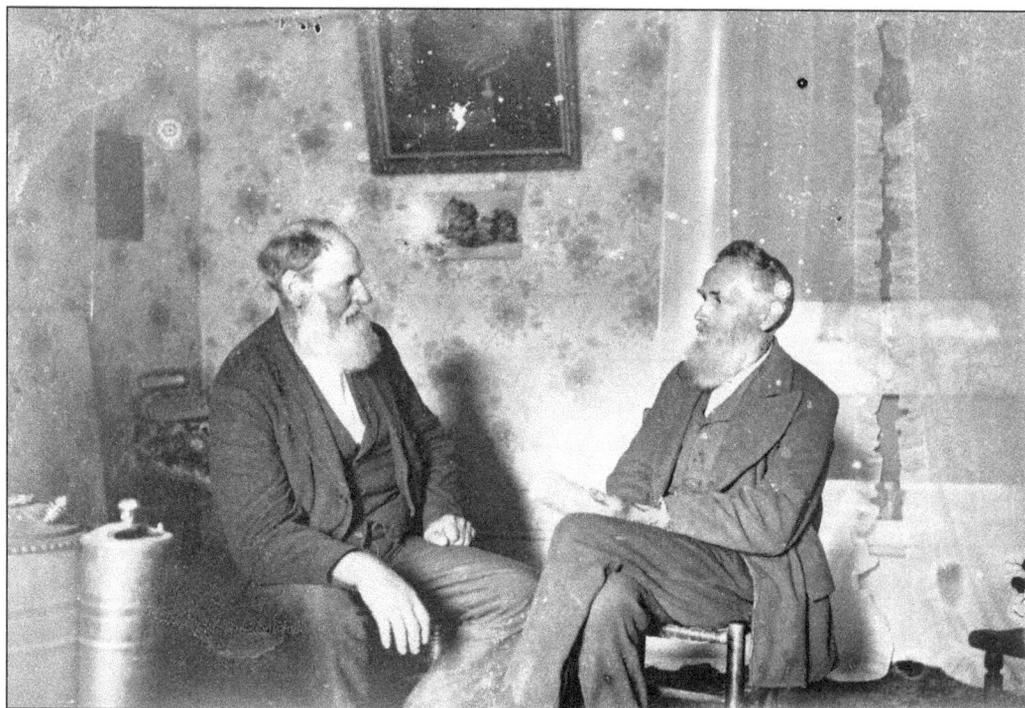

Civil War buddies John D. Greever (right) and ? Bourne are apparently discussing serious business in this photograph. In addition to its booming farms, Burke's Garden was home to a variety of businesses during a high point in the community's history. (Courtesy of A. S. Greever.)

James Robert Meek (1865–1932) is shown with his wife, Josephine Groseclose Meek (1868–1921). Through the generations, the Meeks have been a very influential Burke's Garden family, owning a large amount of land and demonstrating an appreciation for the nature around them. (Courtesy of Ben Lineberry.)

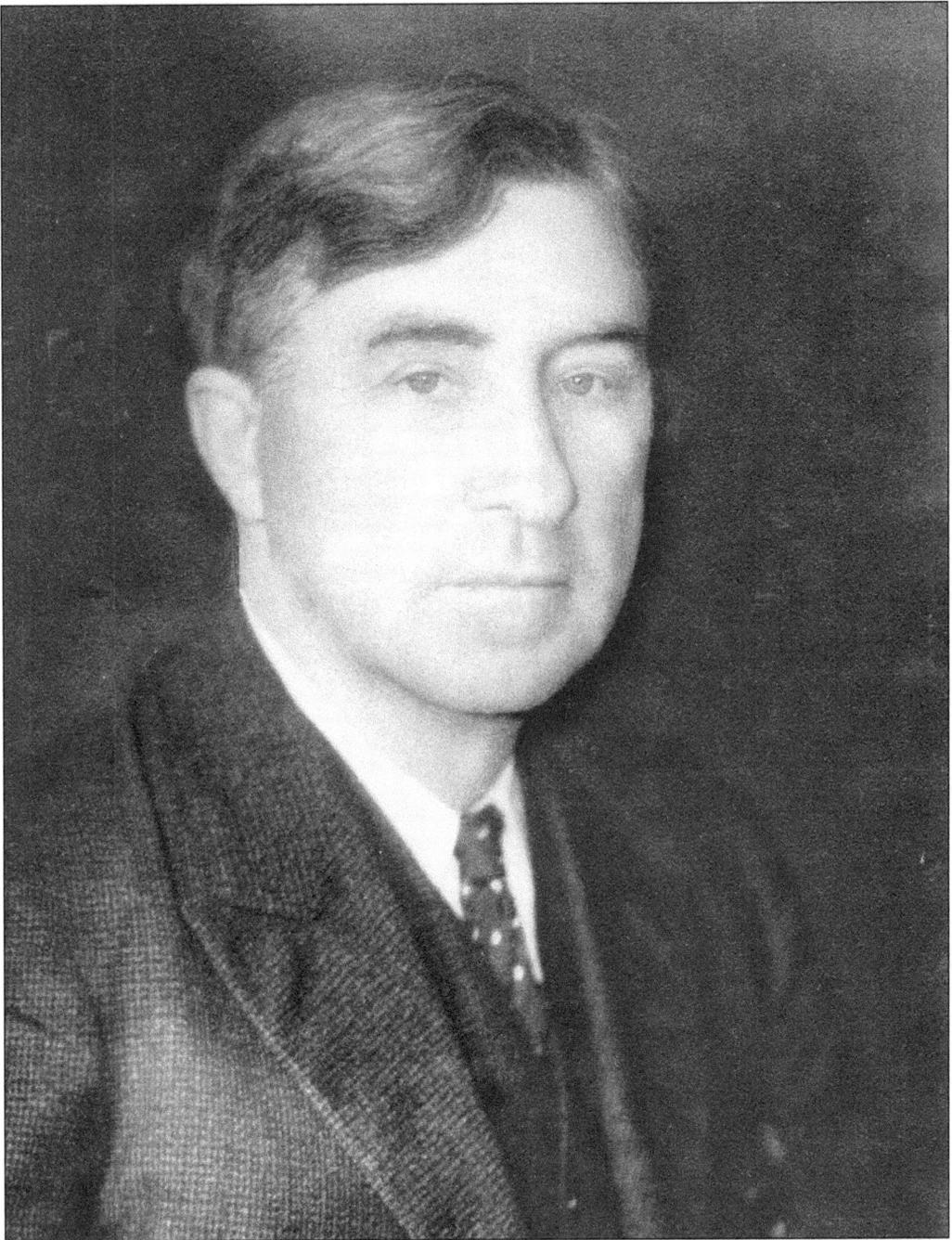

Robert S. Moss operated several Burke's Garden farms, including about 5,000 acres during the years 1874 to 1943. A born leader, among other honors he served as chairman of the board of visitors at Virginia Tech for 25 years. (Courtesy of the Moss-Lincoln scrapbook.)

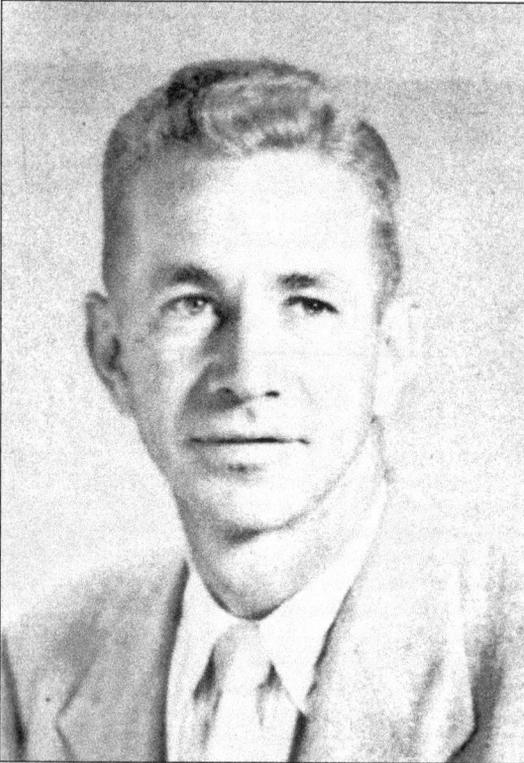

Edgar P. Greever, retired Tazewell County treasurer, is a Garden native who lives on the land settled by his ancestors. When he taught in the Burke's Garden School, this photograph was published in the 1955 school annual, the *Garden Gate*. (Courtesy of Alex Chamberlain and the *Garden Gate*.)

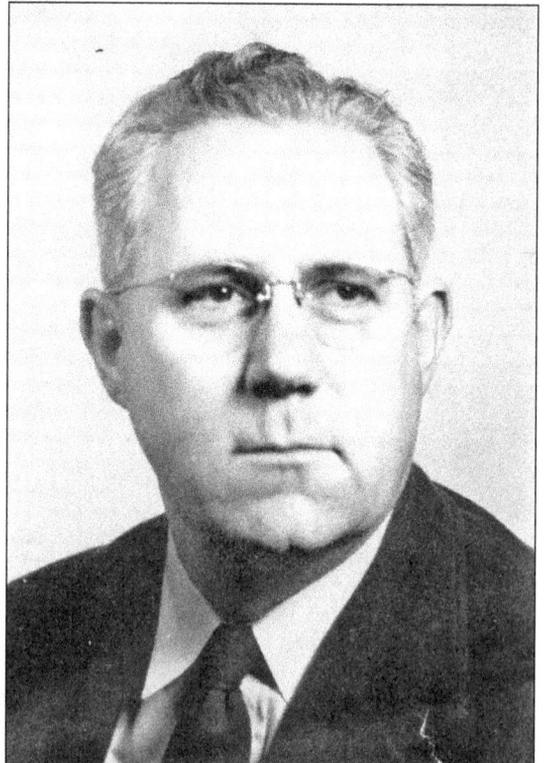

J. P. Buchanan arrived in Burke's Garden as a principal and teacher of agriculture in the high school. He later taught agriculture for many years at Tazewell High School. He was known as "Mr. Buck" to hundreds of students. (Courtesy of Alex Chamberlain and the *Garden Gate*.)

Grace Whitman Bowman, the wife of Edward L Bowman, lived in the east end of Burke's Garden on a prosperous farm. The east end consisted of many busy homes and thriving farms during that era. (Courtesy of Elizabeth Bowman.)

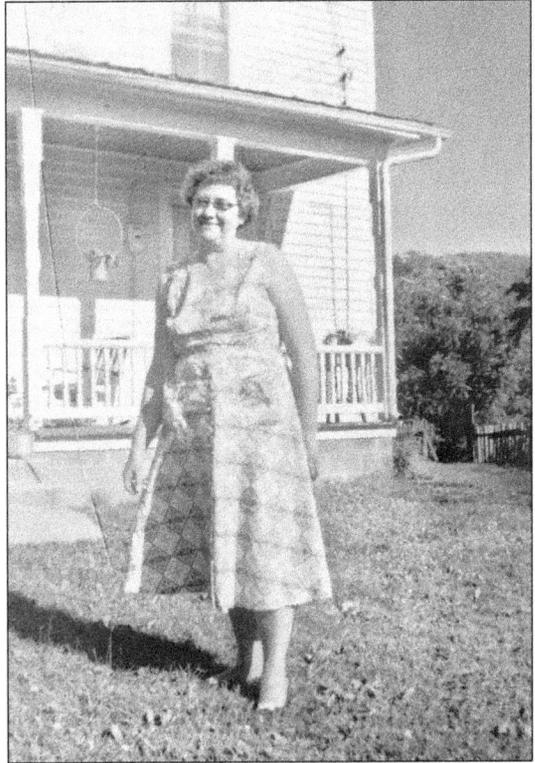

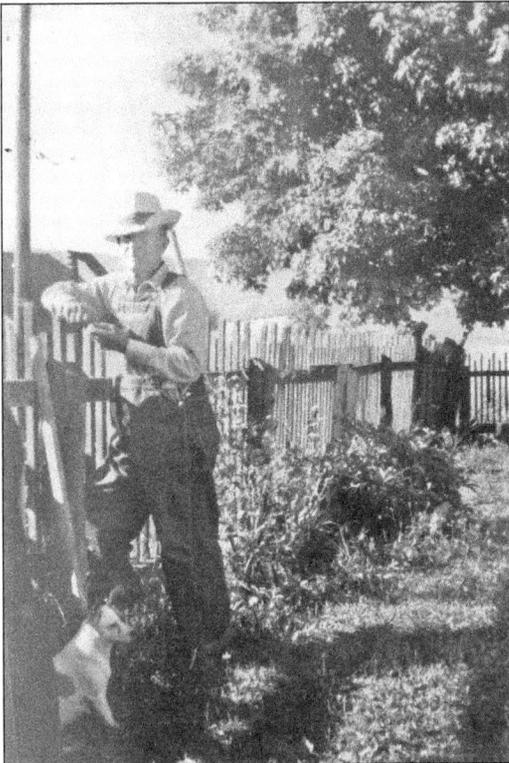

Edward L. Bowman bought his east-end farm in 1941. He and his family were known for their dedication to work and home and their concern for neighbors and friends in every situation. (Courtesy of Elizabeth Bowman.)

Leon and Donie Francis Davis lived on a beautiful Burke's Garden farm and raised a large family. Members of the Davis family are recognized throughout the Southwest Virginia area and beyond. (Courtesy of Ruth Tarter.)

John and Helen Boling, well-known Burke's Garden residents, are remembered for their interest in and love of the area. Their home became a flower-covered showplace in the summer months. (Courtesy of Helen Boling.)

After building this house in 1954, Cleo and Aubrey Kitts enjoyed many happy years in Burke's Garden. Cleo died in 1989 and Aubrey in 1975. Kitts family descendants can now be found throughout the country. (Courtesy of Faye Cuddy.)

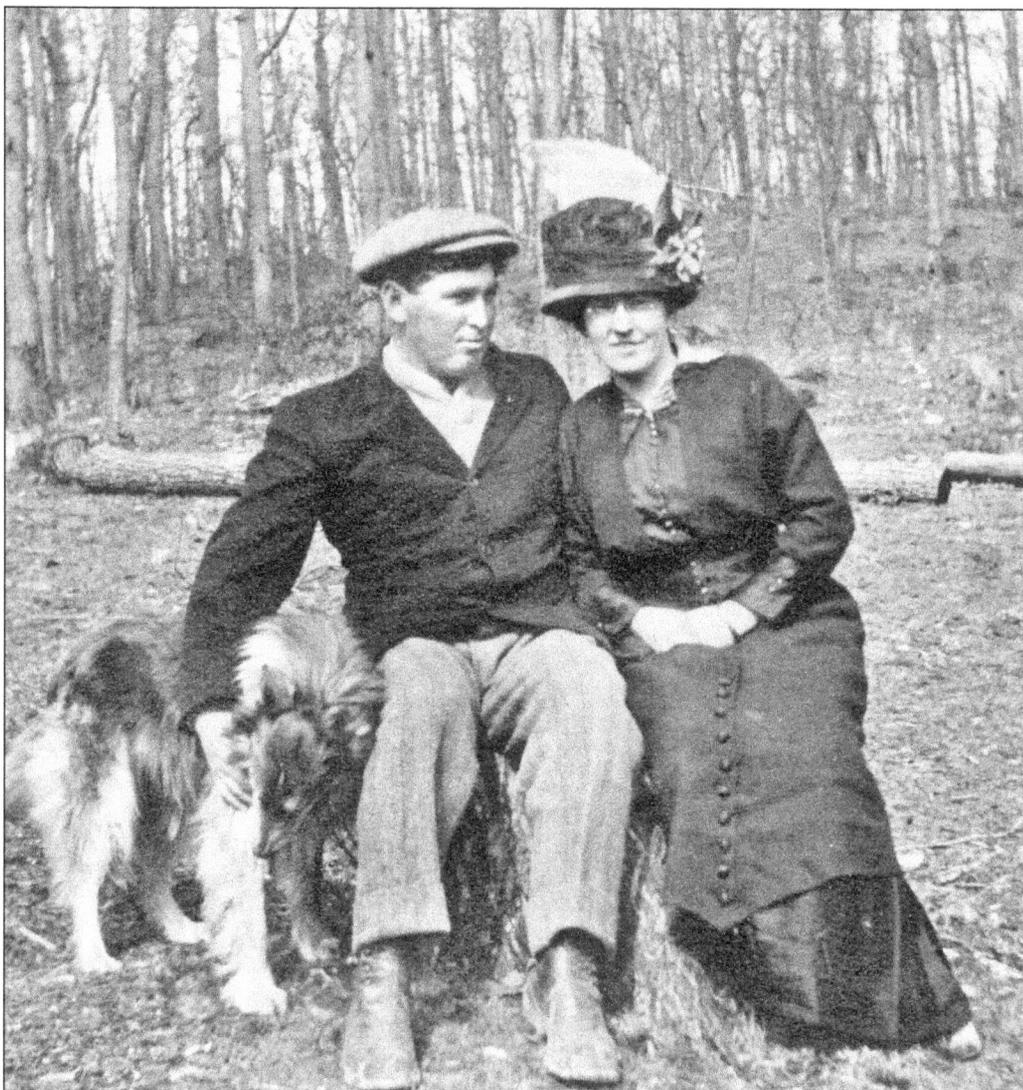

Lifelong residents Elmer and Stella Davis Rhudy seem content on a Sunday afternoon outing with their dog. Elmer Rhudy served as Burke's Garden's rural mail carrier for 48 years and three months, retiring in 1957. (Courtesy of Ruth Snapp.)

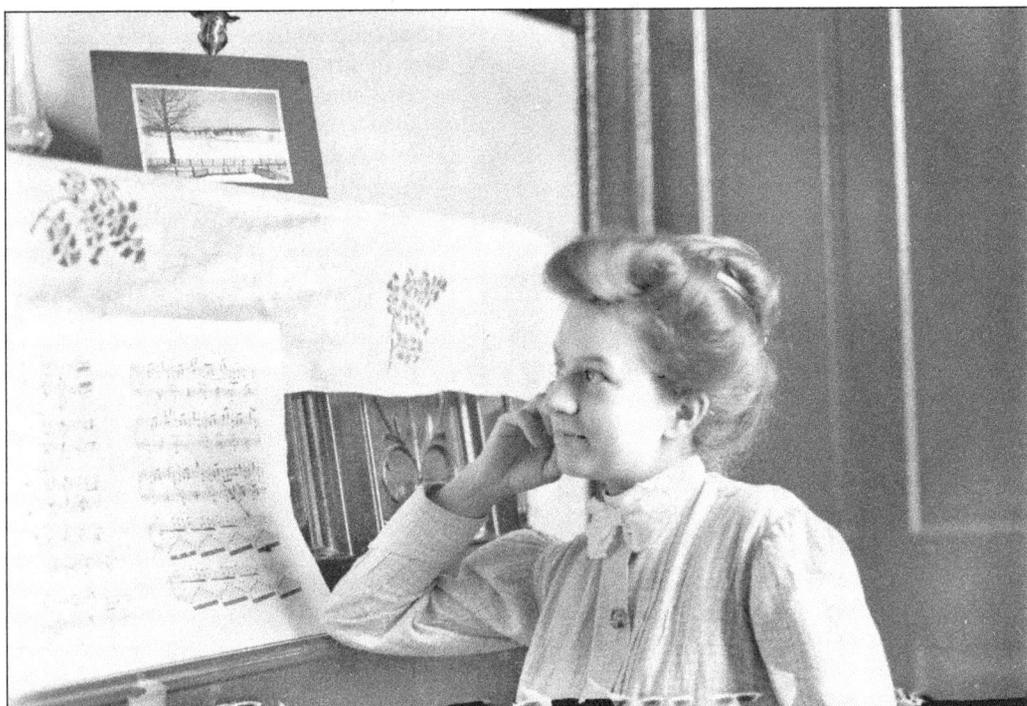

Elizabeth Greever, the wife of A. S. Greever, taught piano lessons and played the organ at the Lutheran church when she lived in Burke's Garden. She first came to the valley in 1900 as a music teacher at the academy. (Photograph by A. S. Greever.)

Bob and Frances Davis are pictured at their Burke's Garden home on their anniversary. They are remembered by their friends and large family, whose members are now scattered around the country. (Courtesy of Jim Bob Davis.)

Many families lived in Burke's Garden for generations. Augustus Lambert and his wife, Lena Baumgardner Lambert, were both longtime residents. They are shown in 1955. (Courtesy of Betty Vanhoozier.)

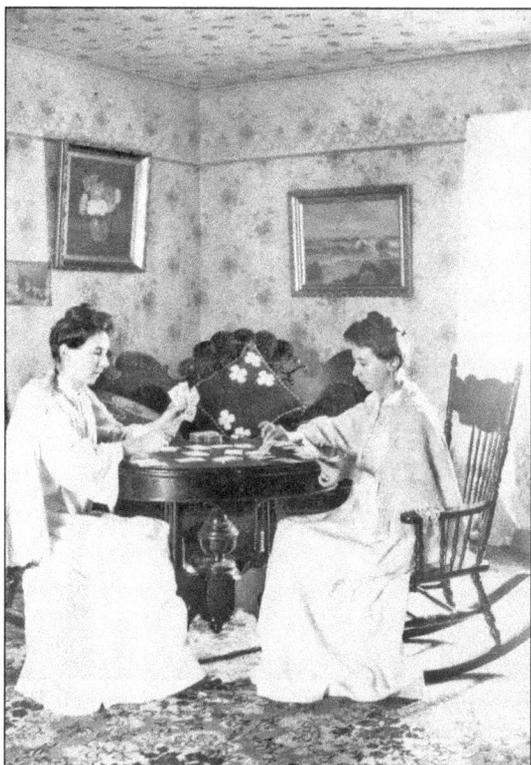

Hattie Greever Moss (left) and Emma Greever meant much to the Burke's Garden community. Women such as the Greever sisters contributed much to the area's family and community life. Both ladies were teachers and leaders in the Lutheran church. (Photograph by A. S. Greever.)

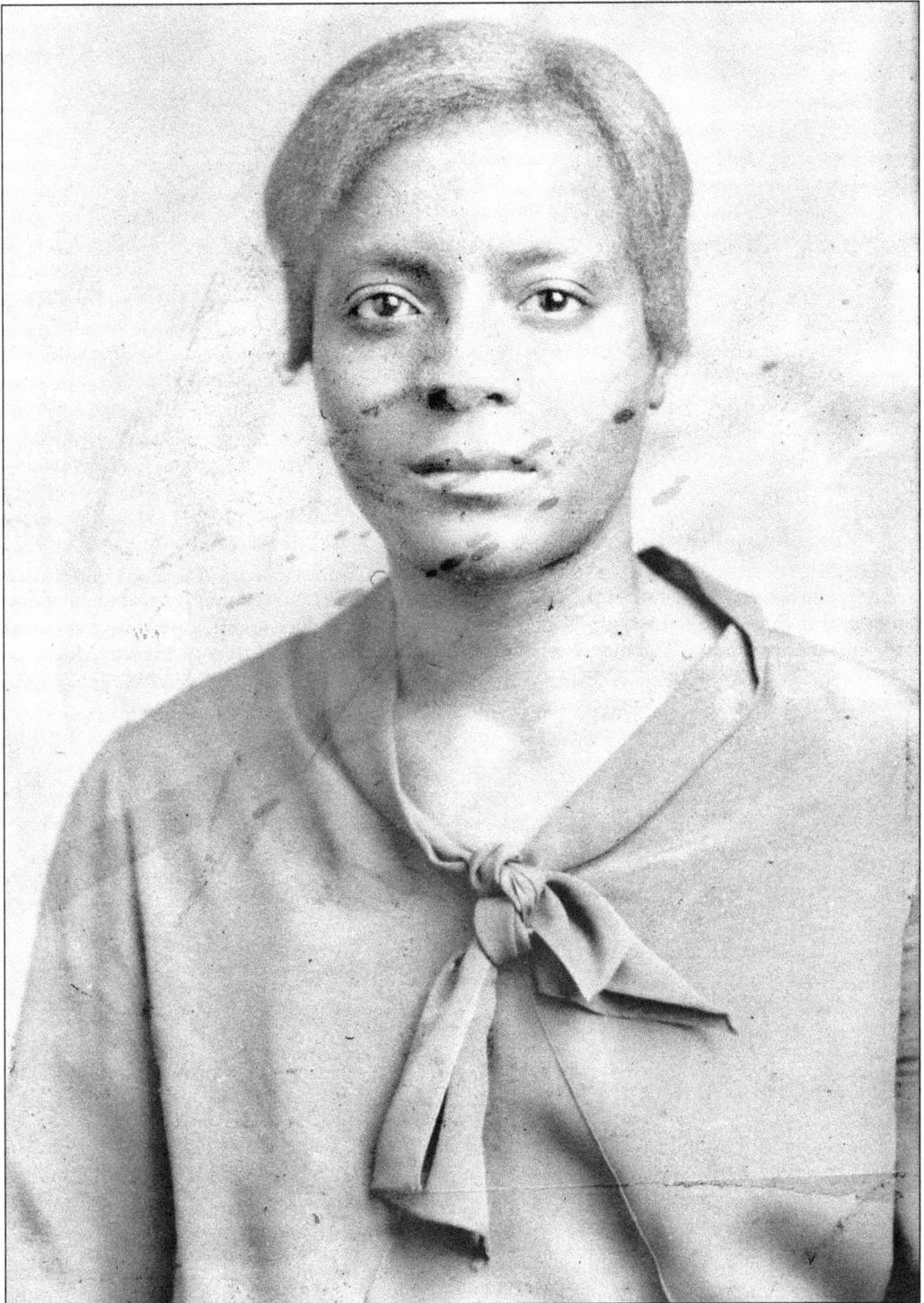

Ollie "Toad" Thompson lived with the Lawson and Moss families for most of her life. She was a favorite of the children, who always raved about her good cooking. The Mosses considered Toad to be a member of their family. (Courtesy of the Moss scrapbook.)

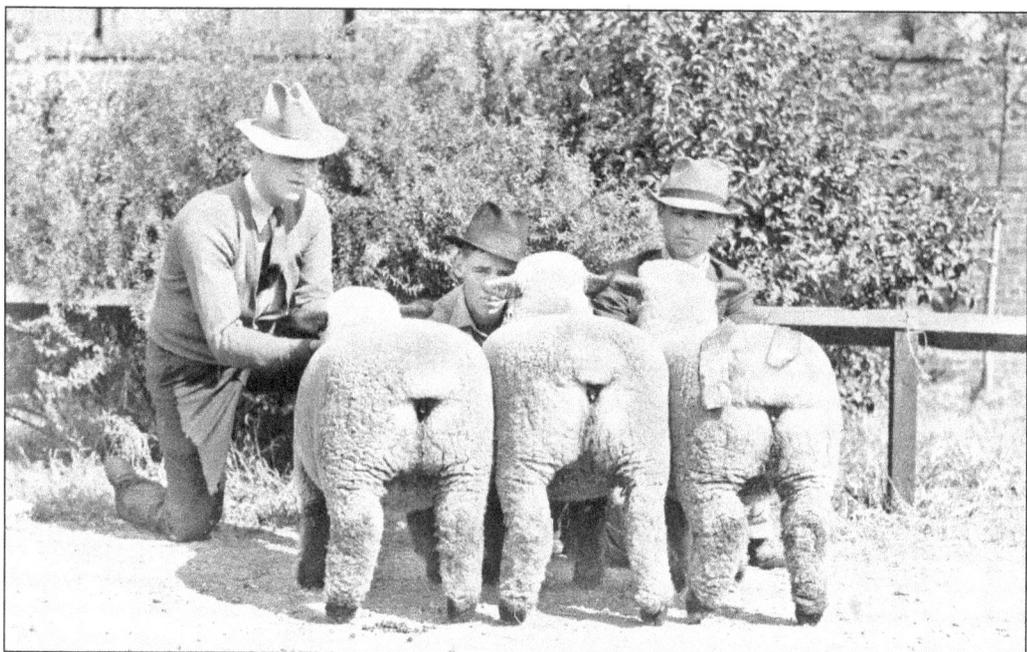

County farm agent George Litton (left) and Alex L. Meek (right) showed the first-place pen of ewe lambs at the Tazewell County Fair in 1937. Burke's Garden produce and livestock are renowned for their superior quality. The man in the center is unidentified. (Courtesy of Marvin Meek.)

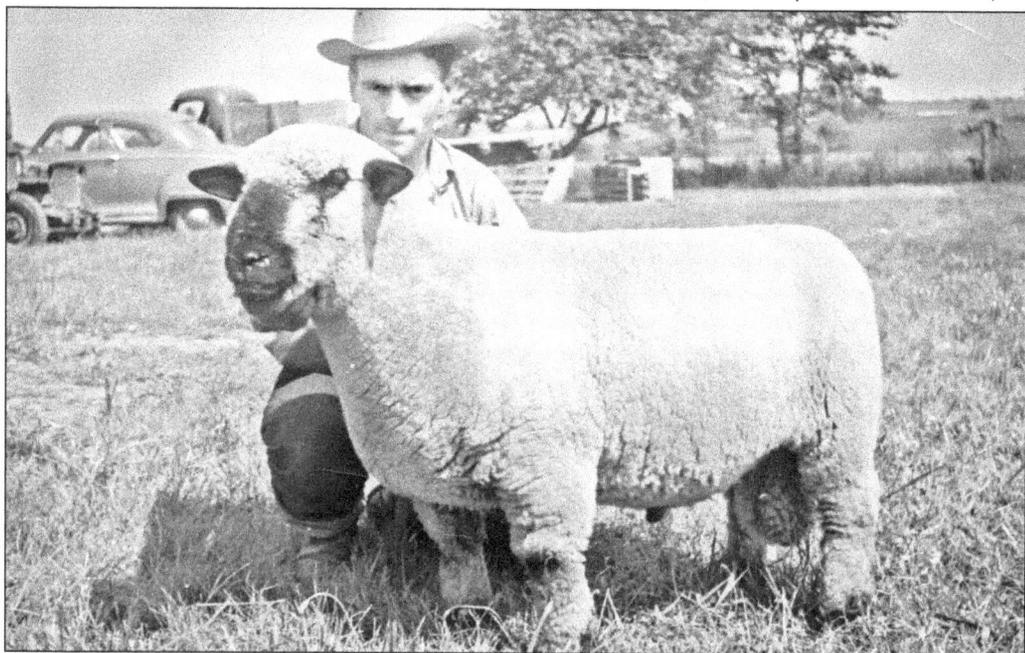

Marvin Meek exhibited the top-selling ram at the Staunton show in 1948, carrying on the tradition of his Burke's Garden family. Meek, born here in the 1920s, left the valley to raise his family. While living in Arizona, he ran a spread three times the size of Burke's Garden. After managing John Wayne's 26 Bar Ranch and other western stints for more than 40 years, Meek and his wife returned to the land of their roots to retire. (Courtesy of Marvin Meek.)

Herbert (left) and Harloe Lambert, the children of Augustus and Lena Lambert, are pictured in Burke's Garden in 1933. The Lamberts were among the earliest settlers of the community. (Courtesy of Betty Vanhoozier.)

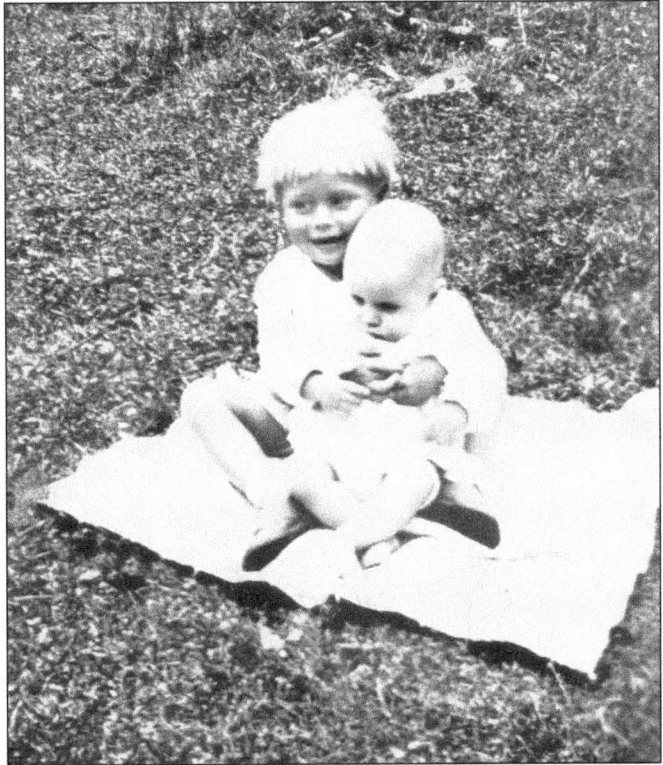

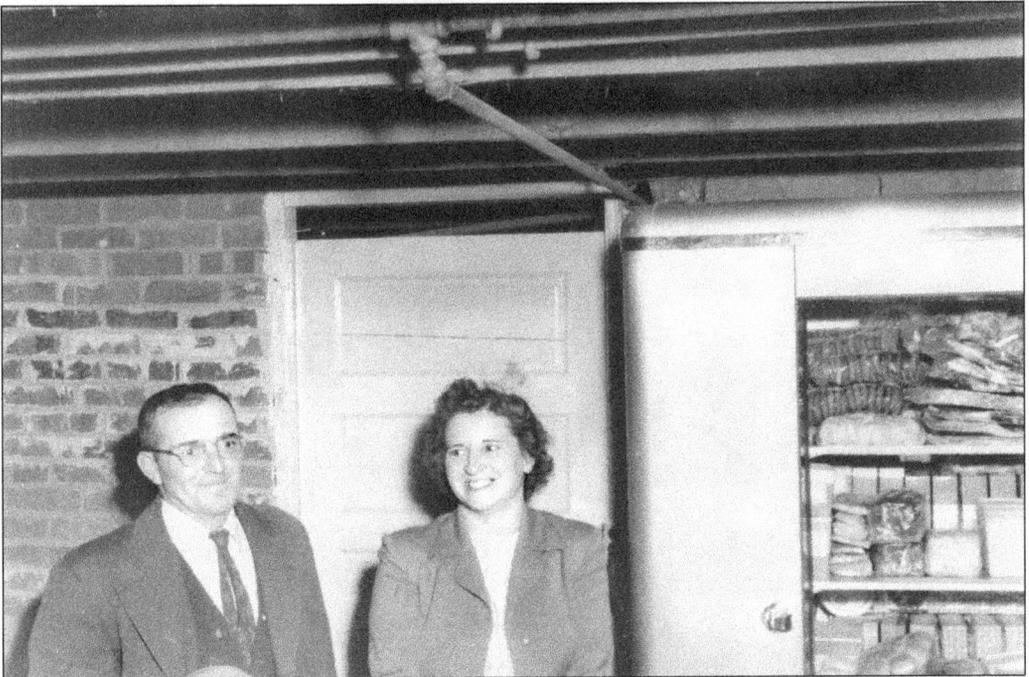

Jack and Hattie Davis were known in the Garden community for their ability to produce excellent farm products year after year. Their farm was recognized statewide as one of the best. (Courtesy of Elizabeth Bowman and the Burke's Garden Community Association scrapbook.)

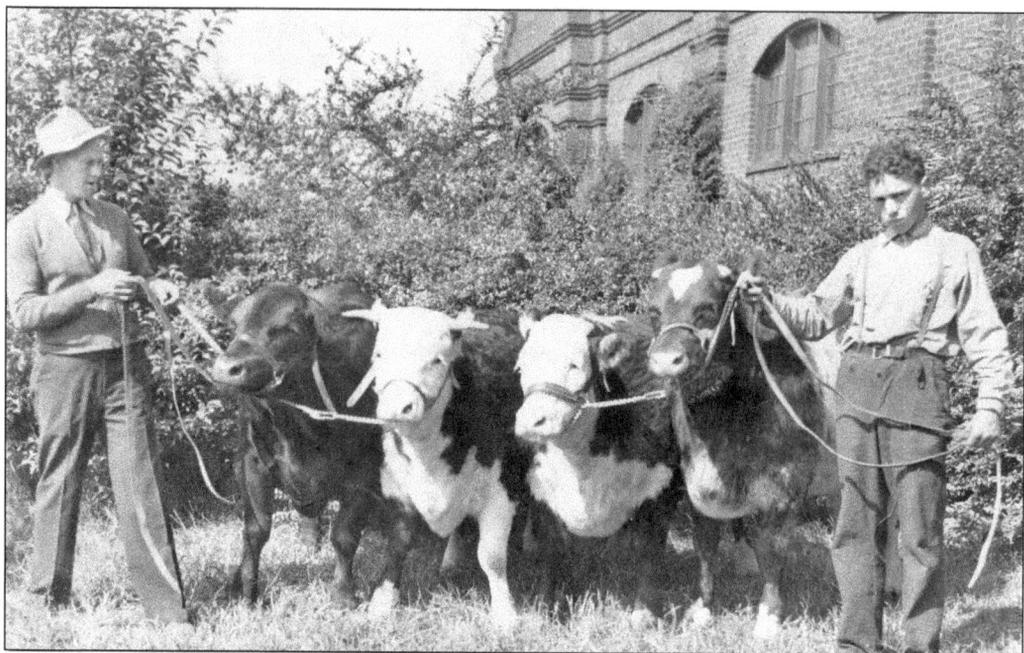

County farm agent George Litton (left) and Marvin Meek showed the champion Hereford steers at the 1936 state fair. Burke's Garden produce and livestock often win blue ribbons at both county and state fairs. (Courtesy of Marvin Meek.)

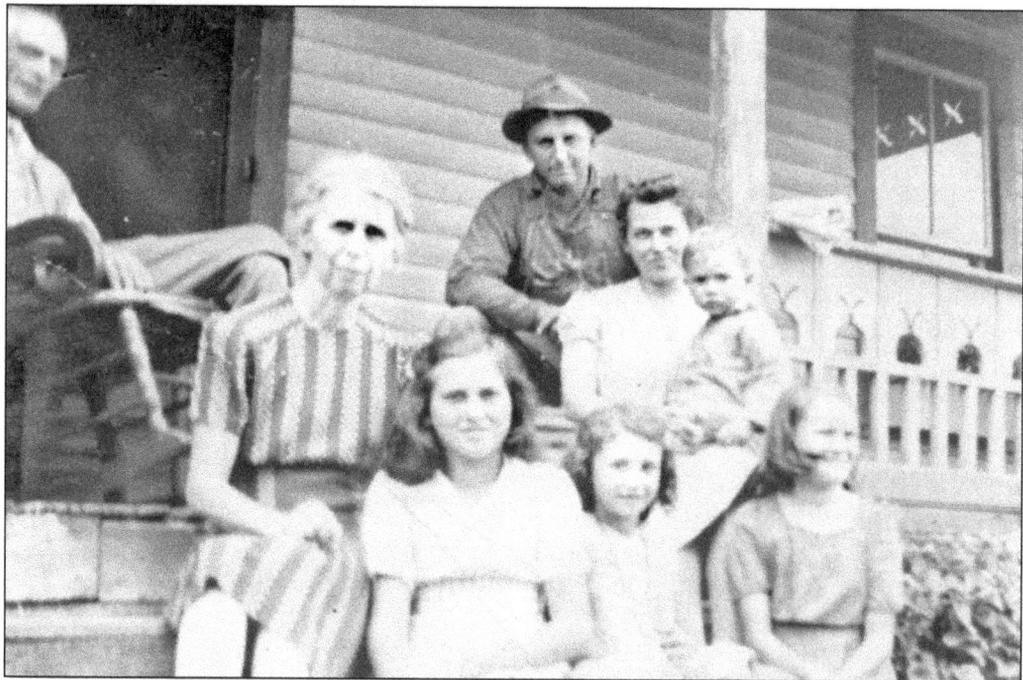

This Edwin Peery family portrait was taken in 1948. From left to right are (first row) Eunice Cooper, Mary K. ?, and Lois ?; (second row) Anna Peery, Bess Moss, and Oscar Moss; (third row) Edwin Peery and Bill Peery. Their house was built in 1908 and burned in 1966. (Courtesy of Eunice Cooper.)

George and Mary Lou Bane Boling are shown at their Burke's Garden home. The Boling family has deep roots in the community. Andrew Boling, listed as a landowner in 1866, served with other family members in the Civil War. Robert and John Stephen Boling both worked as medical doctors. (Courtesy of Juanita Boling.)

Garnett Lawson, the daughter of R. M. Lawson, grew up at Oak Grove Farm and spent much of her life on this rich land. She was known for her cultural lifestyle. In later years, she moved to Wytheville. (Courtesy of the Oak Grove Farm scrapbook.)

W. H. Moss, seen here at age 17, was a native of Burke's Garden and a well-known landowner and farmer. (Courtesy of Pam Moss.)

Bill Boling, also a native of the Garden, carried the mail to rural patrons from 1966 to 1990. Rural Route 3, Tazewell, postal customers depended on Bill to get the mail through for more than three decades. The birthday cake was made by Elsie Matney. (Courtesy of Juanita Boling.)

Shown in 1939 at age 80, Leticia "Lettie" Huddle Wynn was the great-grandmother of mailman Bill Boling. The Huddles and Wynns were among the early settlers of Burke's Garden. (Courtesy Juanita Boling.)

Perhaps these young Peerys are engaged in a game of hide and seek in 1935. Pictured from top to bottom are Margaret, Edwin Jr., Tom, Archie, Eunice, and Lois. The Peerys were early pioneers of Tazewell County. (Courtesy of Linda Peery.)

This tribute to the late Roy O. Wilson was written by his niece, Nancy Wilson Neal: "This was a young man who left his home, father, and brothers to fight in a war in a foreign land he had only read about. He was killed during the invasion of Normandy while still in his twenties. His body was returned three years later to the Burke's Garden Cemetery where he was buried with other members of his family. My father, Buford Wilson, kept his memory alive with stories about their youthful days." (Courtesy of Nancy Neal.)

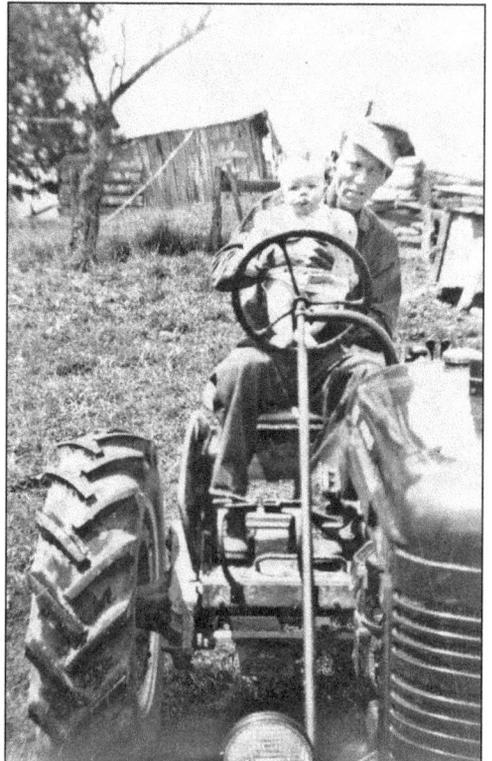

Burke's Garden native Buford Wilson rides on his tractor with his daughter, the seven-month-old Nancy. (Courtesy of Nancy Neal.)

Buford Wilson (left), his brother Elmer Wilson (seated), and friends bale hay in Burke's Garden in July 1951. Farming in Burke's Garden was often a family affair. In fact, many hands were necessary to run a successful community farm. (Courtesy of Nancy Neal.)

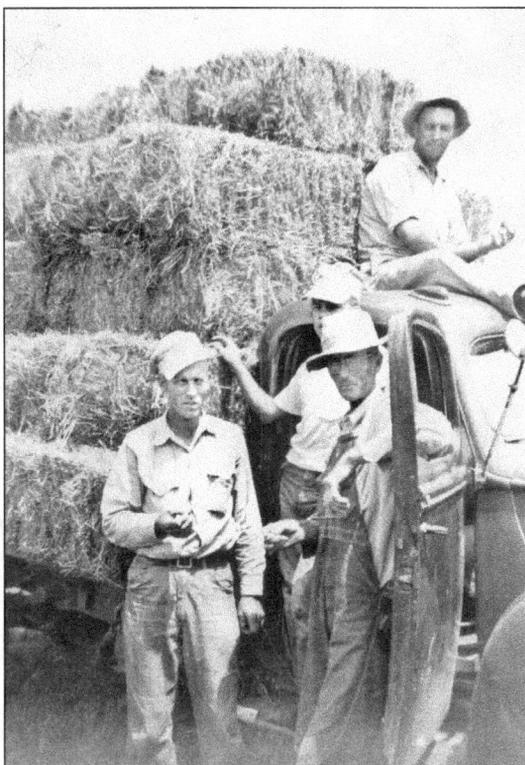

Mollie Jordan, the wife of Dan Jordan, is pictured in front of the J. R. and Josephine Meek home in the early 1900s. She waits to greet family or perhaps visitors approaching the residence. (Courtesy of Ben Lineberry.)

Mack and Pauline Brown played the roles of their ancestors at the Tazewell County sesquicentennial celebration in 1950. Burke's Gardeners joined with other area residents in celebrating the county's 150th anniversary. (Courtesy of the Brown family.)

Joe (left) and Bob Moss are seen on the Lawson-Moss farm in their young days. The 22-room Moss family house, built around 1900, stands on the site of the former Gov. John Floyd home. John B. Floyd served as governor of Virginia from 1849 to 1852, followed by a stint as secretary of war under Pres. James Buchanan and as a brigadier general in the Confederate army. (Courtesy of the Lawson-Moss scrapbook.)

Jim and Louise Hoge are known throughout Southwest Virginia for their detailed historic research, especially in connection with their Burke's Garden roots. Louise Greever Hoge taught at the Burke's Garden School for many years. She married Jim Hoge (the "unofficial mayor" of Burke's Garden), and together they authored the book *Burke's Garden and Its People*. (Courtesy of the Hoge family.)

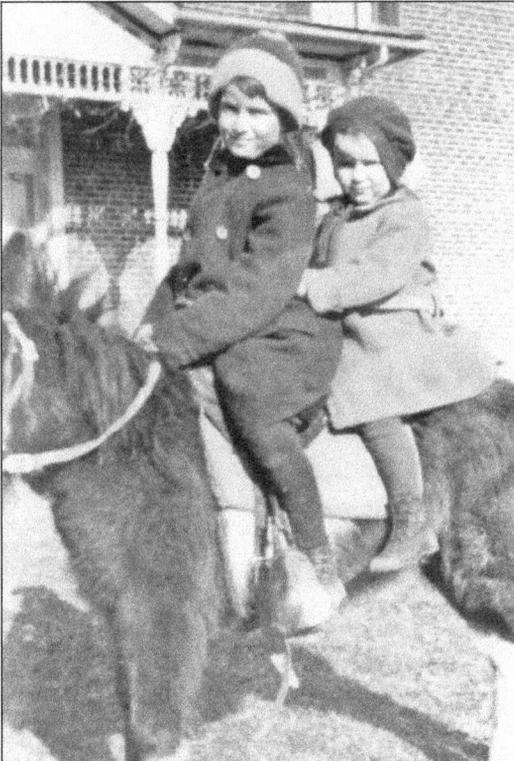

James Robert Meek Jr. (left) and Mildred Brenda Meek pose while riding their favorite pony in front of their Burke's Garden home on a brisk winter day in 1913. (Courtesy of Ben Lineberry.)

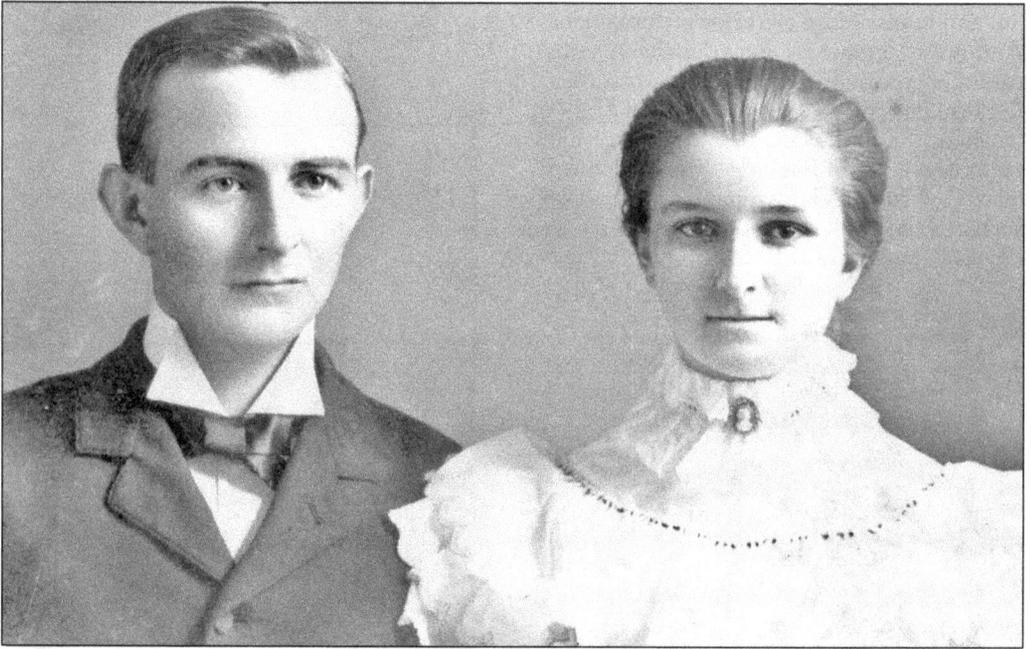

James Henry Groseclose (1876–1943) and his sister, Fanny Gilmer Groseclose (1880–1941), are pictured during the early years of the siblings' lives in the Burke's Garden community. (Courtesy of Ben Lineberry.)

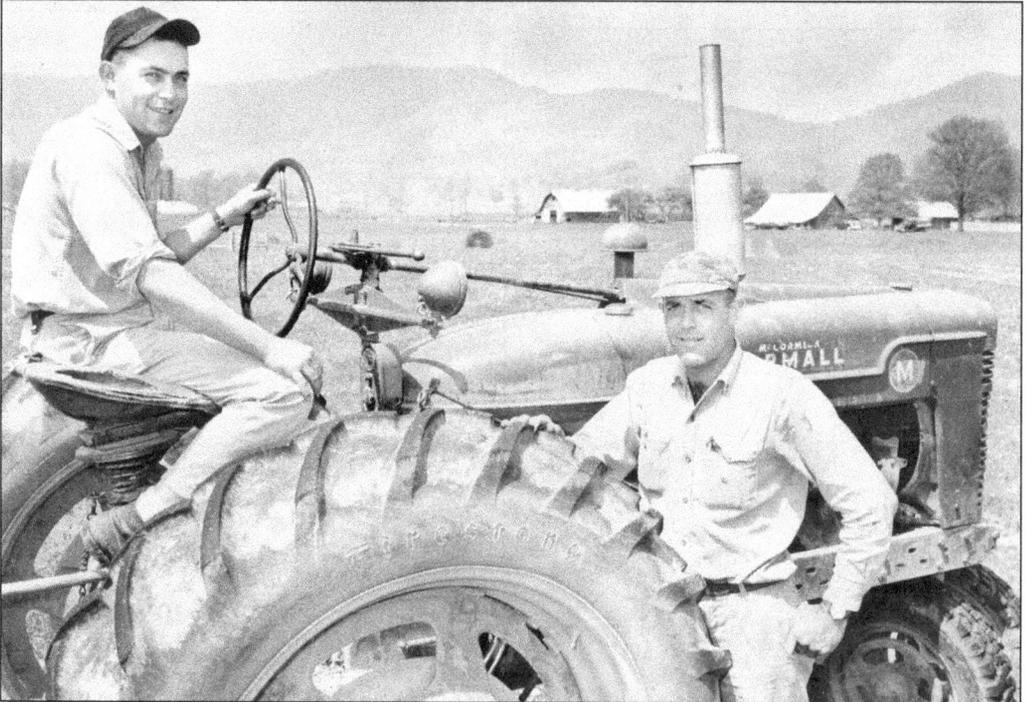

In the early 1950s, brothers Charles (left) and Bill Moss pose at their tractor as they prepare for a full day's activities on the farm. Their parents were Will and Sara Davis Moss. (Courtesy of Pam Moss.)

Three

GROUPINGS AND GATHERINGS

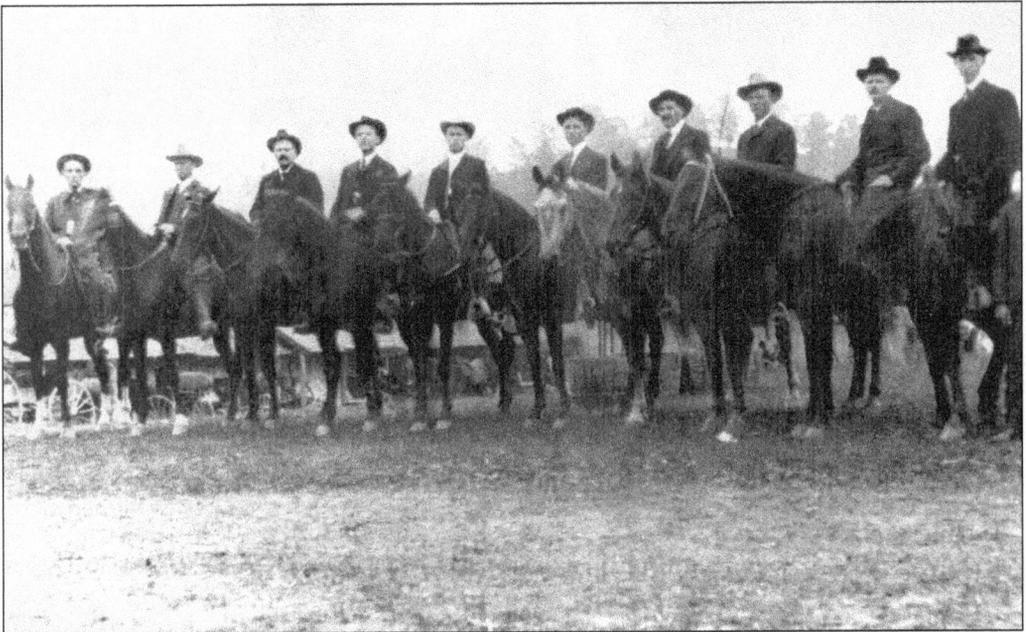

The 10 sons of John Tiffany Litz of Burke's Garden line up on horseback, making an impressive photograph that has been handed down for generations by family members. Seen here, from left to right, are Jim, John, Sam, George, M. O., Gratton, Peter, Harold, Al, and Joe Litz. (Courtesy of George H. Litz.)

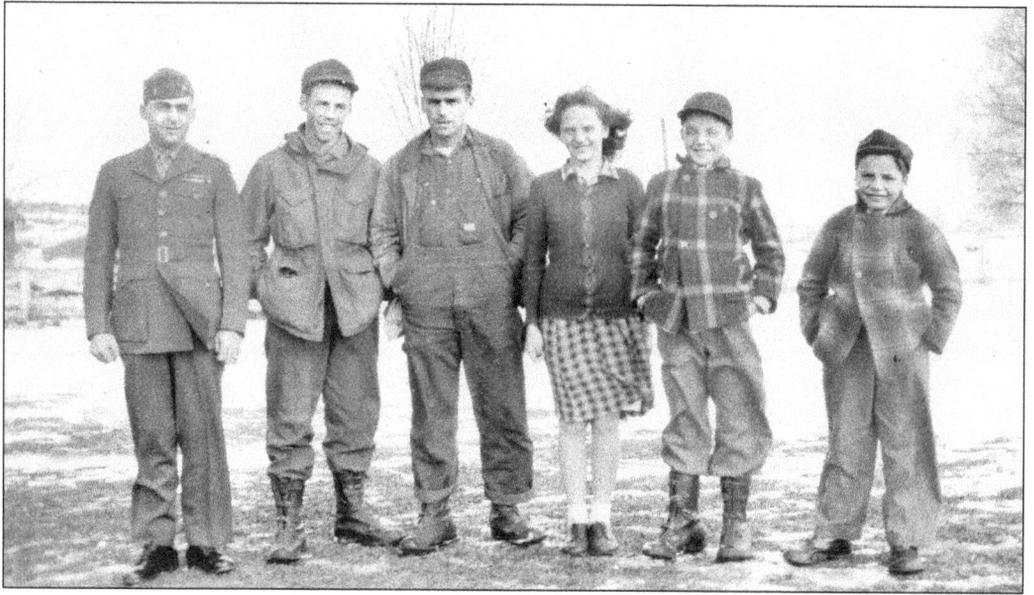

The children of Alex L. Meek are, from left to right, John Joe, Alex "Bud," Marvin, Lillian, Tom, and Jack. They are pictured in the Garden during World War II. (Courtesy of Marvin Meek.)

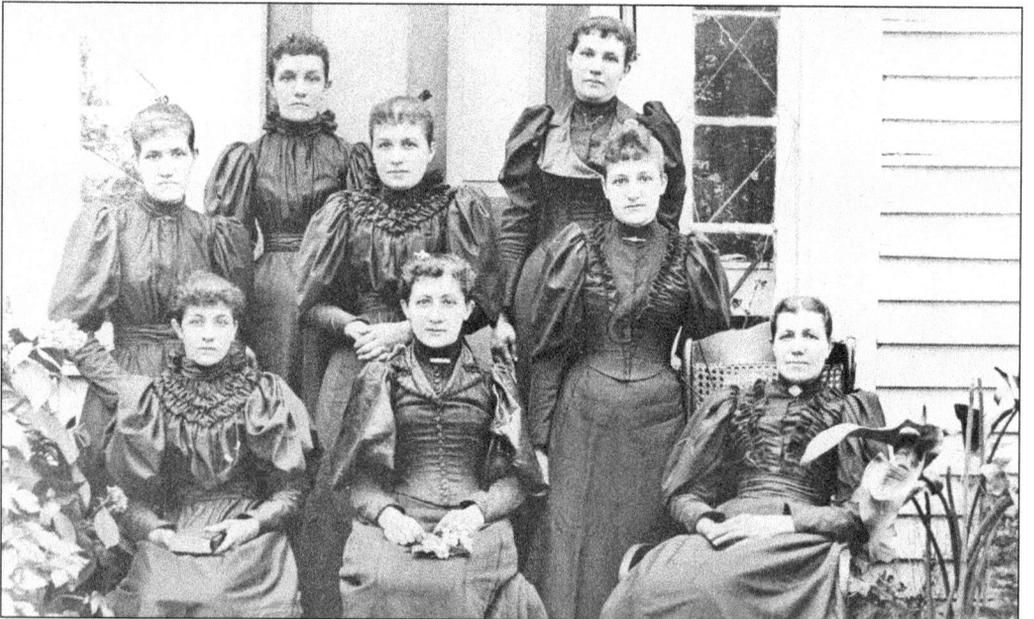

The daughters of Rufus F. Goodman (1824–1901) and Letitia Thompson (1835–1895) filled many positions in Burke's Garden, including postmistress, telephone operator, store manager, hat maker, casket maker, farmer, housekeeper, and quilt maker. The sisters were as follows, from left to right: (first row) Ollie (1869–1921), Lettie (1865–1929), and Molly (1855–1913); (second row) Susie (1860–1925), Jennie (1863–1923), and Maggie (1876–1949); (third row) Nannie (1867–1950) and Sally (1871–1936). There were also four Goodman brothers: Rufus Edward (1856–1914), William Thomas (1858–1928), Robert (1878–1948), and Joseph (1875–1885). Their father, Rufus F. Goodman, had arrived in Burke's Garden and worked for his commanding officer following the Civil War. (Courtesy of Tommy Coleman.)

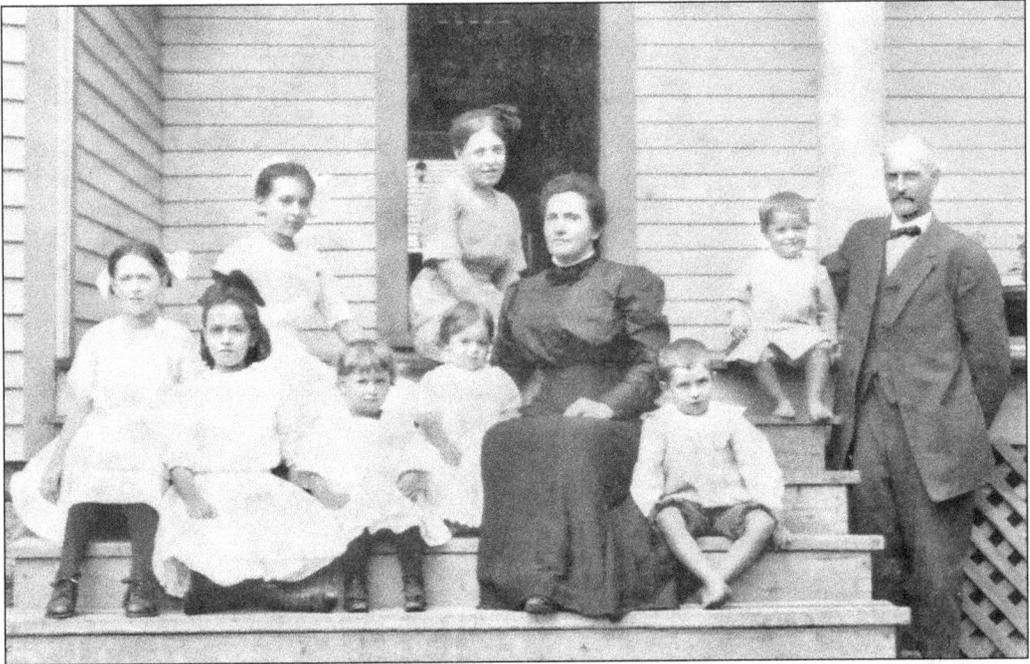

The members of the large William Leon Davis and Donie Frances Keister Davis family, shown in 1913, were identified by great-granddaughter Mary Ann Vaughan. From oldest to youngest, those family members were Sarah Harless, Emma Ruth, Mary Louise, Hattie, Oscar Leon, Anna Mae, Joe Addison, James, and Robert. Two children were born later: William Beuford "Jack" and Mona Frances. One child, Patty, died at the age of eight. (Courtesy of Mary Ann Vaughan.)

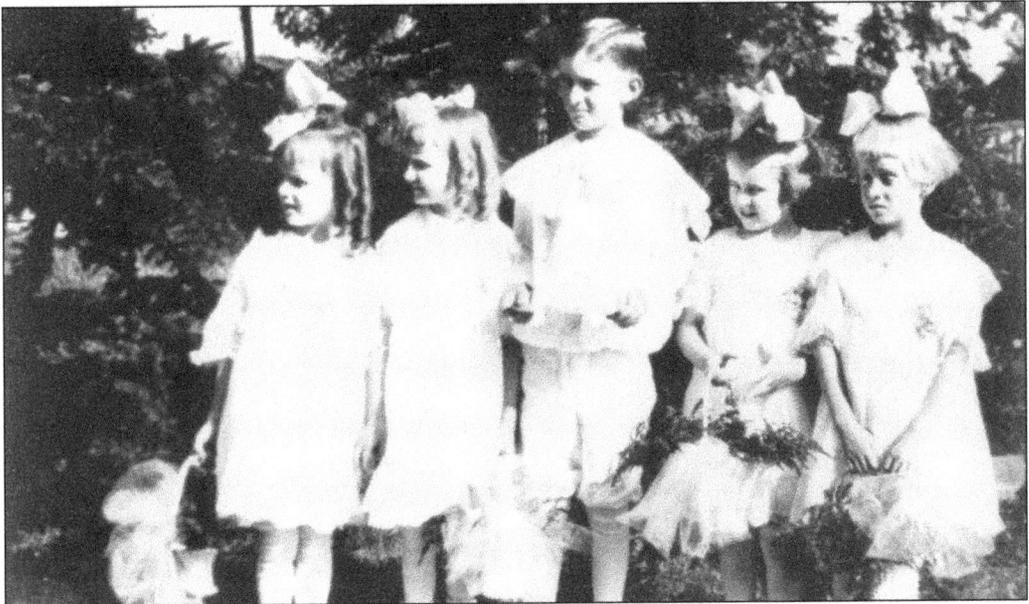

Young people attend the marriage of Pansy Mae Meek and Isaac N. Fuqua in 1918. The wedding was held at the James Robert and Josephine Brenda Groseclose Meek home. Included in the wedding party were, from left to right, Maria Bowen, Janie Hoge, Robert Meek Jr., Mildred Meek, and Mary Moss. (Courtesy of Ben Lineberry.)

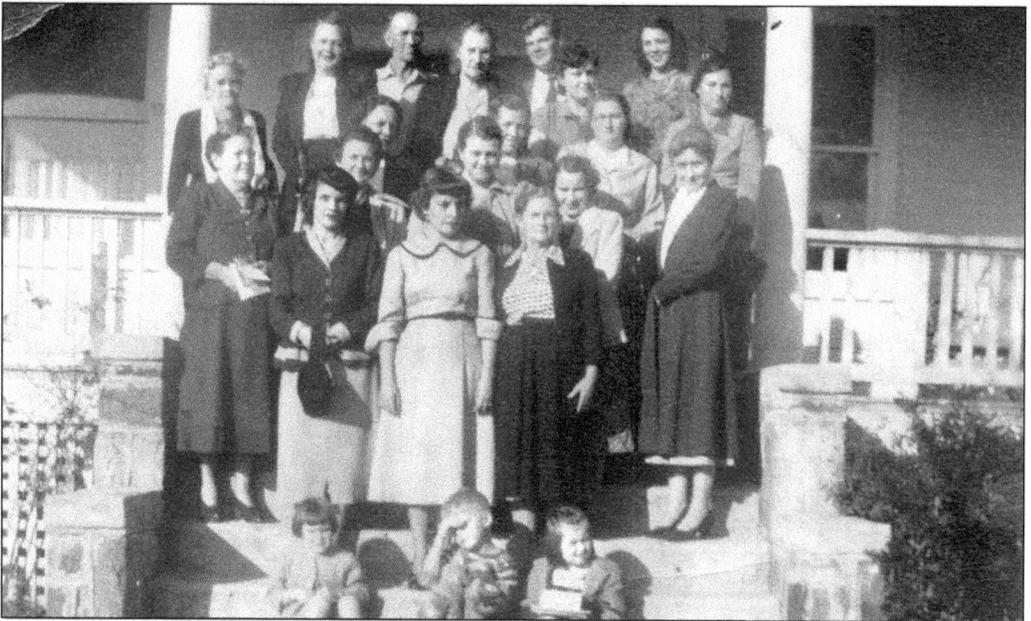

The Burke's Garden Methodist Missionary Society members included the following, from left to right: (first row) unidentified children; (second row) Nell Hall, Virginia Mae Page, and Ruth Thompson; (third row) Sarah Moss, two unidentified, Mildred Lineberry, and unidentified; (fourth row) Ruby Fox, Ida Wilson, and Esther Cornwell; (fifth row) Mrs. Joe White, Frances Moss, three unidentified, and Louise Hoge; (sixth row) Stephen Fox, the minister, and the minister's wife. The meeting was held at the Stephen and Ruby Fox home in the east end of Burke's Garden. The house was built by James Robert Meek in the 1920s. His children, Truby Meek and Dora Meek Poole, and their families all lived here at different times. (Courtesy of Ben Lineberry.)

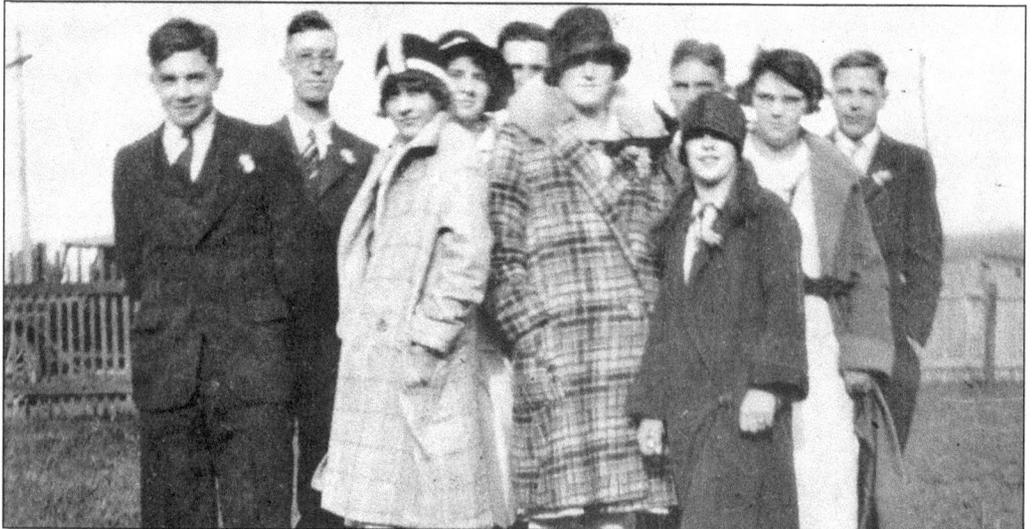

The 1927 senior class at Burke's Garden High School consisted of 10 students. Pictured here, from left to right, are the following: (first row) Mildred Brenda Meek, Mary Moss, Mattie Gladys Hilt, Ruth Patrick Hilt, and Nellie Sue Brooks; (second row) Hugh Kent Cassell, Thomas Perry Goodwin, William Kent Compton, Francis Moss Hoge, and George Richard Thompson. (Courtesy of Ben Lineberry.)

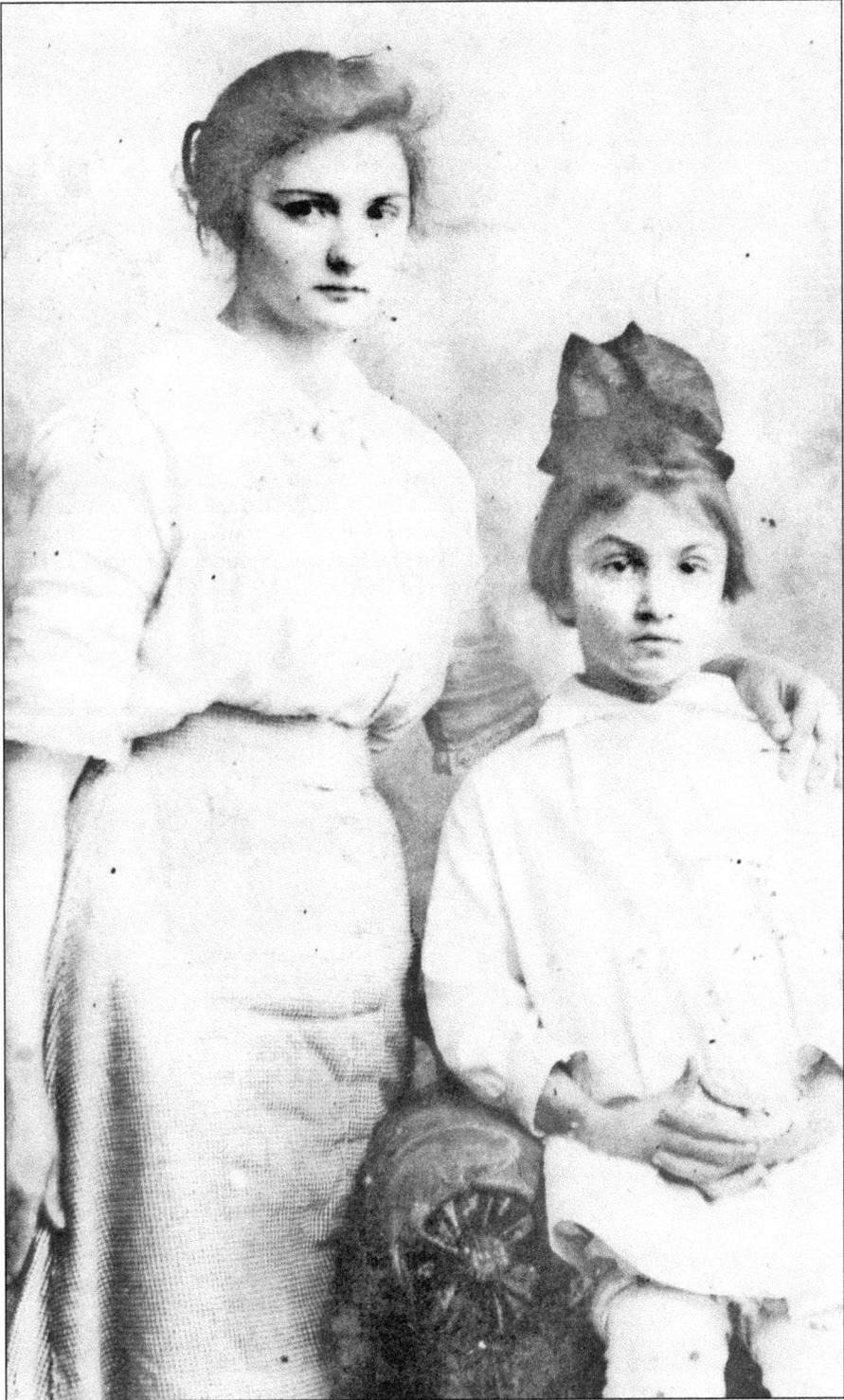

Bess Mahood (Moss) (left) and Mary Mahood were early Burke's Garden residents. (Courtesy of Mary K. Lotts.)

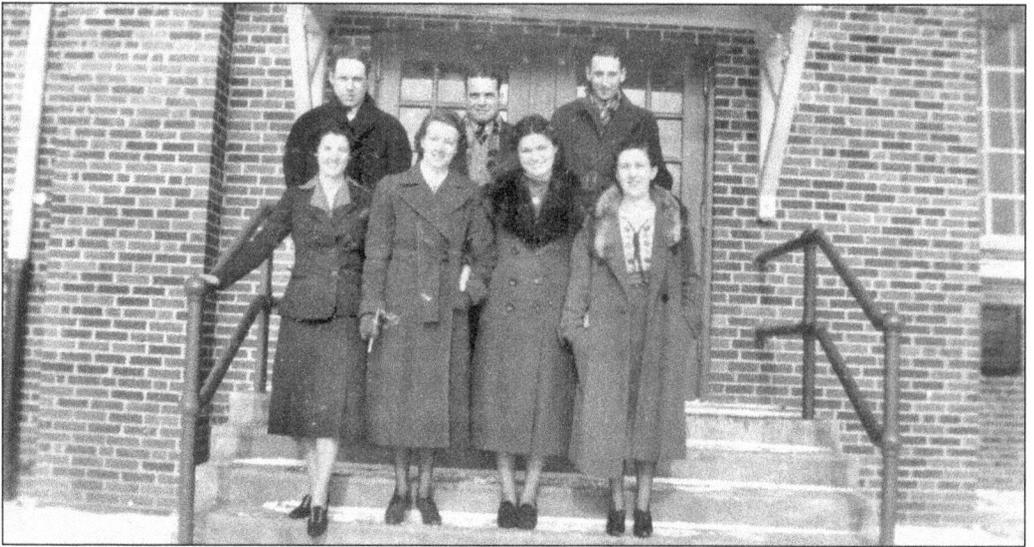

The 1938 Burke's Garden School faculty included the following, from left to right: (first row) Ruth Crabtree, Reba Miller, Louise Greever, and Dorothy Hughes; (second row) James P. Buchanan, Roy L. Ringstaff, and Allen K. Thomas. (Courtesy of Marvin Meek and the *Garden Gate*.)

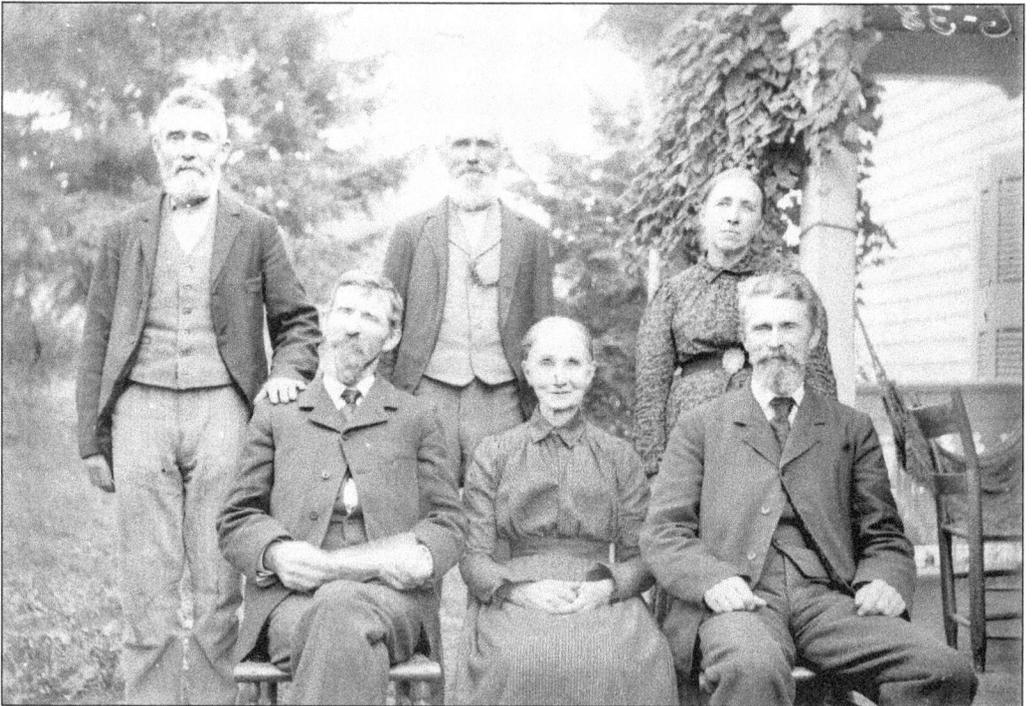

Shown in 1900, from left to right, are (first row) Thompson Greever, Lizzie Greever, and Campbell Greever; (second row) Charles H. Greever, John D. Greever, and Mary Spracher Greever. (Courtesy of A. S. Greever.)

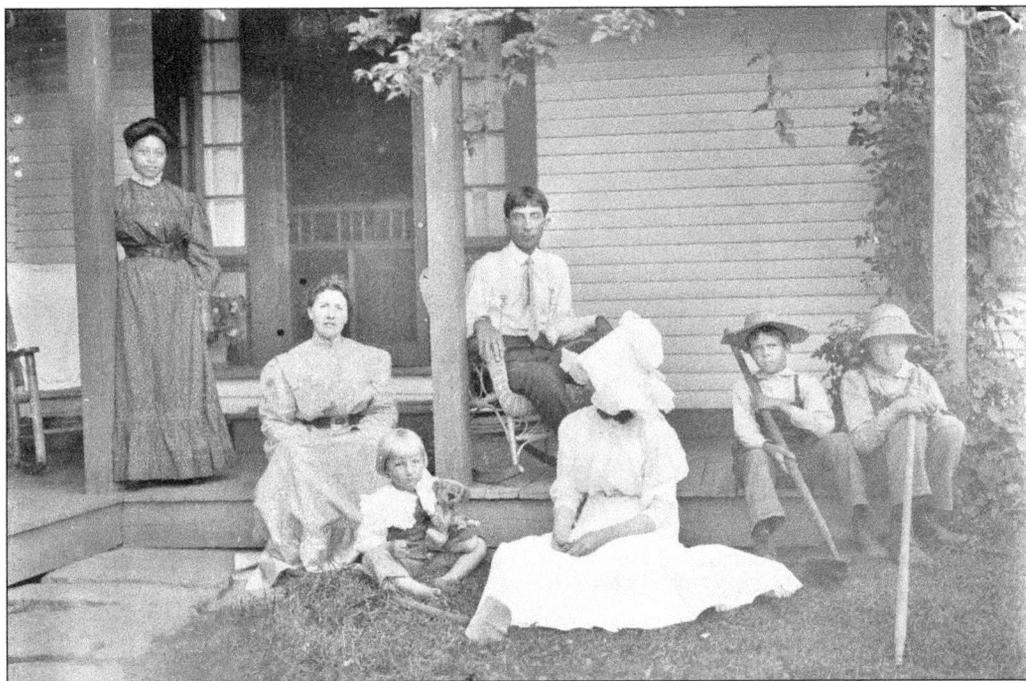

Members of the Bob Moss family pose with Toad Thompson on the front porch of their Burke's Garden home. Pictured from left to right are Toad, Carrie Moss, little Joe Moss, R. S. Moss, and three unidentified guests. (Courtesy of A. S. Greever.)

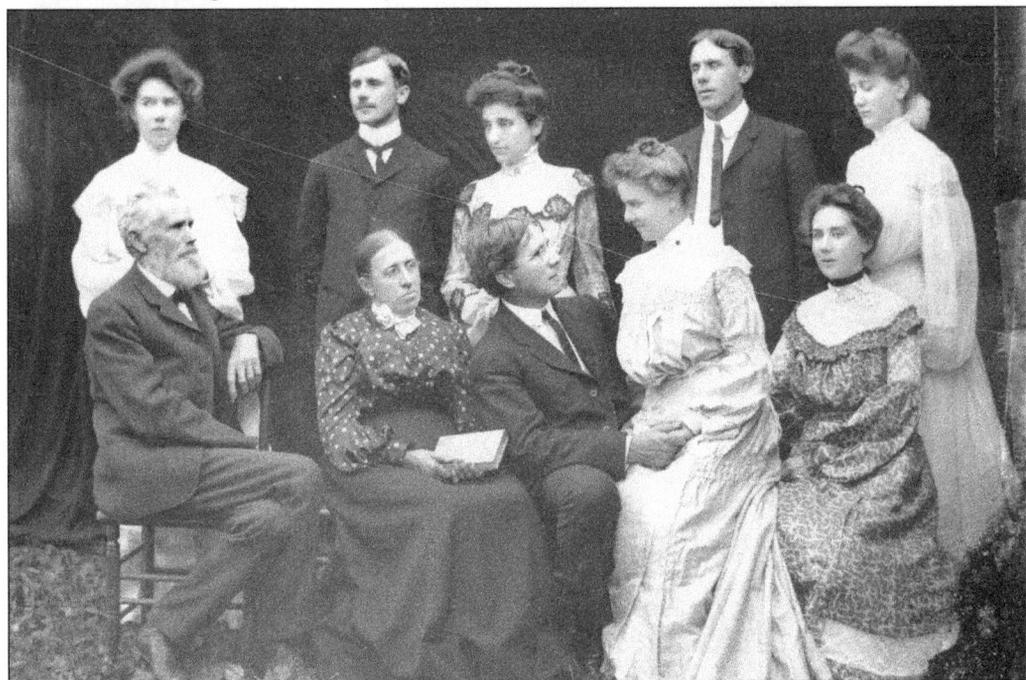

The Greever family is photographed in the early 1900s. Seen here, from left to right, are the following: (first row) John D., Mary E., Edgar L, Margaret, and Emma; (second row) Ida R., Walton H., Roberta, Albert S., and Hattie. (Courtesy of A. S. Greever.)

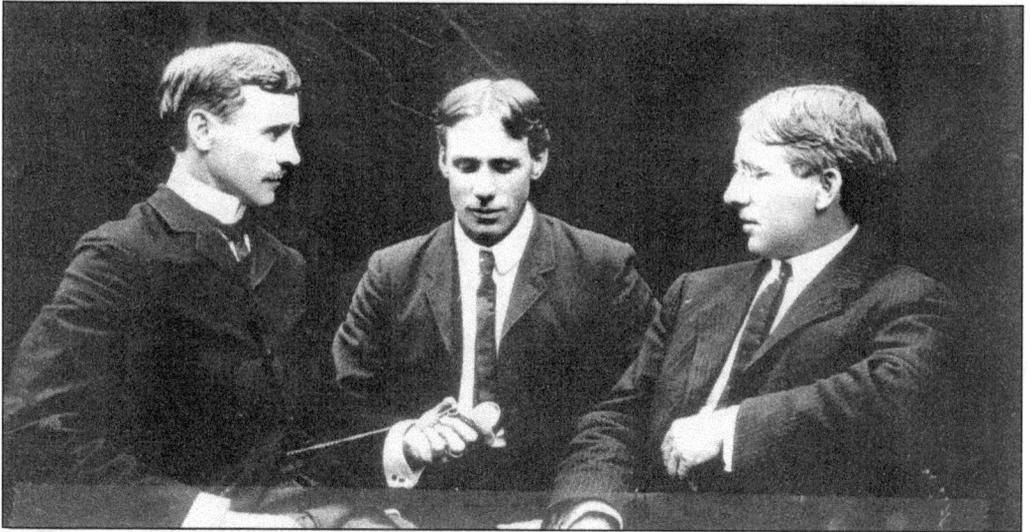

The Greever boys, all graduates of Roanoke College, included Walton Harlowe Greever (class of 1892) (left), who is holding the gold watch given to him by his father for sustaining a grade average of 96 for all four years. Other family graduates pictured are Albert Sidney Greever (1887) (center) and Edgar Lee Greever (1887). In later years, the Roanoke graduates were Albert Sidney Greever Jr. (1928), John Dudley Greever II (1930), Edgar Philip Greever (1940), and Eleanor Greever Lewis (1978). (Courtesy of A. S. Greever.)

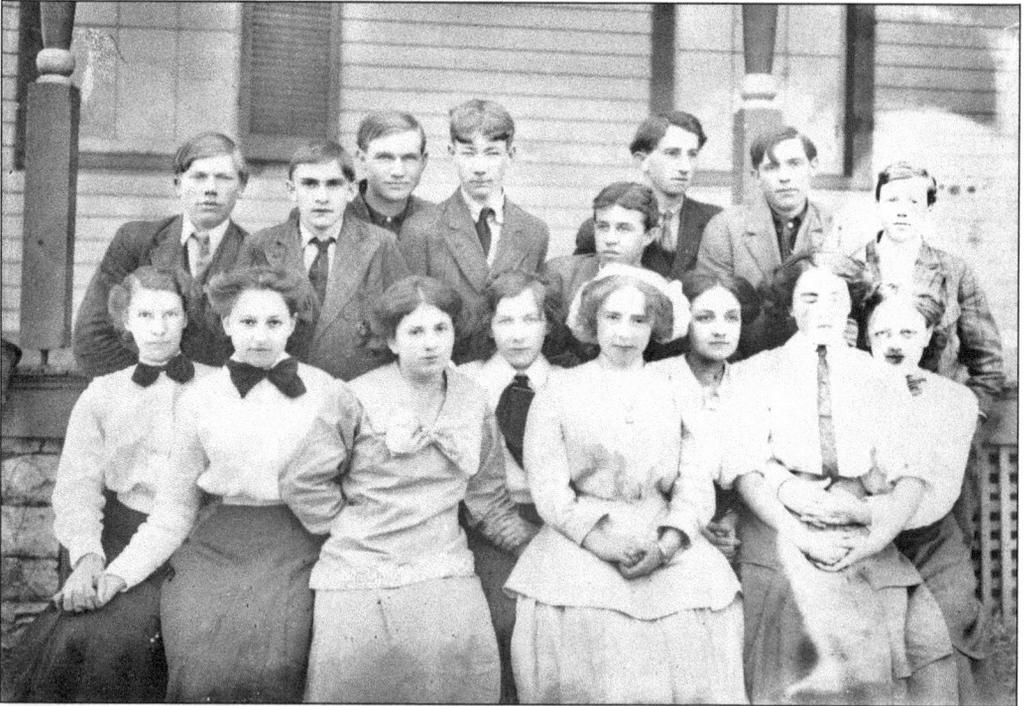

The Burke's Garden Academy students of 1915 were as follows, from left to right: (first row) Bessie Rhudy, ? Howell, Pearl Rhudy, unidentified, Ethel Meek, unidentified, and Lettie Moss; (second row) Vance Stowers, Tommy Howell, Walt Edwards, Albert Suiter, Leach Rhudy, Bill Shawver, Vint Moss, and unidentified. (Courtesy of A. S. Greever.)

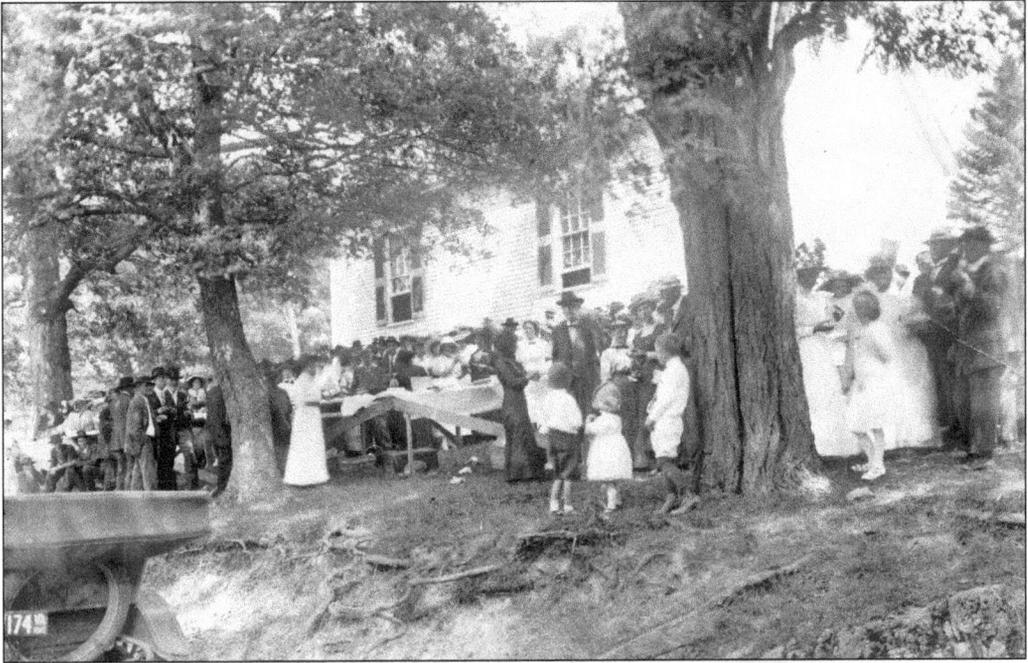

The Burke's Garden Lutheran Church played host to a meeting of the Virginia Synod of the Lutheran Church in 1923. This congregation is the only remaining Lutheran church in Tazewell County today. (Courtesy of A. S. Greever.)

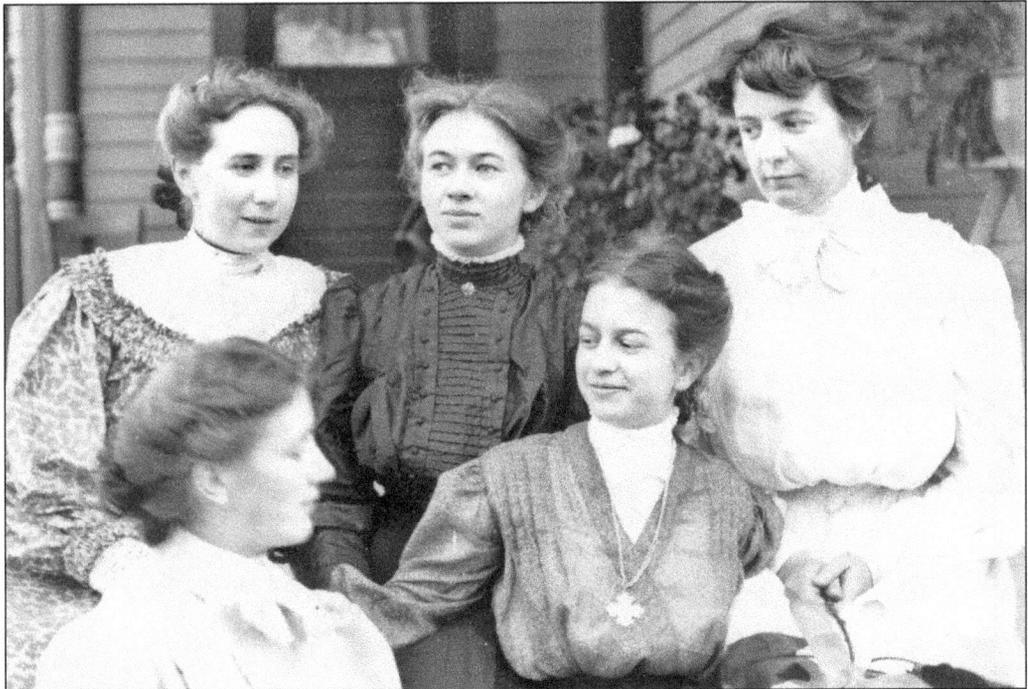

Early-1900s fashions can be studied at this meeting of Burke's Garden friends and relatives. Seen here are, from left to right, (first row) Hattie and Emma Greever; (second row) Edith Coyner, Elizabeth Greever, and Nello Gose. (Photograph by A. S. Greever.)

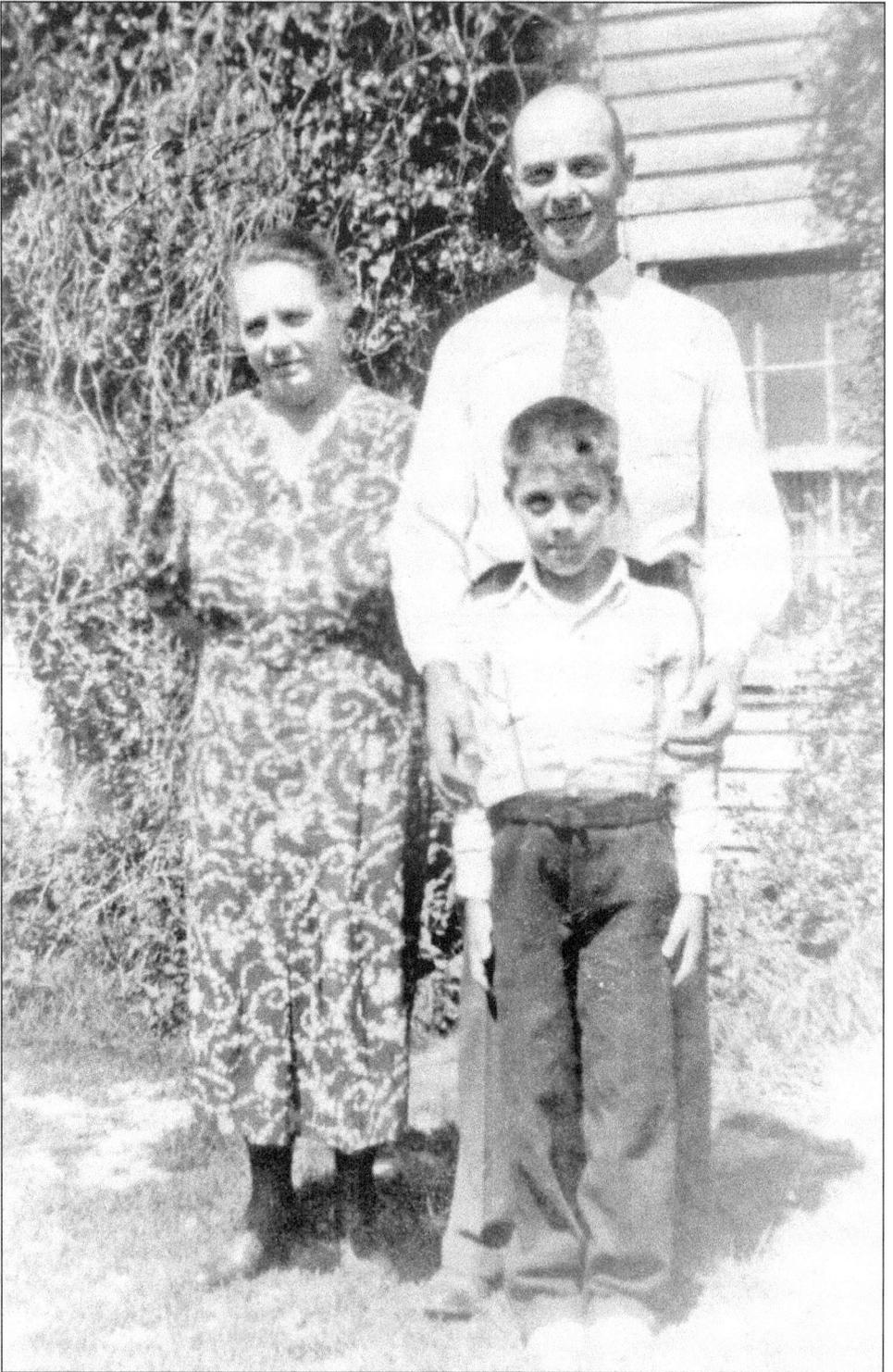

W. H. Boling (front) poses with his aunt, Lena May Boling, and uncle, John Robert Boling, natives of the Garden. (Courtesy of Juanita Boling.)

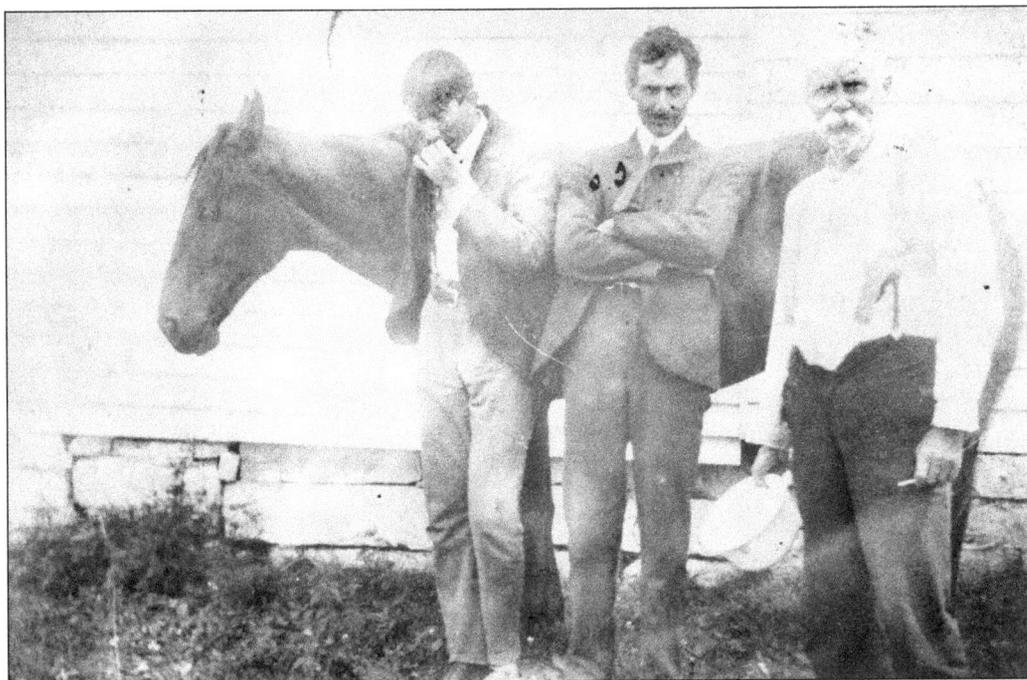

Pat Davis (left), William C. Thompson (center), and Rufus Thompson were landowners in early Burke's Garden. Descendants of all three families continue to live in the community and neighboring towns today. (Courtesy of Marvin Meek.)

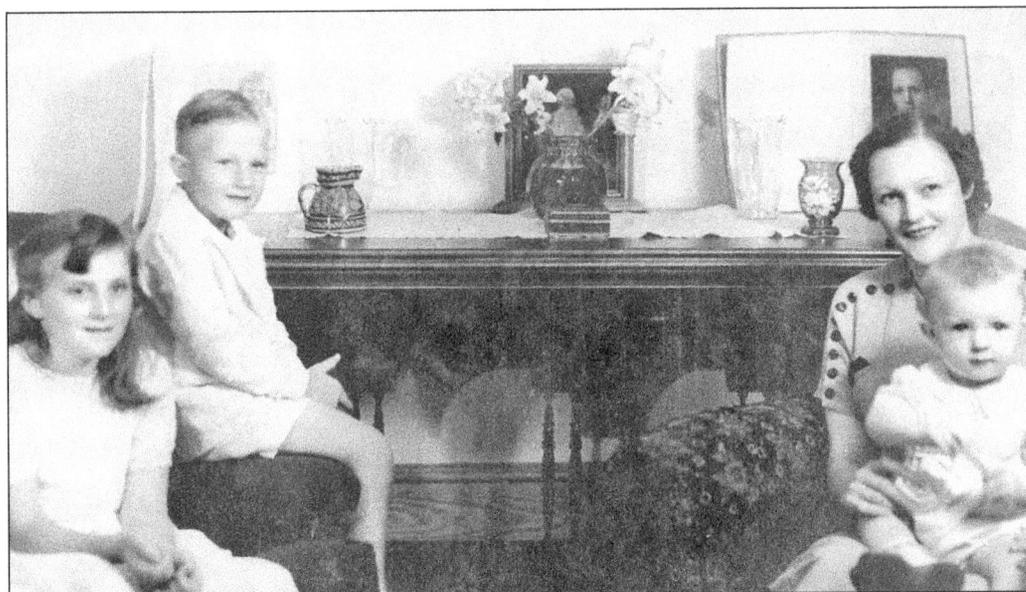

Shown here, from left to right, are Ann, Bob, Frances, and Joe Moss. The Moss family is widely connected throughout the area. Marybelle Moss Groseclose died in 1988 at age 88, the last of 44 Moss first cousins who lived in Burke's Garden. (Courtesy of the Moss scrapbook.)

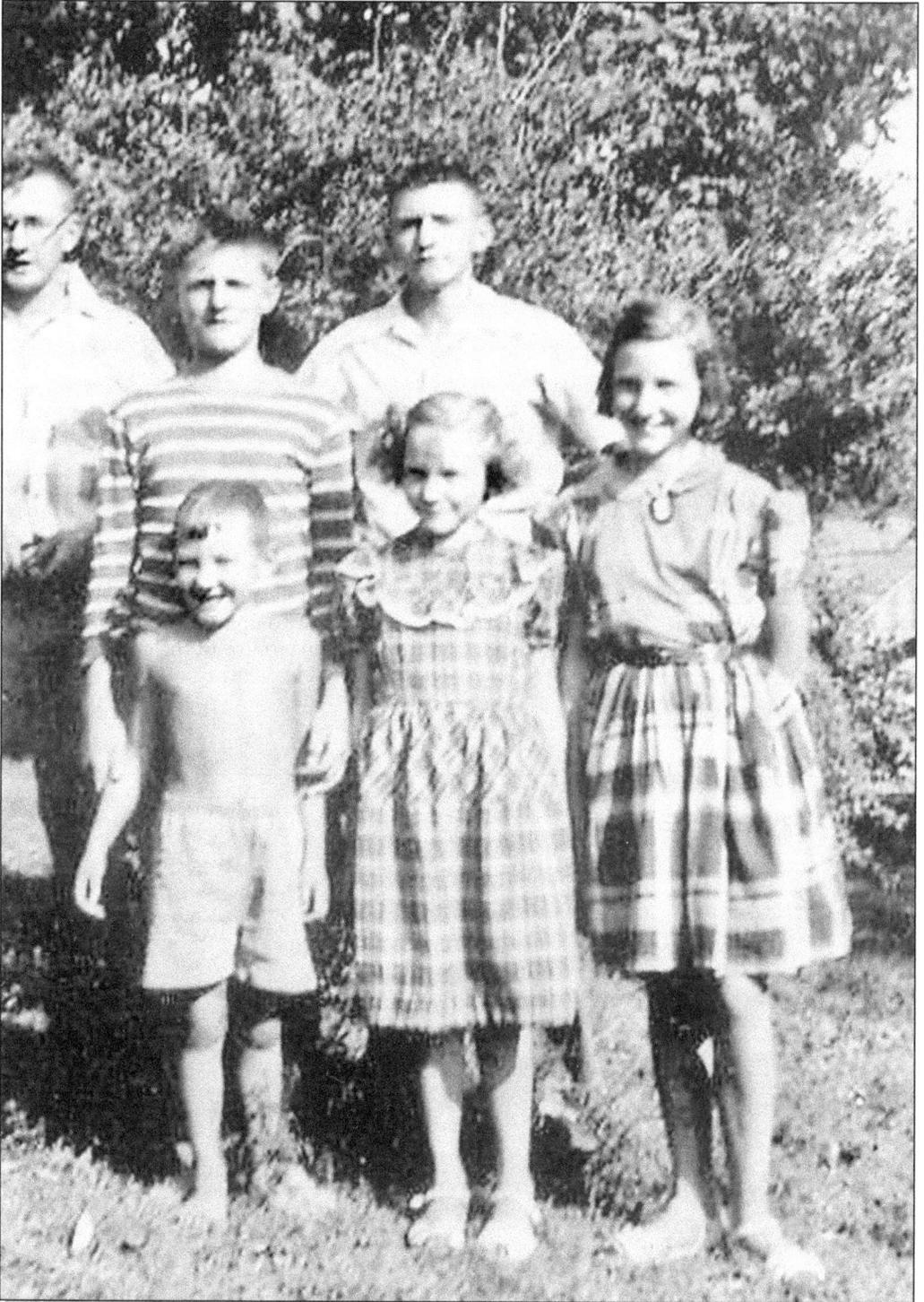

The children of Thomas and Ora Howell, pictured in the mid-1950s, are, from left to right, (first row) Norman, Elizabeth, and Celia; (second row) Gary, Merle, and Nelson. The Howell family first came to Burke's Garden in the late 1800s. (Courtesy of Gary Howell.)

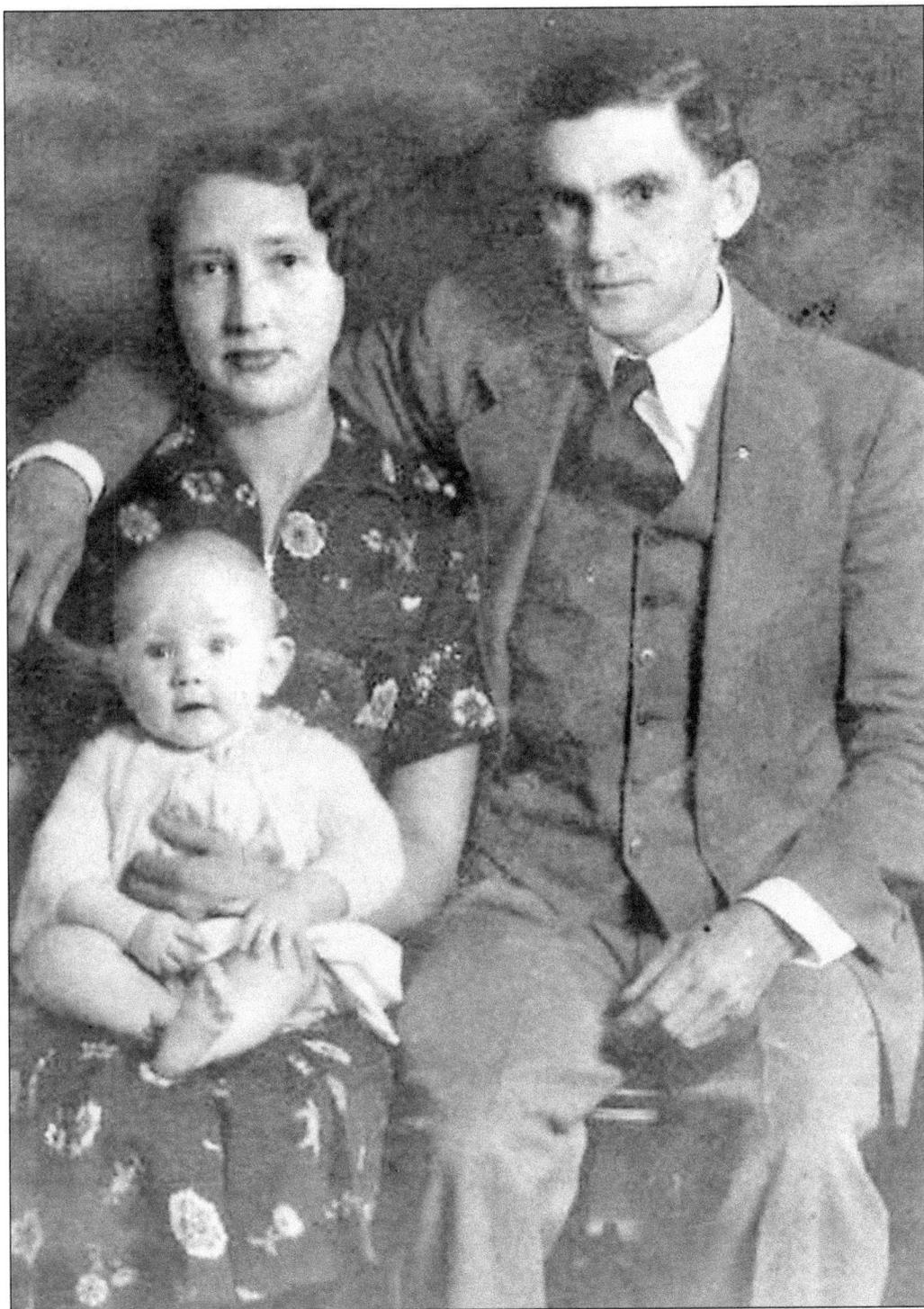

Thomas and Ora Howell appear with their son Gary in 1937. Gary now lives in Wilmington, North Carolina. People who grew up in Burke's Garden now reside in many different parts of the country. (Courtesy of Gary Howell.)

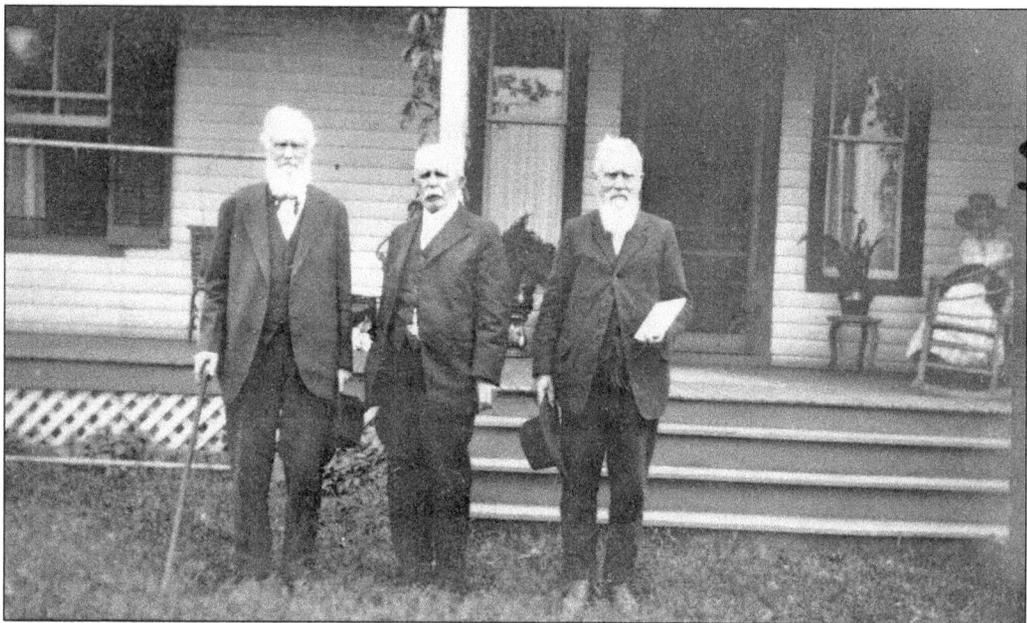

From left to right, John D. Greever, Maj. J. Ogden Murray, and Charles H. Greever pose in front of the Greever home. Major Murray was the author of the well-known book *Immortal 600*. (Courtesy of A. S. Greever.)

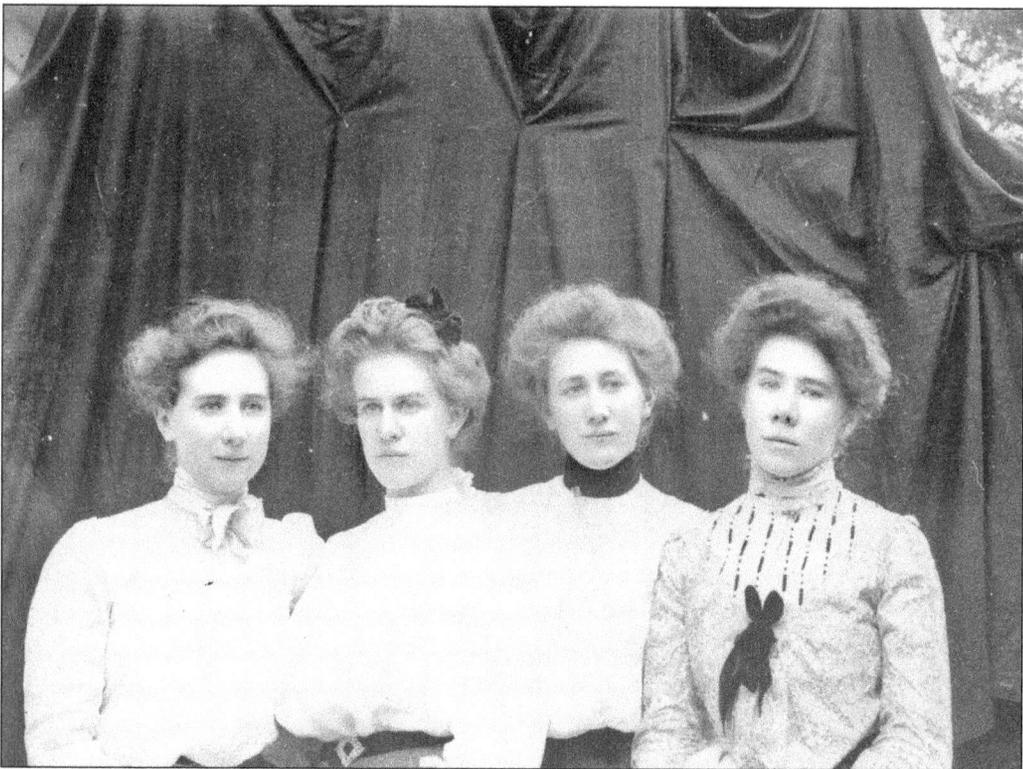

From left to right, Emma, Margaret, Hattie, and Ida Greever helped their brother A. S. Greever at the Burke's Garden Academy. (Courtesy of A. S. Greever.)

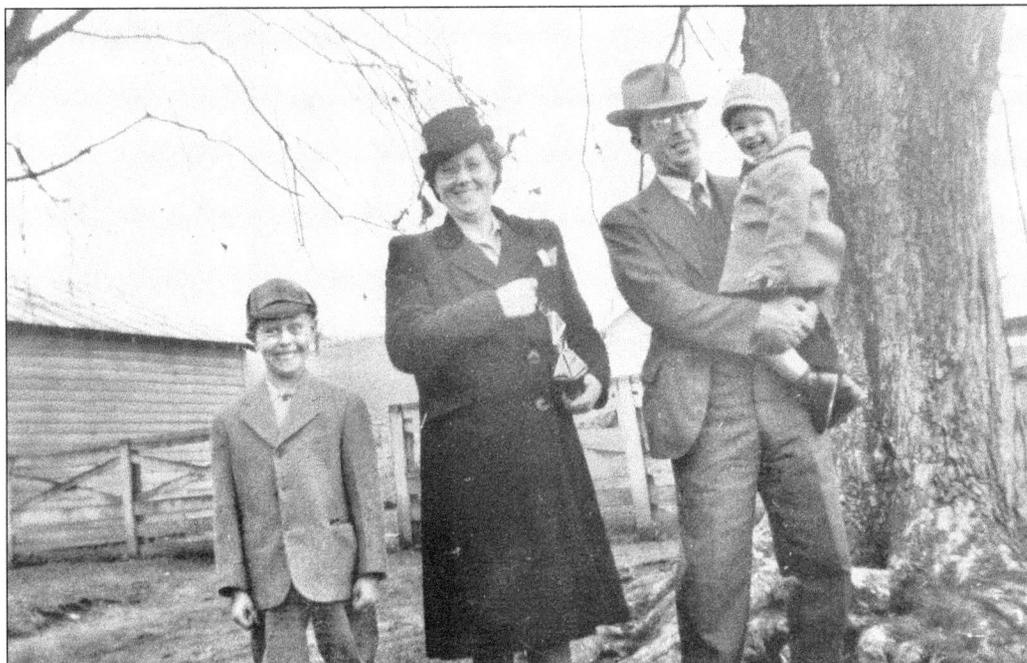

Donald Davis (left) walks with Frances, Bob, and Jim Bob (in Bob's arms) on the family's Burke's Garden farm on an autumn day. The quartet appears to be on its way to an important community function. (Courtesy of Ruth Tarter.)

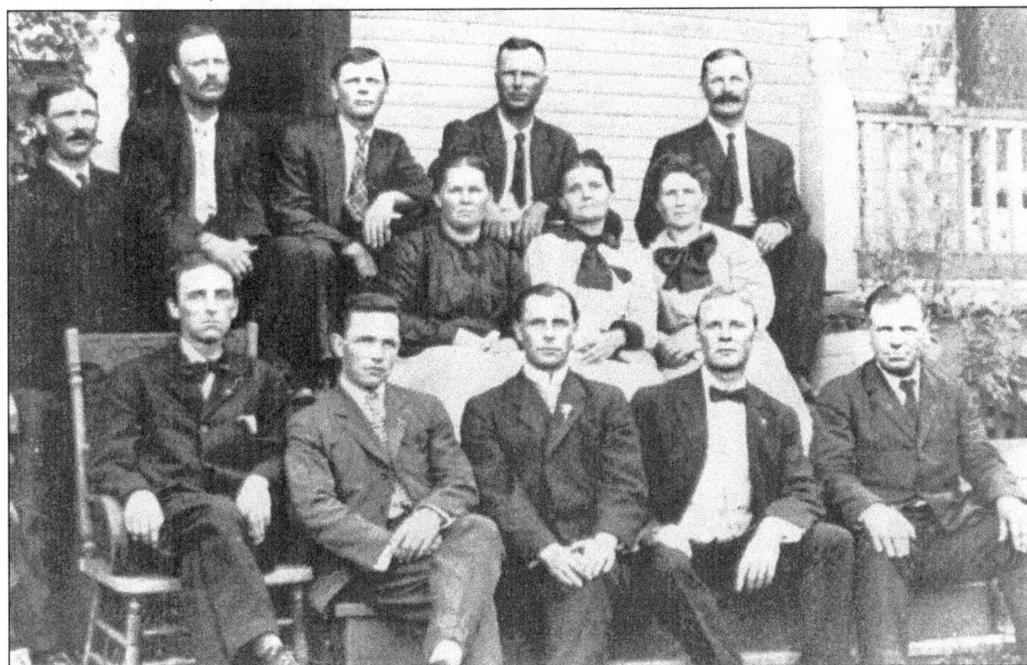

John Tiffany Litz of Litz Lane in Burke's Garden had 10 sons and 3 daughters. Pictured here, from left to right, are (first row) Jim, Grat, M. O. "Rone," George, and Sam; (second row) Nannie Atelia Sluss, Sally McGuire, and Kate Smoot; (third row) Joe, Harold, A. Z. "Al," John, and Peter. (Courtesy of Vivian Litz Merhoff.)

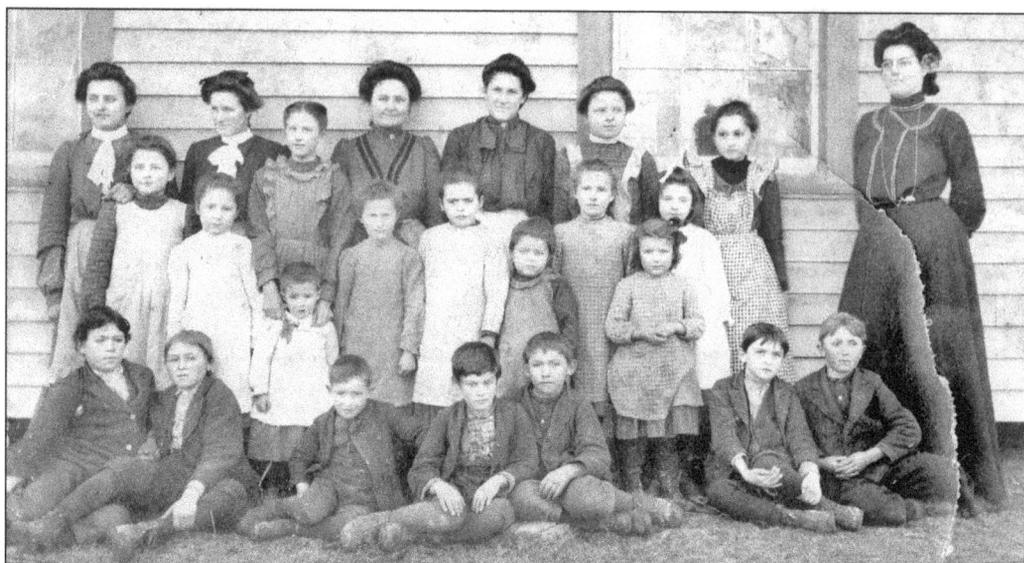

A variety of students were taught by Miss Billy Moss at the Litz School. In the early 1900s, seven community schools operated in Burke's Garden, including Glade, Litz, Rhudy, Ike's, Greever, Groseclose, and Gose. The following 1908 roster of students at the Rhudy School was contributed by Bobby Short: Kate Felty, Allie Thompson, Ruth Davis, Charlie Thompson, Dewey Short, Bud Atwell, Joe Kitts, Will Henry Wynn, ? Davis, Hattie Davis, Pattie Davis, Bess Moss, Lawrence Felty, Steve Felty, Alec Mahood, and Selden Thompson. Maude Moss served as their teacher. Later the Greevers established the Burke's Garden Academy, which educated boarding students from a wide area. It was known for preparing students so thoroughly that graduates could enter their second year of college. (Courtesy of W. Merle Howell.)

The Walkers lived in the west end of Burke's Garden. Annie Walker Barger and Bill Walker were brother and sister. Annie was the great-grandmother of Libby Bowman. She died in 1950 at the age of 87. (Courtesy of Elizabeth Bowman.)

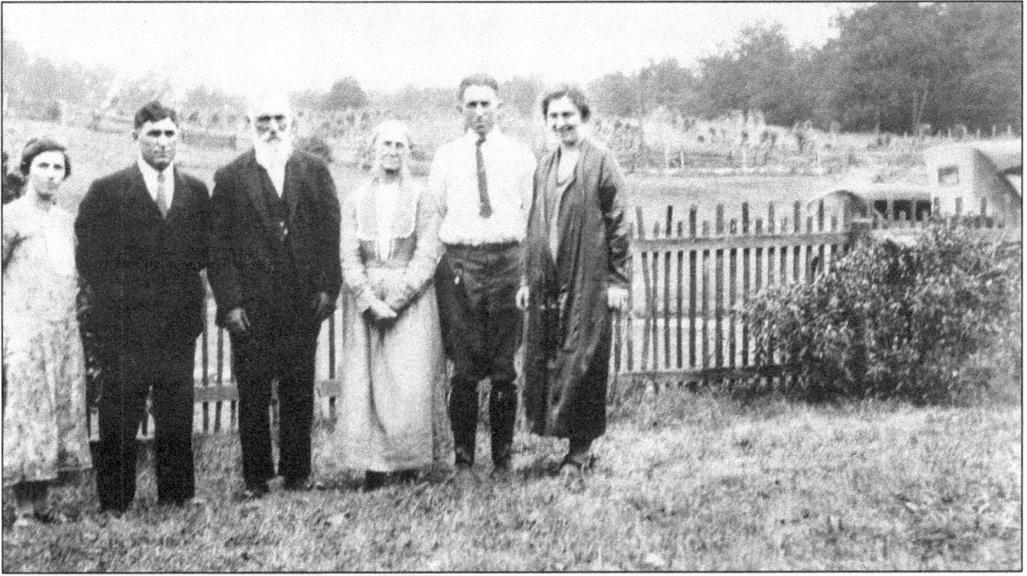

The Family of Levi Rhudy, a native of the Garden, gathered on a summer day in the mid-1900s. They are, from left to right, Lettie Cronise, Elmer Rhudy, Levi Rhudy, Nannie Mahood Rhudy, Clarence Rhudy, and Pearl Leslie. (Courtesy of the Mullins files.)

It's a happy day for these cousins, Sally Litz Hedrick (left) and Ruth Tarter (right), pictured with their mothers, Louise Davis Litz (left center) and Ruth Davis Brown. (Courtesy of Ruth Tarter.)

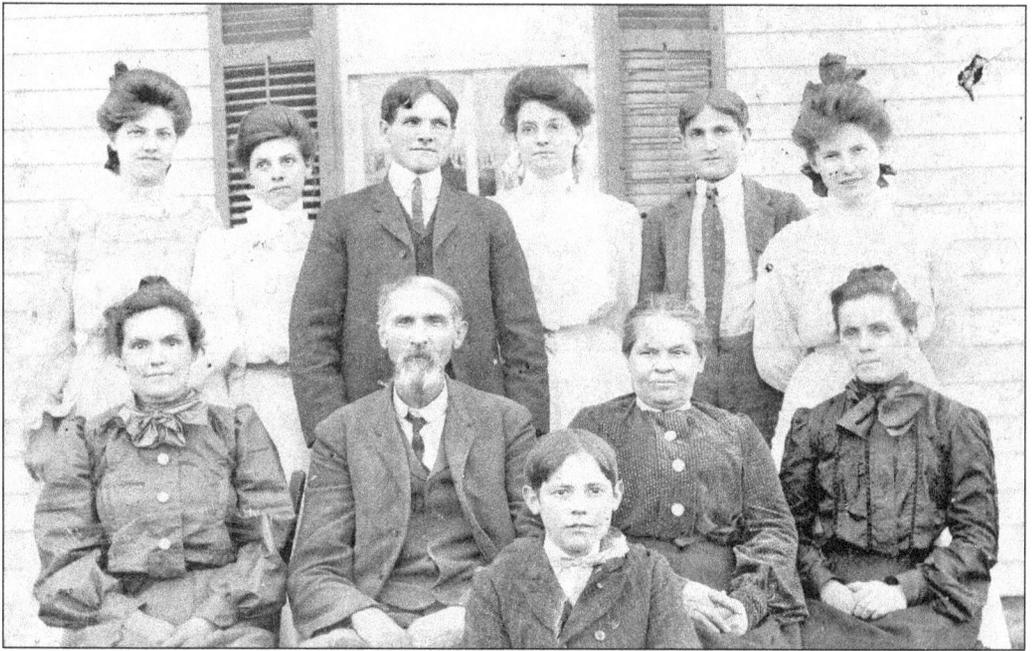

The prominent Rush Moss family included the following, from left to right: (first row) Florence Stowers, Rush Moss, Vint T. Moss, Louise Davis Moss, and Ann Peery; (second row) Lucy Moss, Mary Moore, Will Rush Moss, Tilley Moss, Ben Moss, and Maude Moss. (Courtesy of Margaret Rhudy.)

Joseph S. Moss Sr. (middle) appears with two other well-known residents of Burke's Garden: Ed Hall (left) and Charles Hall. A horse, pickup truck, and tractor (in the garage) are visible, as well as the white picket fence in front of this west-end farmhouse. (Courtesy of the Lawson-Moss scrapbook.)

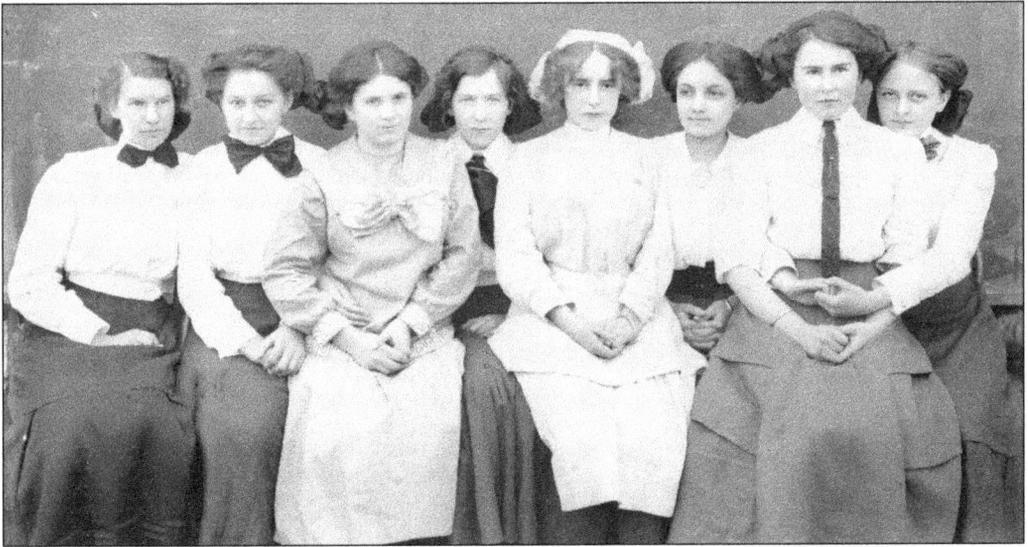

These young ladies must have been pupils at the Burke's Garden Academy about 1910. Pictured from left to right are Becky Rhudy, ? Howell, Pearl Rhudy, unidentified, Ethel Meek, unidentified, Ida Long, and Mary Belle Moss. (Photograph by A. S. Greever.)

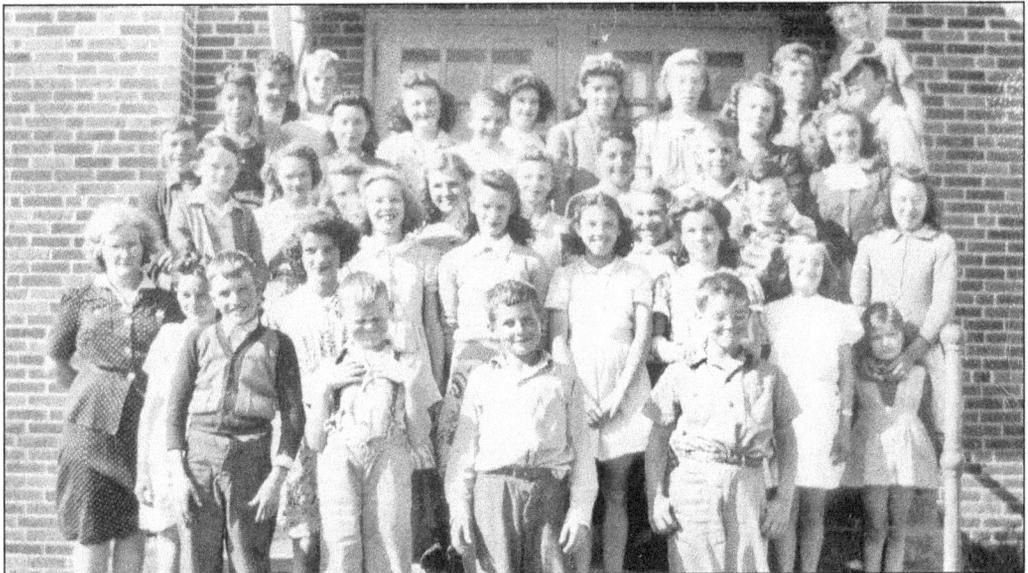

This Burke's Garden School class of the mid-1940s, taught by Mrs. Baugh, consisted of many students who stayed and made their homes in the community. Seen here, from left to right, are the following: (first row) Walter "Buddy" Wilson, Barnes Goodman, Curtis Repass, and Gene Davis; (second row) Mrs. Baugh, Lucille Kitts, and Jean Ann Thomas; (third row) Bobby Short, Verna Lambert, Margaret Sue Kitts, Joyce Kimberlin, Joanne Goodman, Lorraine Thompson, and Barbara Hoge; (fourth row) Shan Shrader, Margaret Wilson, unidentified (partially hidden), Thelma Wilson, Maxine McCann, Peggy Repass, Harry Tibbs, and Laura Belle Kitts; (fifth row) J. L. Rhudy Jr., Ailene Kimberlin, Vernal "Buck" Lambert, Gene Davis, Dulaney Snapp, Louise Repass, and Lillian Meek; (sixth row) Tom Meek, Herbert Lambert, Ruth Lambert, Faye Kitts, Lucille Thomas, Eva Lambert, Bobby Tate Goodman, Bill Dillow, and Bobby Moss. (Courtesy of Betty Vanhoozier.)

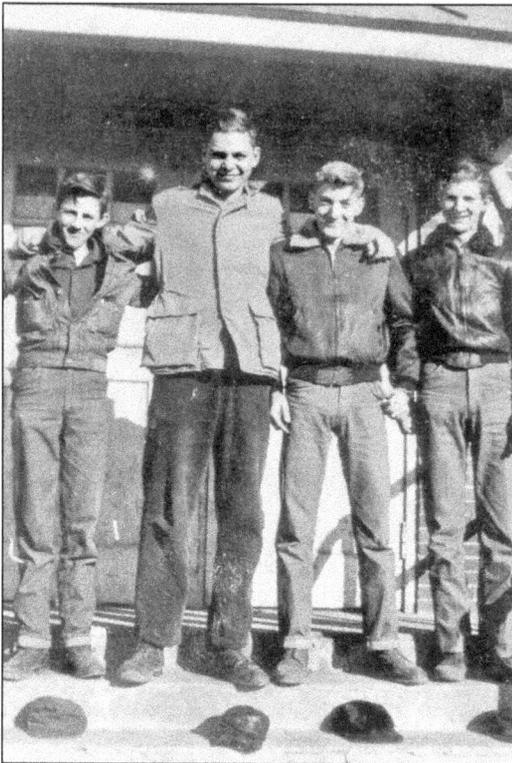

From left to right, Bill John Rhudy, Kent Hoge, Arlice Kimberlin, and Henry Vanhoozier Jr. pose on the steps of the Burke's Garden gym in 1957, just a few years before the school would close and the students would be sent to Tazewell schools. (Courtesy of Betty Vanhoozier.)

Mallie Moss has her hands full with Miriam Greever, Francis Hoge, Virginia Greever, Mary Moss, J. D. Greever, and Albert Greever. The group appears under a large oak tree in the yard of the Moss home. (Photograph by A. S. Greever.)

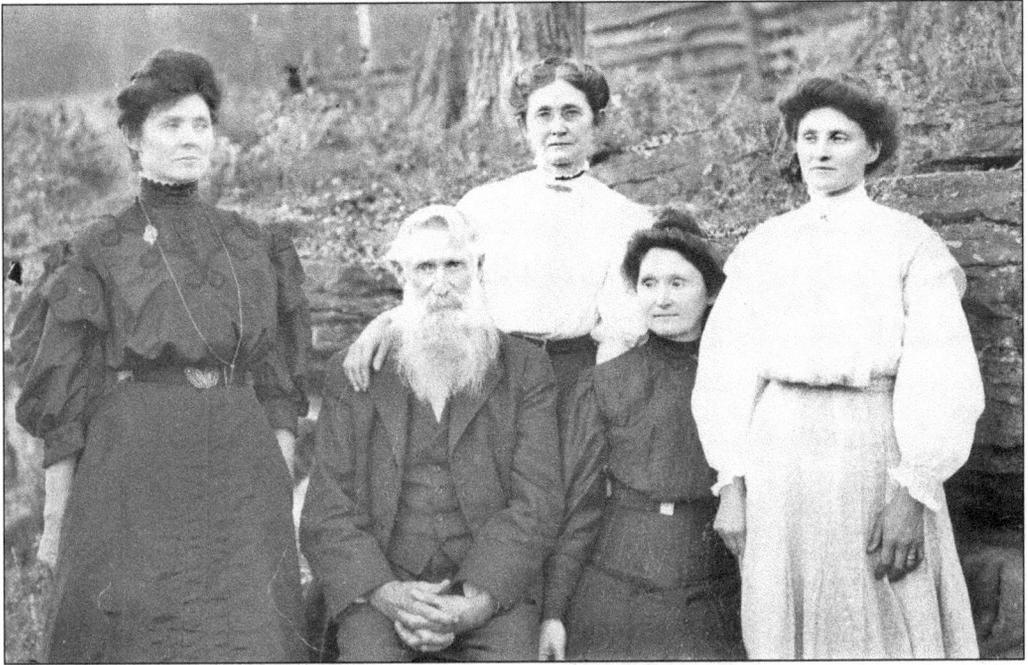

The Mahood (originally MacHood) family immigrated to the United States from Scotland after the Revolutionary War. This image is believed to depict the family of Stephen Mahood, who was born in Burke's Garden in 1839. (Photograph by A. S. Greever.)

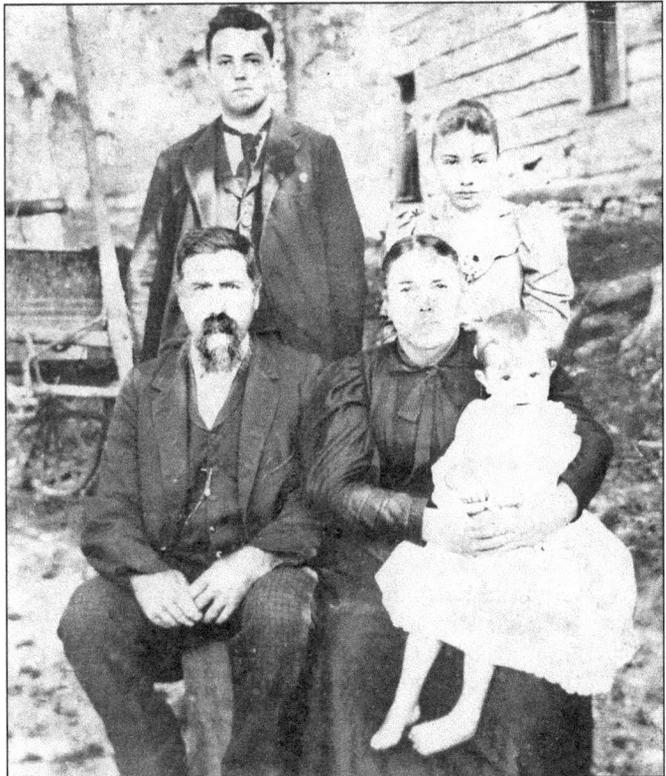

Shown from left to right are the following: (first row) Stephen and Agnes Greever Fox and grandson J. William Shawver; (second row) John David Fox and his sister, Mattie. This photograph was taken beside the David Spangler Fox home in 1895. The baby went on to become a prominent Tazewell County doctor who lived in Tazewell. (Courtesy of Elizabeth Ann Fox Martin.)

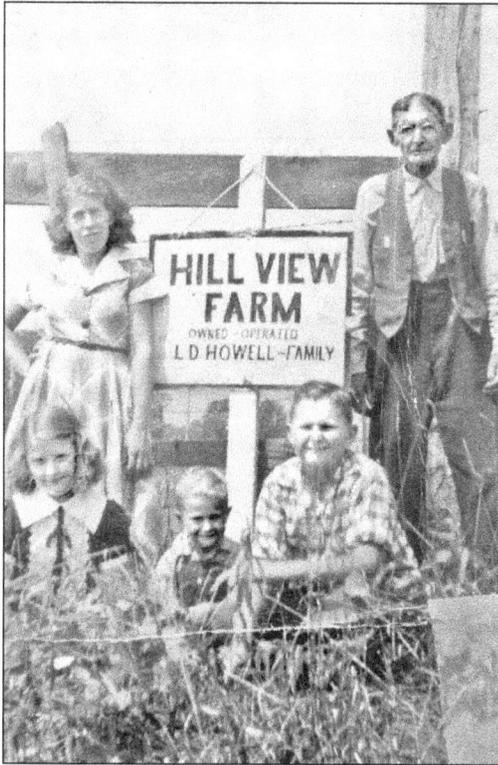

The Howell family pose in 1953 with a sign designating the family farm as the Hill View Farm. The children are, from left to right, Rita, Gerald, and Grady. The parents are Laura and Lewis. (Courtesy of Rita Howell.)

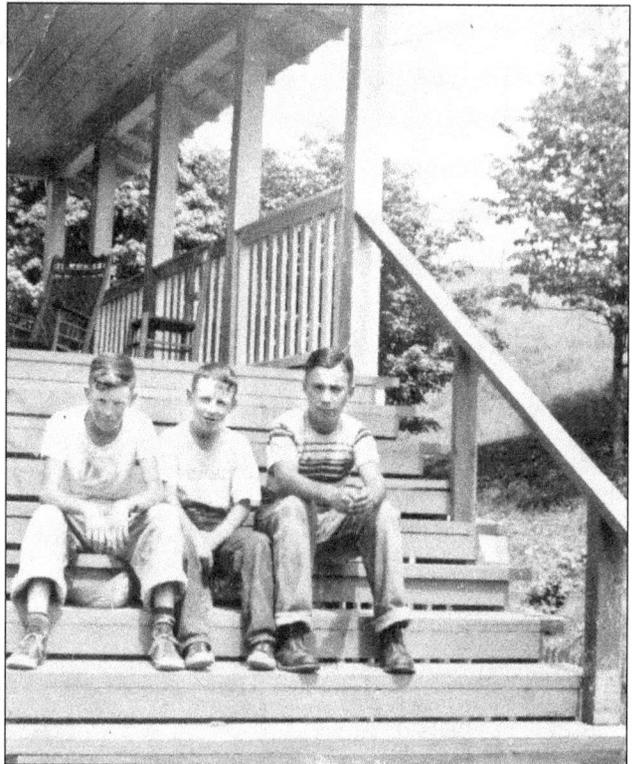

Ralph Wilson, 13 (left); Jimmy Cornwell, 10 (center); and Ben Lineberry, 13, relax on the front steps of the Lineberry home in Burke's Garden on a summer day in 1952. (Courtesy of Ben Lineberry and Rita Etter.)

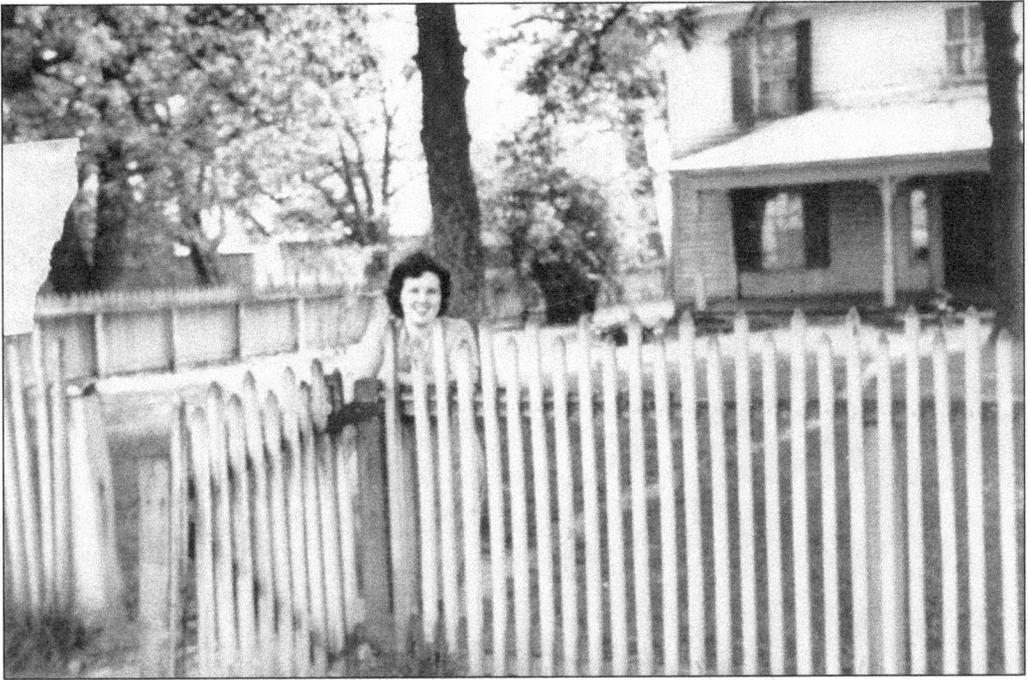

The Goodman house was originally built of logs in 1800 with later additions. Nannie was the last survivor of the immediate family. Here Joan Goodman Repass stands in front of the home. (Courtesy of Joan Goodman Repass.)

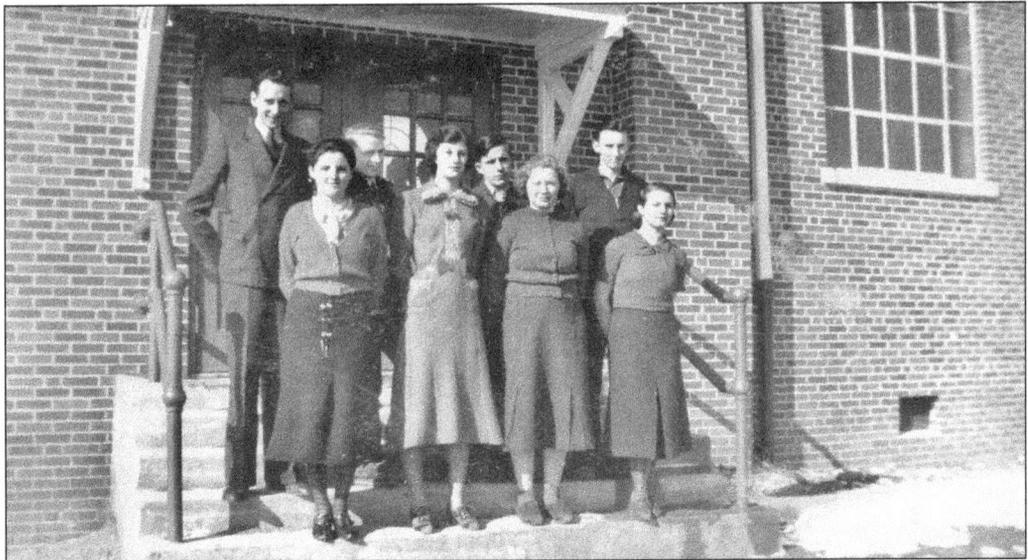

The 1938 graduates of Burke's Garden High School gather for a photograph. Pictured from left to right are the following: (first row) Grace Repass, Lettie Hanshew, Elizabeth Lester, and Sally Harrison; (second row) sponsor Allen K. Thomas, Joe Frank Meek, Alvin Raines, and Sam Neal. (Courtesy of Marvin Meek and the *Garden Gate*.)

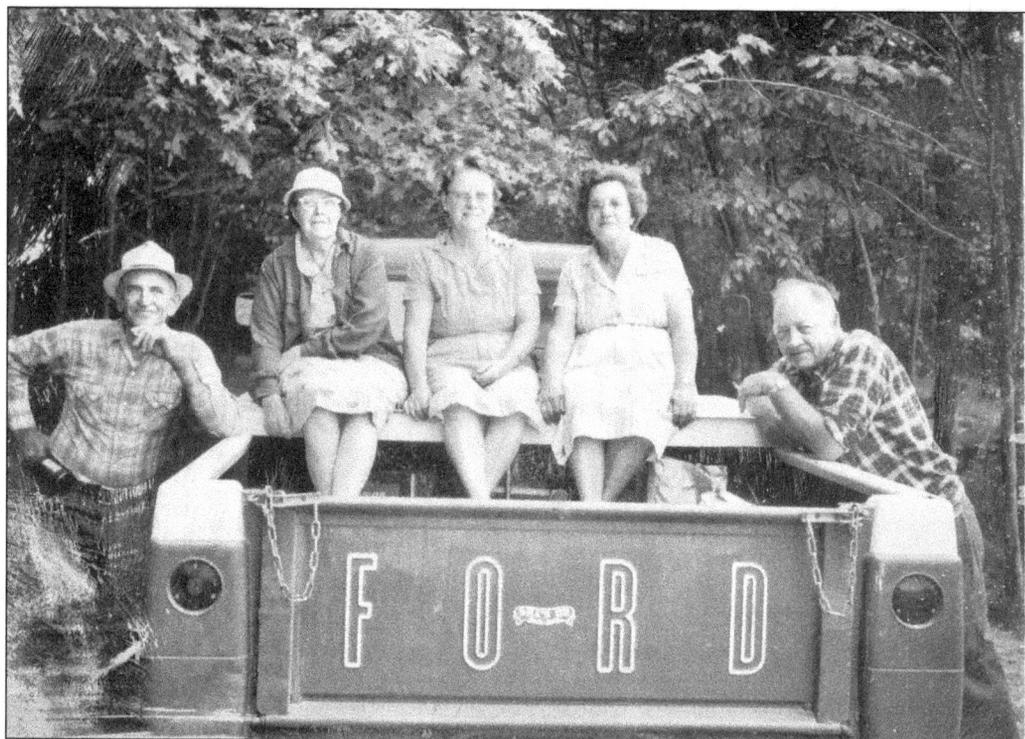

On a summer day, the ride from Burke's Garden to Ceres is an adventure that true mountaineers appreciate. Enjoying the ride in June 1965 are, from left to right, Bill Brown, Mary Brown, Mary Lou Boling, Ethel Boling, and Ira Boling. (Courtesy of Juanita Boling.)

Little Joe Moss (left), unidentified (center), and Aubrey Kitts are ready for a day's work—or play—in the Garden. (Courtesy of A. S. Greever.)

The T. E. and Elizabeth Moss
Howell family sits for a portrait in
1896. Shown from left to right are
the following: (first row) Mary,
Margaret, and Grace; (second
row) Gertrude, T. E., Elizabeth,
and Thomas M. (on lap); (third
row) Parke, William, and Lewis.
Thomas E., the first Howell, came
to Burke's Garden about 1870
after emigrating from England. He
served as the ruling elder of the
newly organized Burke's Garden
Presbyterian Church for 50 years.
(Courtesy of W. Merle Howell.)

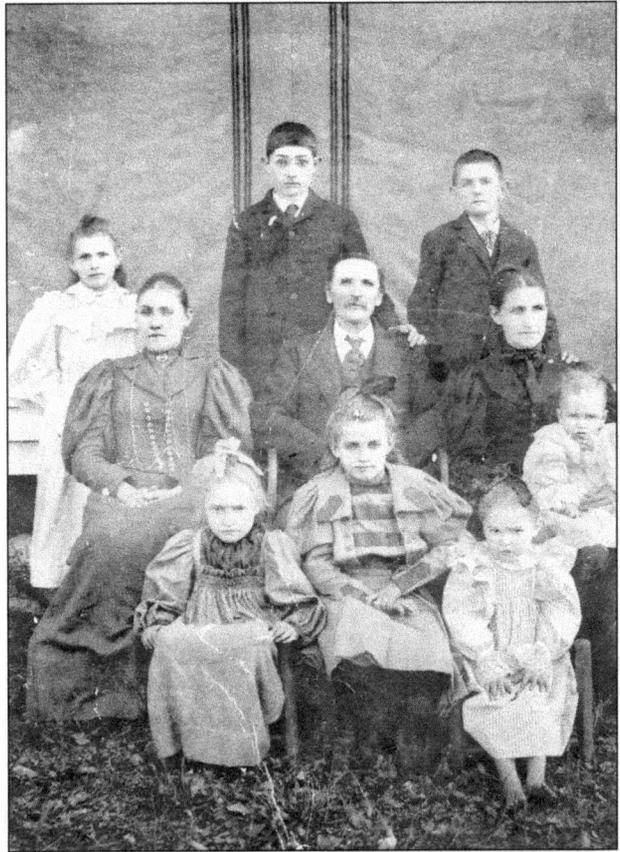

From left to right, Johnny Shrader,
Sarah Burkett, Laura Howell, and
Ethel Etter stand behind their
parents, Joe and Nellie Shrader,
in the family's backyard in 1938.
(Courtesy of Rita Howell.)

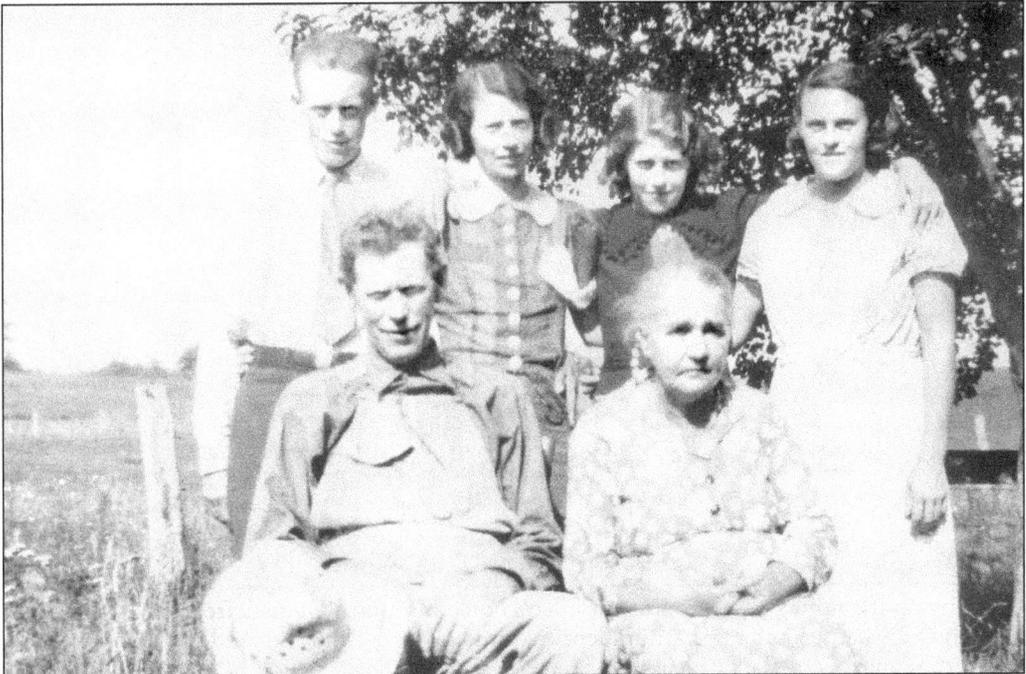

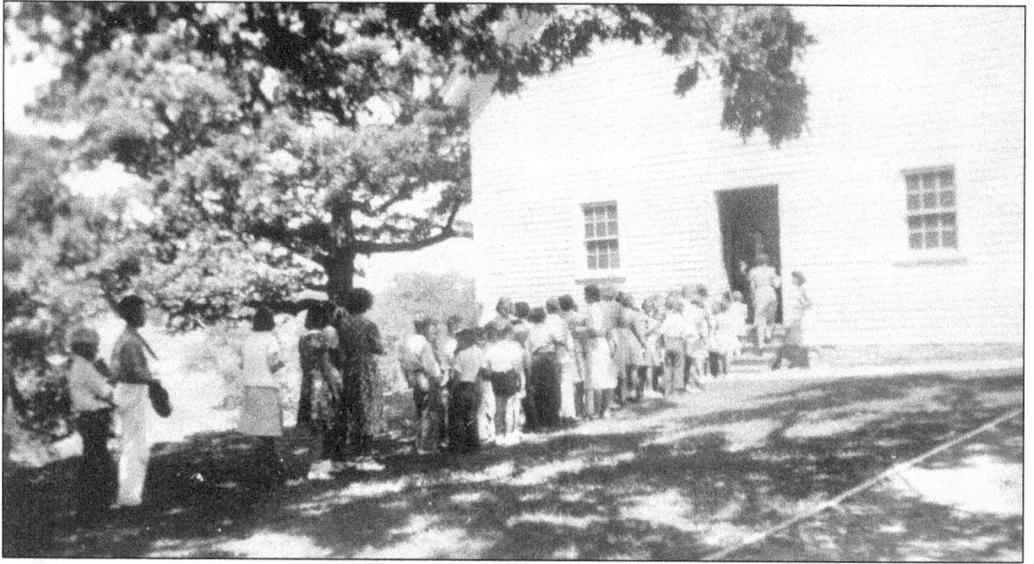
In 1940, Bible school at the Central Church attracted a large number of youngsters from the different parishes of Burke's Garden. The Central Church, now the Lutheran church, got its name when various congregations worshiped there on alternating Sundays. (Courtesy of Colleen Cox.)

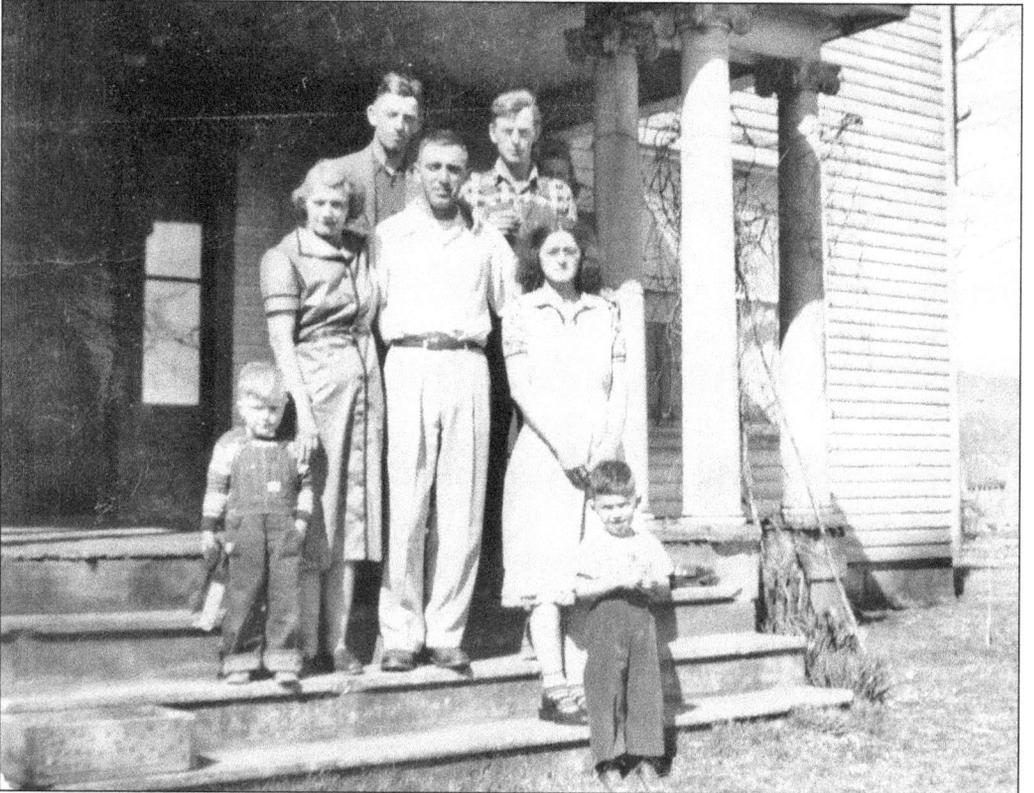
Standing on the front steps of their aunt Ellen's home in Burke's Garden are, from left to right, (first row) ?, Ellen, Butch, and an unidentified woman and child; (second row) Roy and Ted Lambert. (Courtesy of Nancy Neal.)

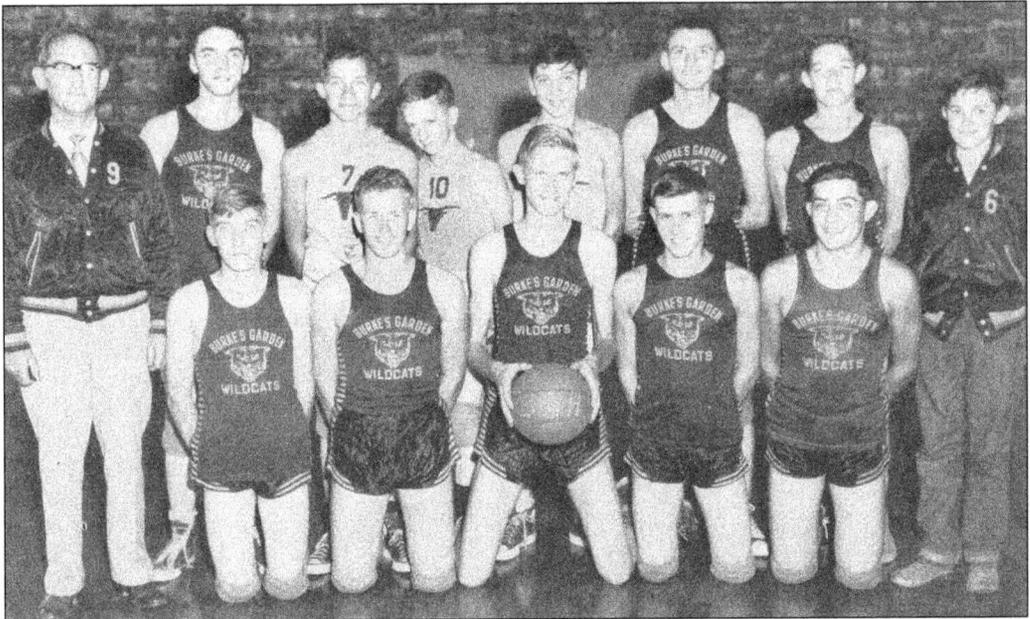

The Burke's Garden School was noted for turning out competitive teams in many sports. In small community schools, basketball was always a favorite. Here the 1955 boys' basketball team poses for a group photograph. Seen from left to right are the following: (first row) Jack Meek, Bill Kitts, Jody Meek, Kent Thomas, Nelson Howell, and Allen Goodwin; (second row) principal George Bird, Arlice Kimberlin, James Shrader, Pritt Reban, Jim Bob Davis, Charles Moss, and Bill John Rhudy. The Burke's Garden Wildcats were, year in and year out, very competitive in their games with neighboring communities. (Courtesy of Alex Chamberlain and the *Garden Gate*.)

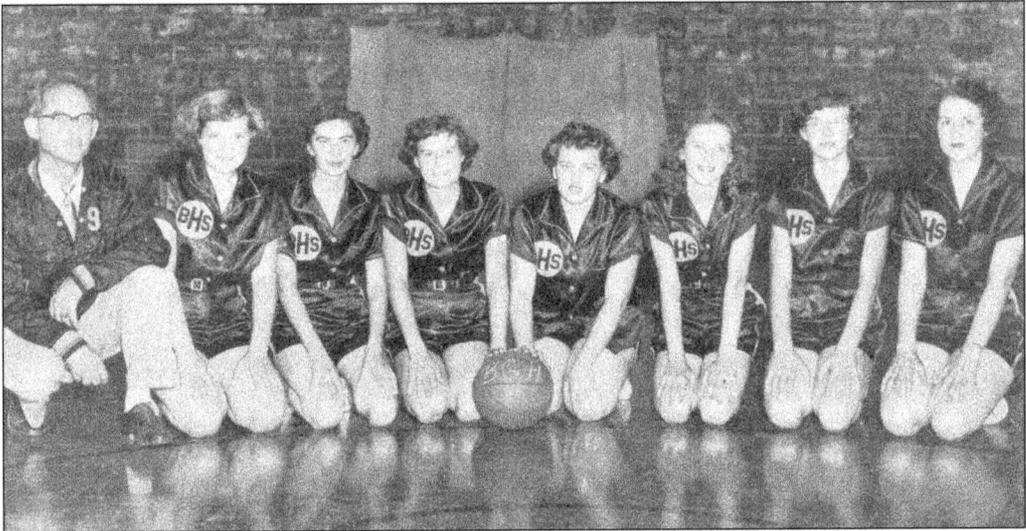

The girls' basketball team gathers for its photograph in 1955. Shown from left to right are principal George Bird, Mattie Brown, Becky Rhudy, Earnesteen McCann, Betty Mae Felty, Nancy Kimberlin, Claudine Brown, and Mary Anne Buchanan. Burke's Garden teams had heated rivalries with schools such as Bland, Rocky Gap, and even Bishop Junior High. Garden teams also regularly competed with larger schools like Tazewell and Graham. (Courtesy of Alex Chamberlain and the *Garden Gate*.)

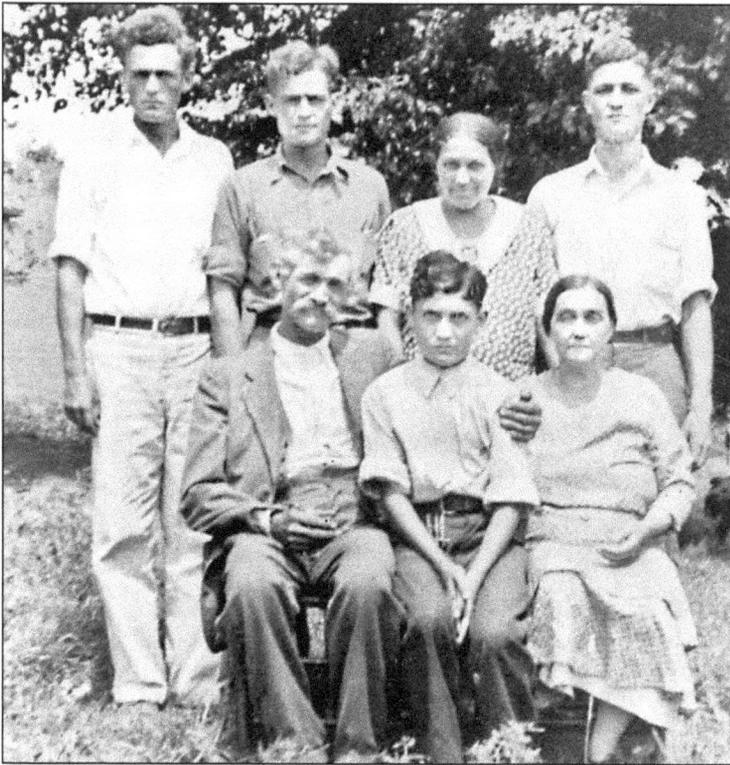

Members of the John Henry Mullins Sr. and Mary Katherine Peak Mullins family pose in the yard in front of their home. Seen from left to right are the following: (first row) John Henry Mullins Sr., John Henry Mullins Jr., and Mary Katherine Peak Mullins; (second row) Roy Mullins, Willy Mullins, Maude Grey Mullins (Kitts, Lockhart), and James L. Mullins. (Courtesy of Jay Lockhart.)

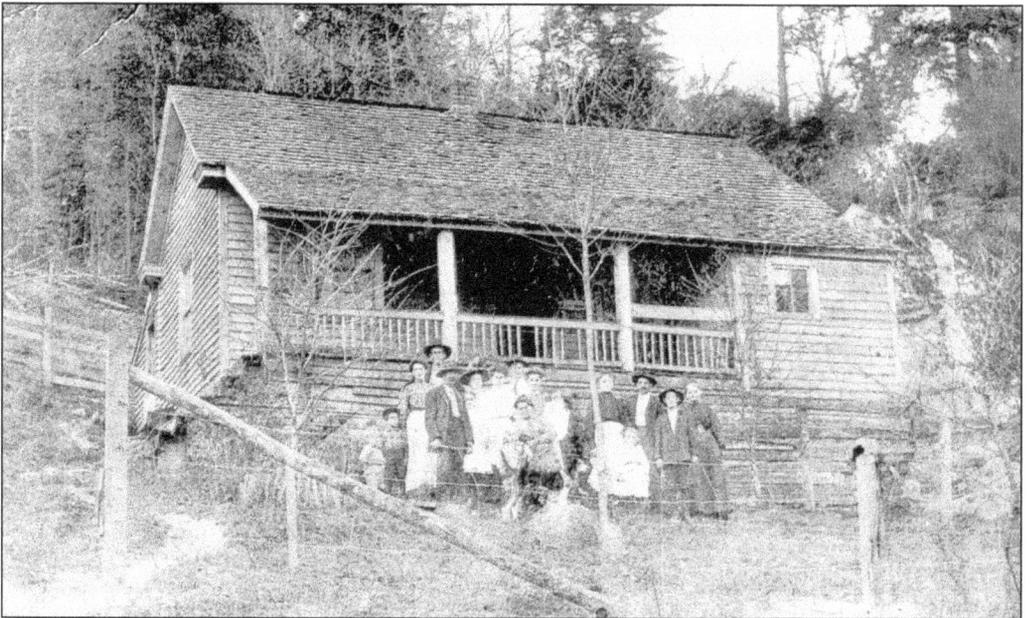

Hoback family members are photographed in front of their home near the mill dam. The two young children to the left are Joe and Henry Thompson. Also pictured are J. W. Hoback, Niti Hoback, Alice Thompson, Bob Thompson, Luther Hoback, and his wife, Bess. Next are Walt Hoback, Jenny Hoback, Cooper Hoback, and his wife, Bess. The little girl in front of Walt is Janette Hoback Lambert. (Courtesy of Mary Lambert.)

Four

HOME SWEET HOME

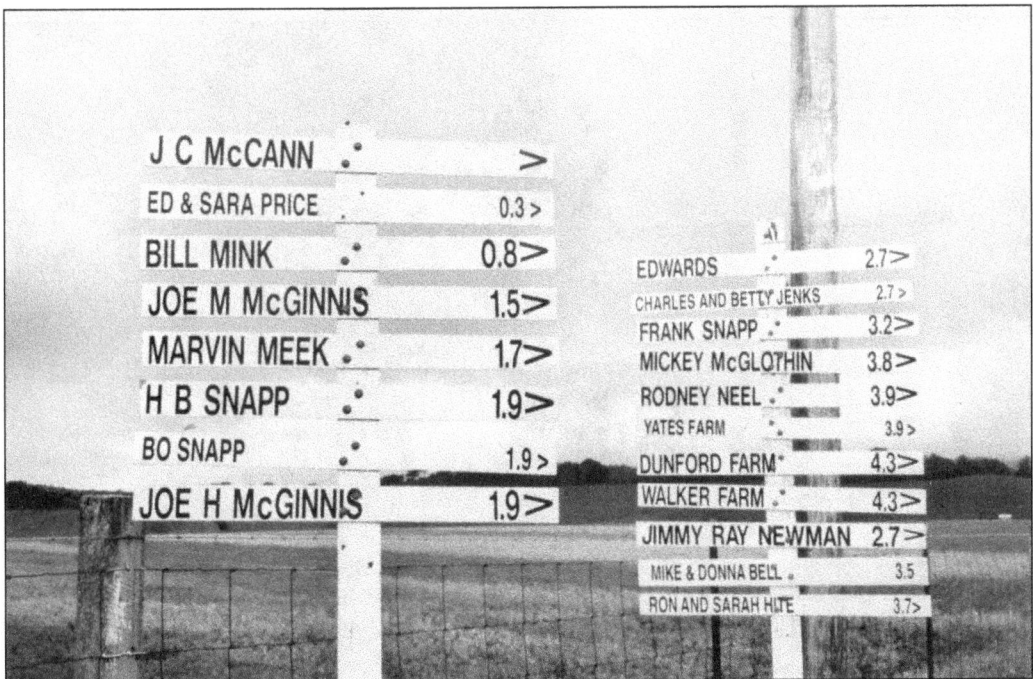

J C McCANN		>
ED & SARA PRICE		0.3 >
BILL MINK		0.8 >
JOE M McGINNIS		1.5 >
MARVIN MEEK		1.7 >
H B SNAPP		1.9 >
BO SNAPP		1.9 >
JOE H McGINNIS		1.9 >

EDWARDS	2.7 >
CHARLES AND BETTY JENKS	2.7 >
FRANK SNAPP	3.2 >
MICKEY McGLOTHIN	3.8 >
RODNEY NEEL	3.9 >
YATES FARM	3.9 >
DUNFORD FARM	4.3 >
WALKER FARM	4.3 >
JIMMY RAY NEWMAN	2.7 >
MIKE & DONNA BELL	3.5
RON AND SARAH HITE	3.7 >

Visitors to Burke's Garden appreciate the historical markers, along with the signs designating the locations of each farm. The Garden is an official Virginia byway, an honor given to rural communities of special interest across the commonwealth. (Courtesy of the Mullins files.)

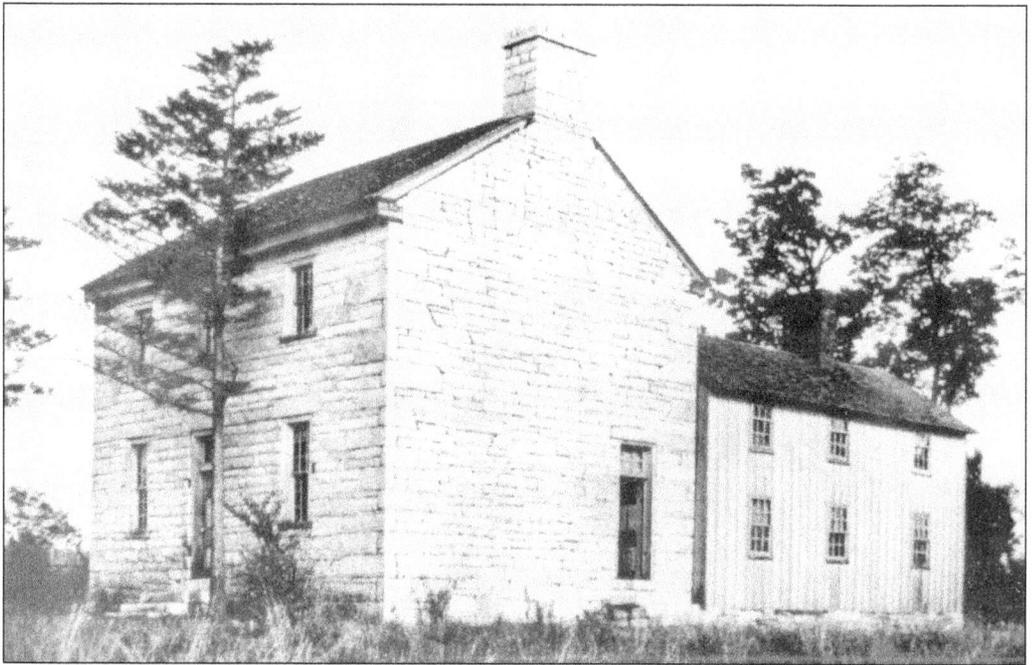

The Peter Gose house was built of stone quarried from an adjacent field about 1812. After the Gose family, its owners included Capt. Thomas Peery III, Joseph Meek, James Robert Meek, H. H. and Mildred Meek Lineberry, and Sarah and Ben Lineberry. The present owner is David Debord. (Courtesy of Ben Lineberry.)

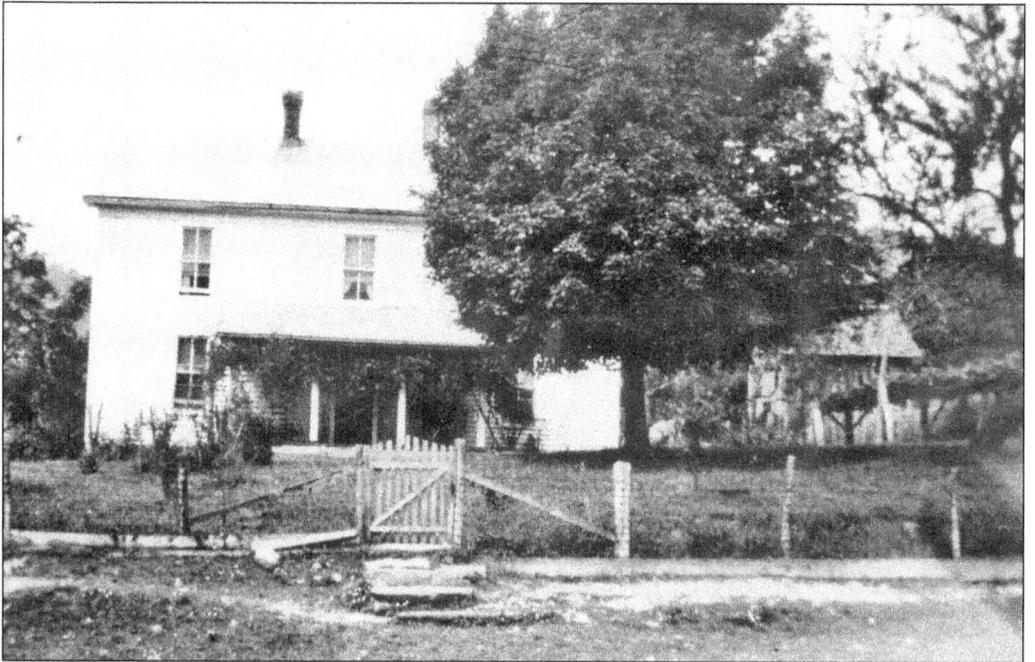

T. E. Howell, an outstanding citizen and businessman, constructed this home in the 1870s. Besides operating a large farm, he served as justice of the peace for 25 years and owned a thriving store. Tommy and Ora Howell lived in the house in later years. (Courtesy of W. Merle Howell.)

The lime kiln on the Greever farm is reminiscent of early farm practices important to life on the historic Garden lands. (Photograph by A. S. Greever.)

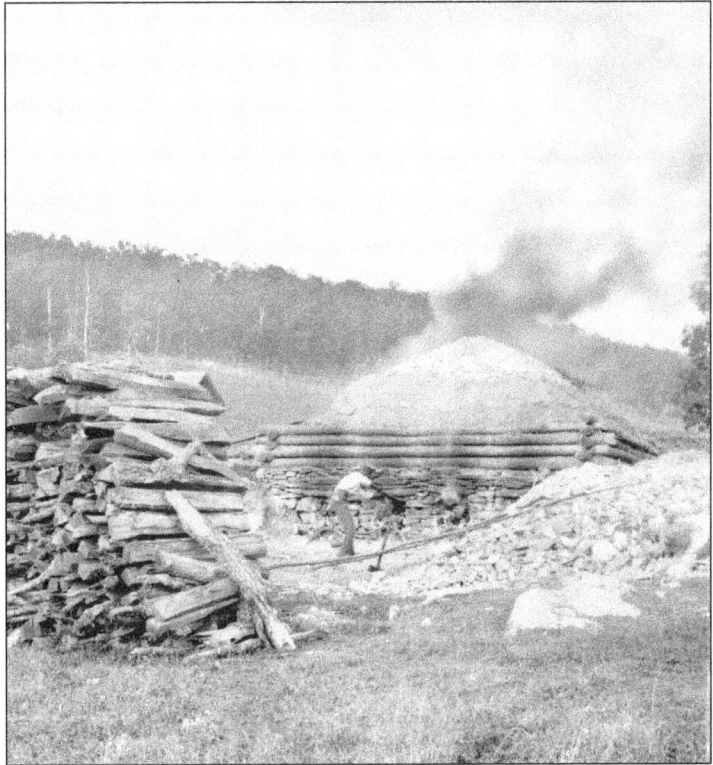

Built as a Catholic church, the small building in the background was later used as a Lutheran chapel from 1902 to 1911. Here, in more modern times, Curtis Repass (left) and Joe Howard McGinnis have fun in the adjoining yard. (Courtesy of Mary Elizabeth McGinnis.)

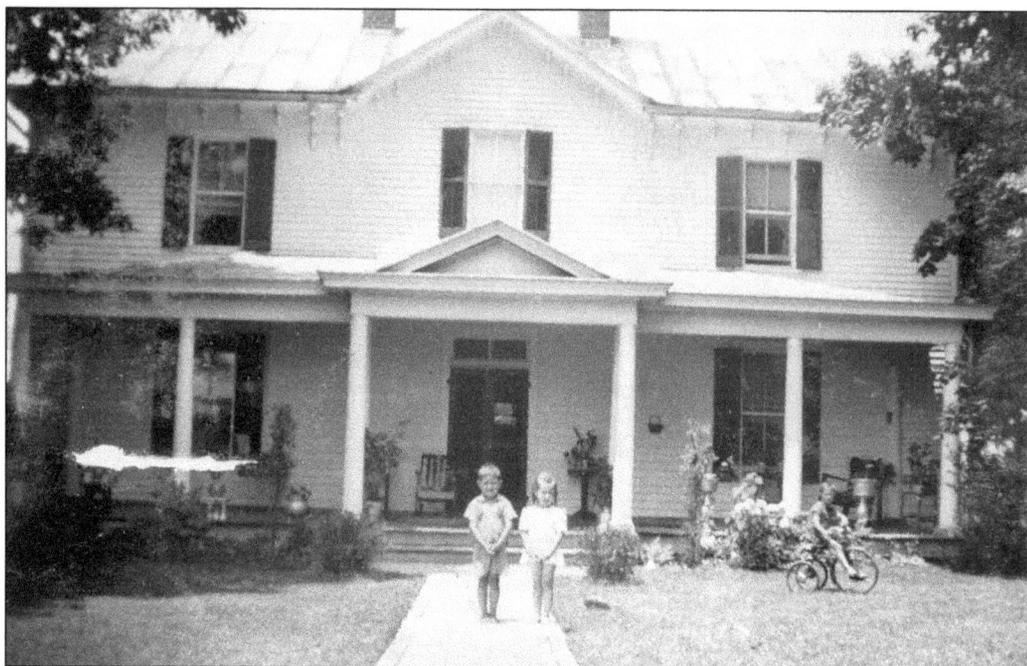

On a summer day in July 1942, Charles Moss and Mary Ann Buchanan play in the yard at the Will Moss home. An unidentified playmate rides a tricycle to the right. (Courtesy of Ruth Tarter.)

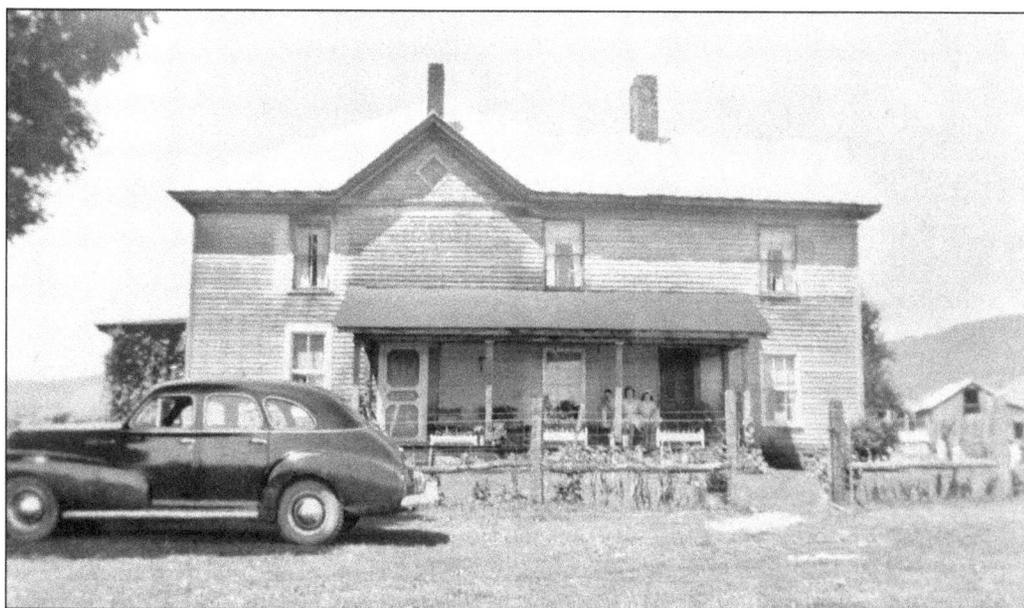

The Frank Moss home seems to combine the old and the modern in this 1957 image. The family car is parked to the left, in front of the house, while the barn is behind and to the right. (Courtesy of Cora and Ernie Wilson.)

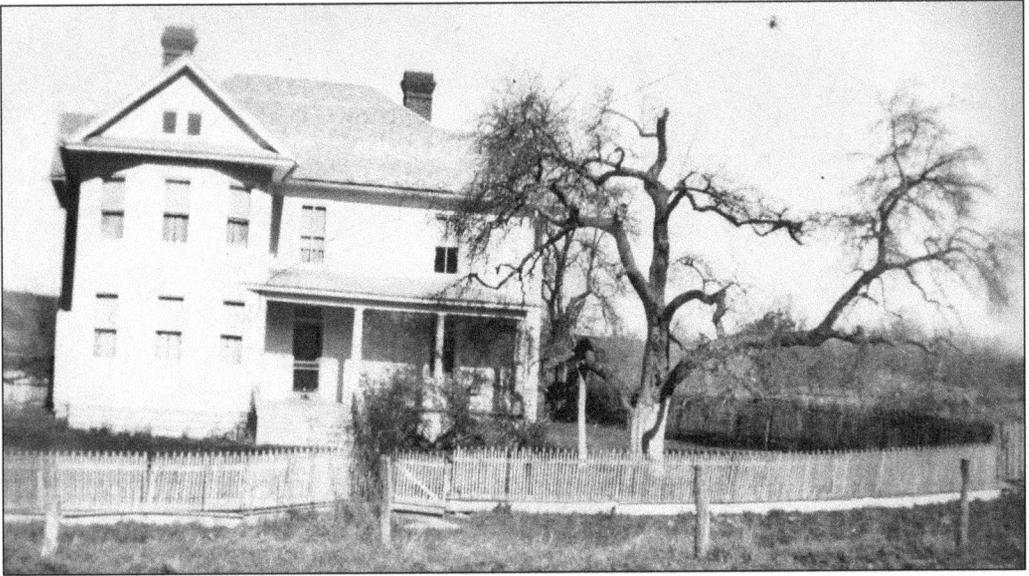

The Burke's Garden home of William Leon Davis and Donie Frances Keister Davis is pictured on a bright summer day in the early 1900s. The Davis family was listed in the 1866 roster of landowners in the Garden. Out of "Lon" and Donie's 10 children, 5 stayed in the Garden and established their own families. (Courtesy of Mary A. Vaughan.)

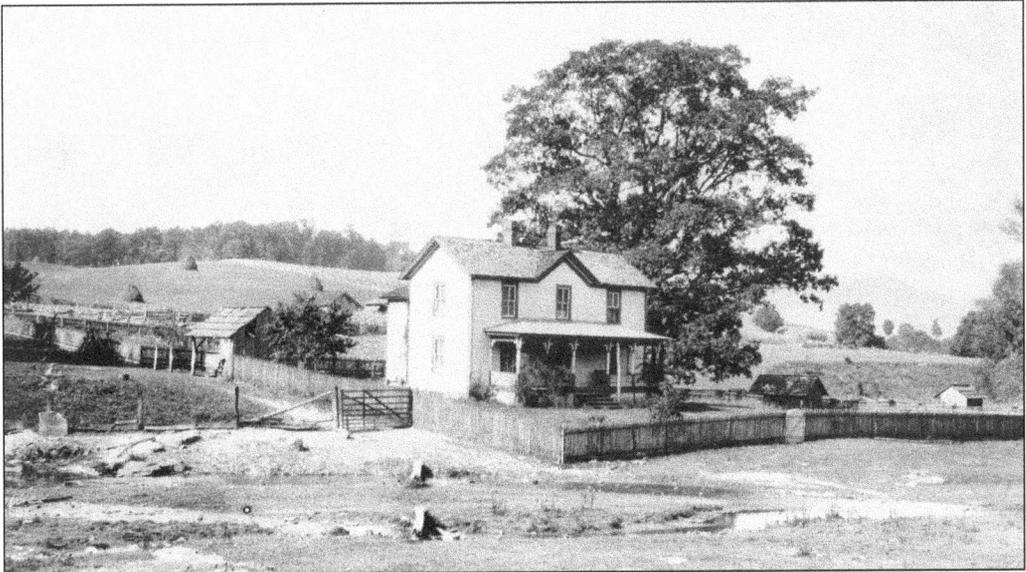

One of the oldest still standing on its original family site, the George Gose Rhudy home was built by the son of George Rhudy. The elder George Rhudy had traded a team of horses for land in Burke's Garden in 1810. (Courtesy of Ruth Snapp.)

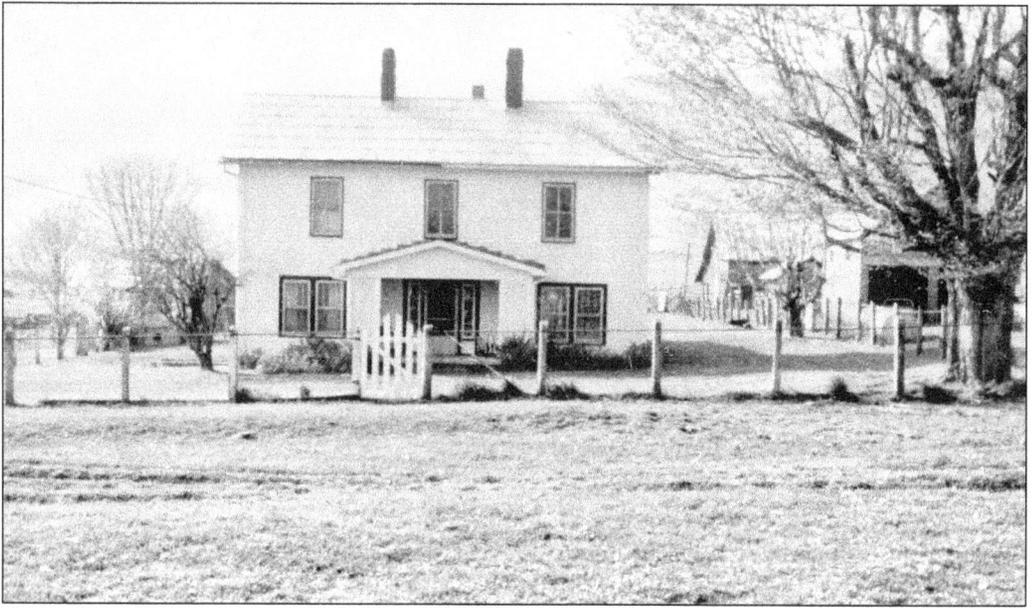

The Bob Davis house was originally constructed of logs in 1829. It was later improved with white weatherboard siding, which is evident in this early-20th-century photograph. (Courtesy of the Davis family.)

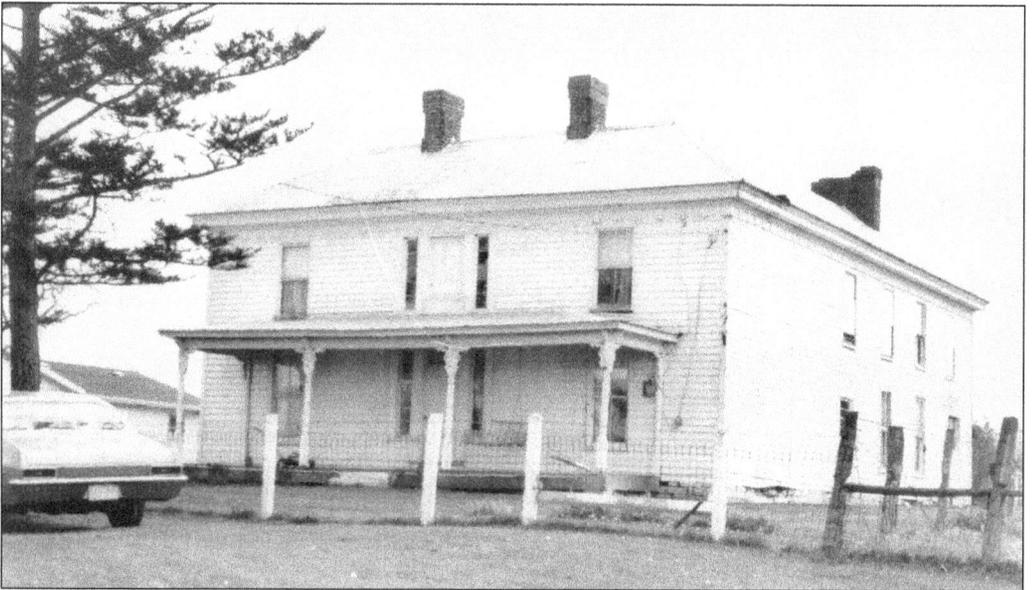

The impressive home of William C. and Ruth Thompson, built in 1861, is now owned by Lenden and Doris Thompson. The Thompsons of Burke's Garden trace their roots to the earliest settlers in the region. They are the descendants of William Patton Thompson, who inherited large tracts of Garden land. (Courtesy of Elizabeth Bowman.)

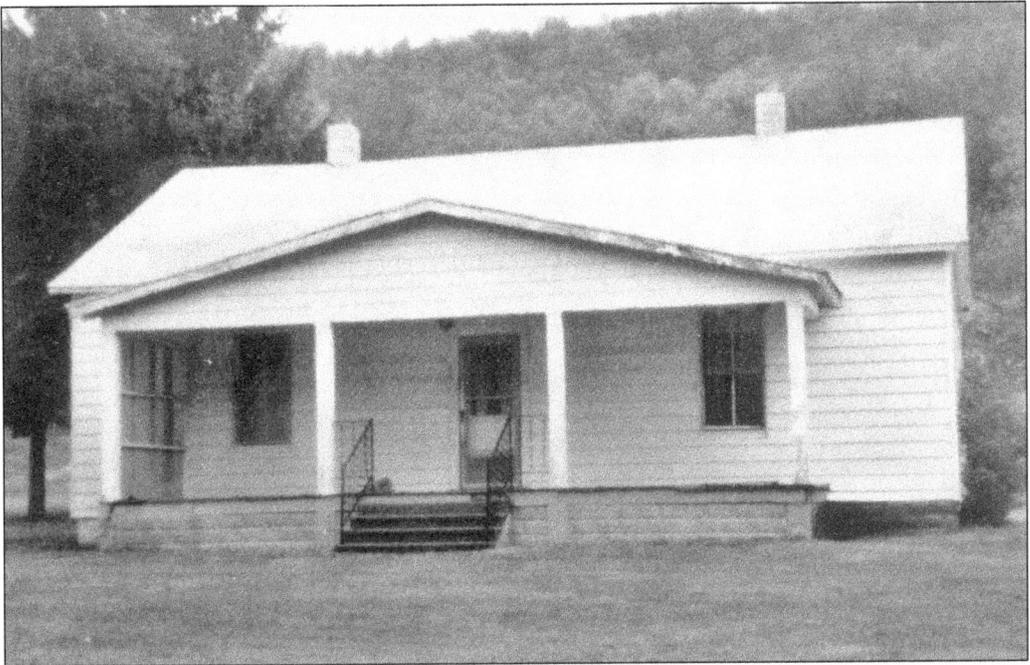

Once located on Little Creek, the Mae Meredith house reminded friends and relatives of the family that lived many years in this beautiful area of Burke's Garden. This house has since been torn down, while Little Creek remains an important part of the community. (Courtesy of Elizabeth Bowman.)

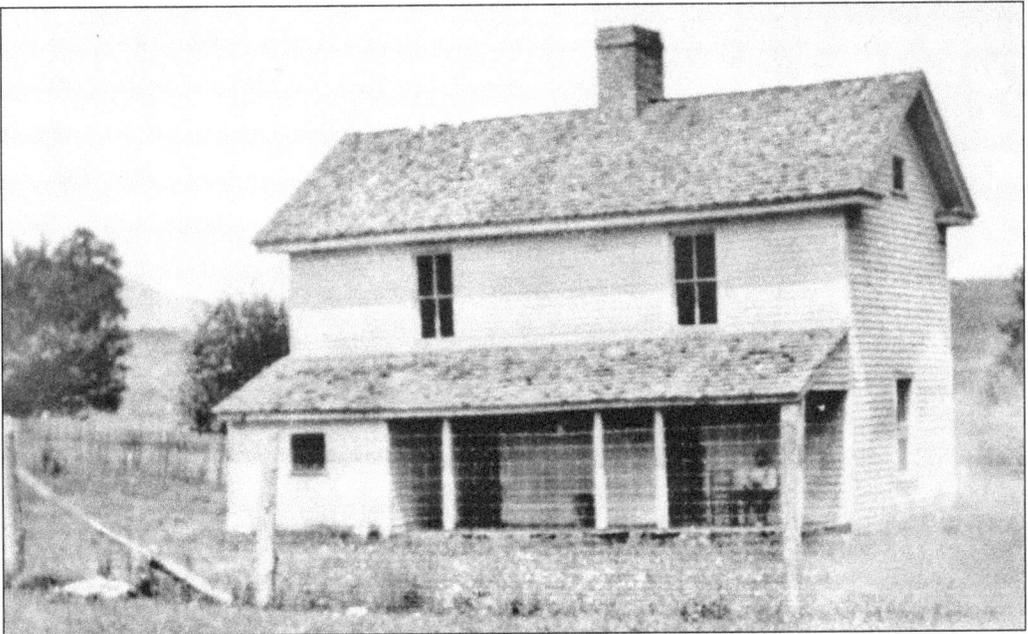

The James Rhudy house was built around 1895 and is still occupied by family members. The Rhudys traveled to Burke's Garden from Grayson and Wythe Counties with the large group of German Lutherans who came to establish new homes in the open territory of the late 1790s and early 1800s. (Courtesy of Colleen Rhudy Cox.)

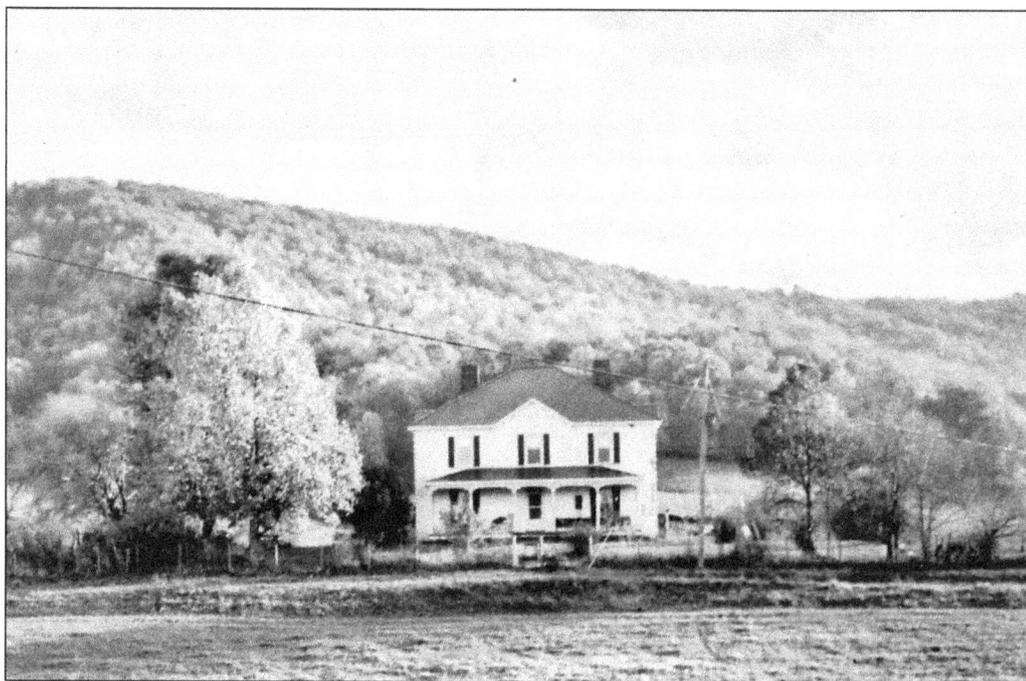

This idyllic setting, in the midst of autumn colors, is typical of the Burke's Garden houses built by early settlers. Starting with the enthusiasm of James Burke, who said, "I have found the Garden of Eden," the beauty of the land has been appreciated. Rush Moss constructed this dwelling in 1894. (Courtesy of Margaret Rhudy.)

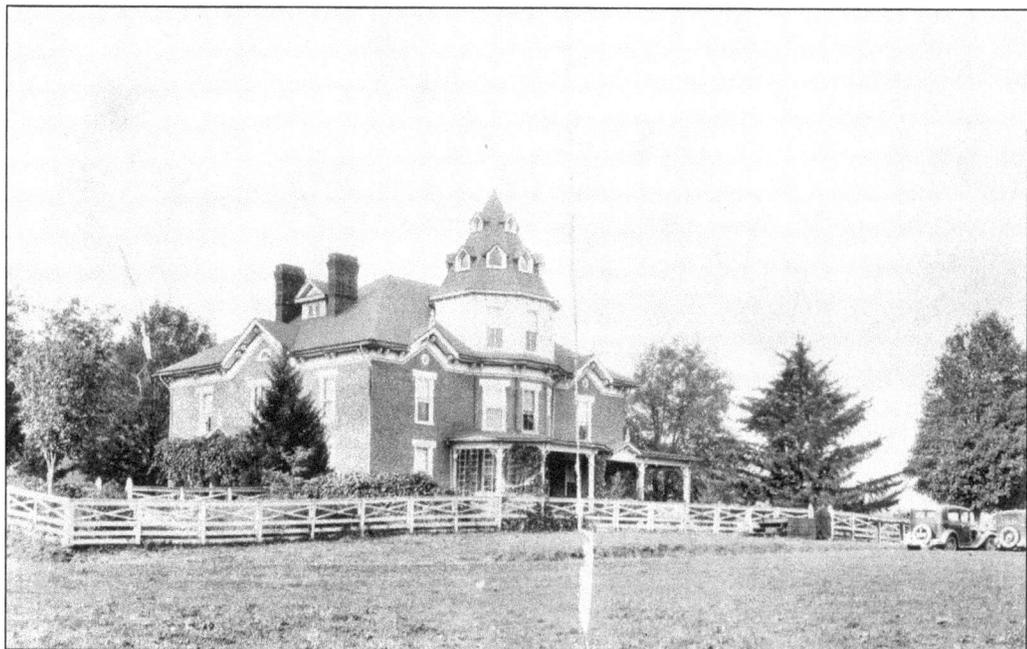

The tower on the original home of James Robert and Josephine Groseclose Meek was built a few years after 1890 to add a unique addition and special beauty still admired today. (Courtesy Ben Lineberry.)

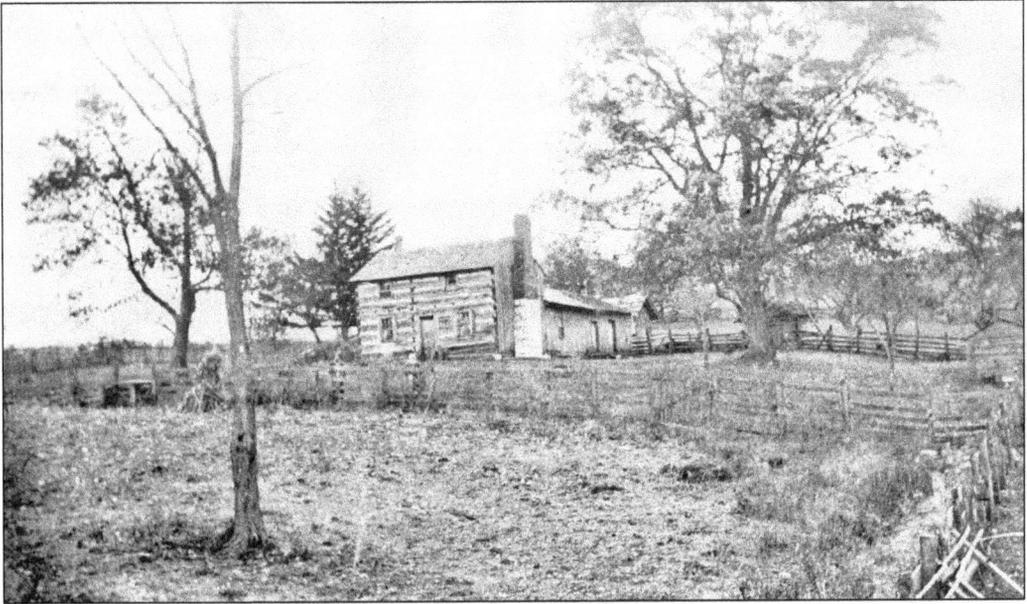

The Isaac Goodman house, built in Burke's Garden about 1820, was photographed by Albert S. Greever around 1890. This residence was one of the first constructed in the bowl-shaped valley. (Courtesy of Mary Elizabeth McGinnis.)

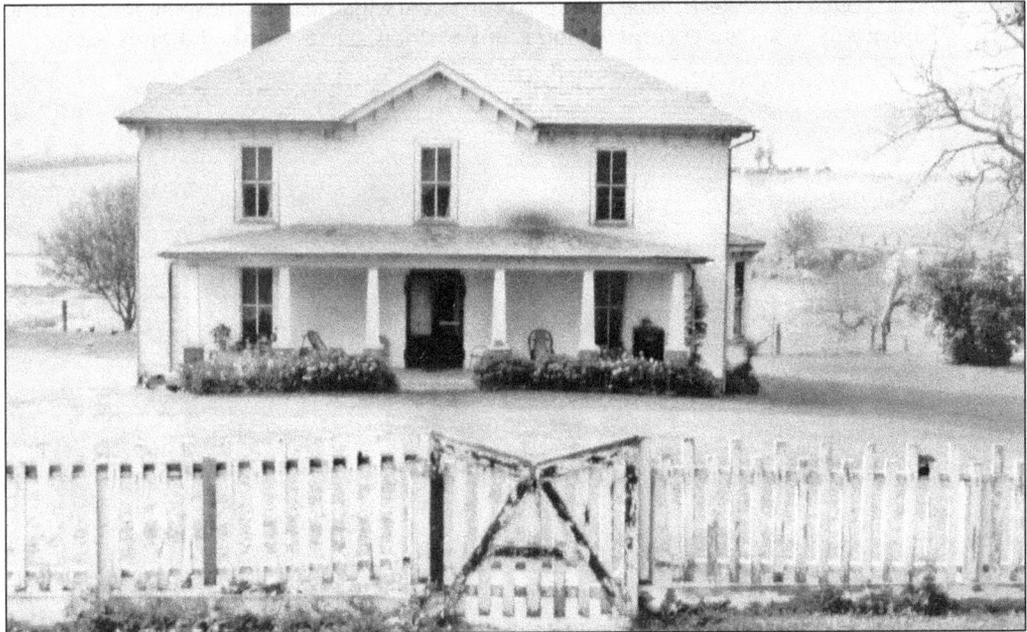

The Alex Meek home was built in 1892 and torn down in 1982. Parts of the old structure were used in the new home built by Marvin Meek. Alex Meek became known nationally for his leadership (and presidency) of the National Hampshire Sheep Association. In the 1930s and 1940s, Burke's Garden was called "the Hampshire Sheep Throne of Virginia." At that time, approximately 1,000 purebred Hampshire sheep were owned by Lawson and Moss, Alex Meek and sons, H. Bowen Meek, J. R. Davis, and C. J. Moss. According to Mildred Lineberry, its high altitude and cool climate make Burke's Garden an excellent place for raising sheep. (Courtesy of Marvin Meek.)

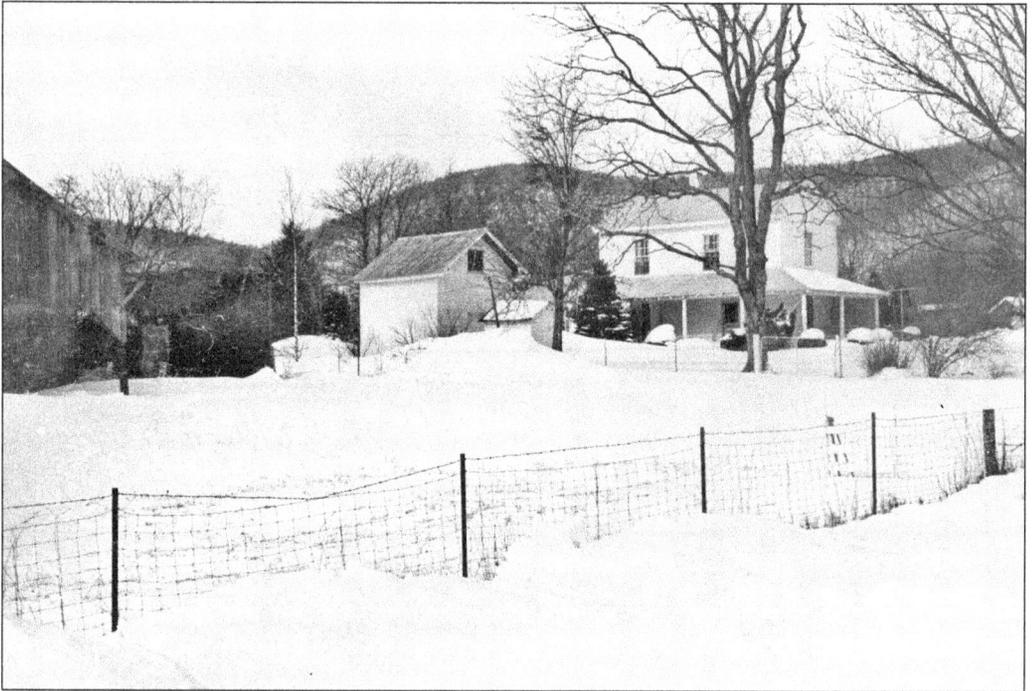

The Leland and Stellena Edwards home looks pretty on a cold winter's day as the snow glistens in the Burke's Garden sun. The date of construction is unknown. (Courtesy of the Edwards family.)

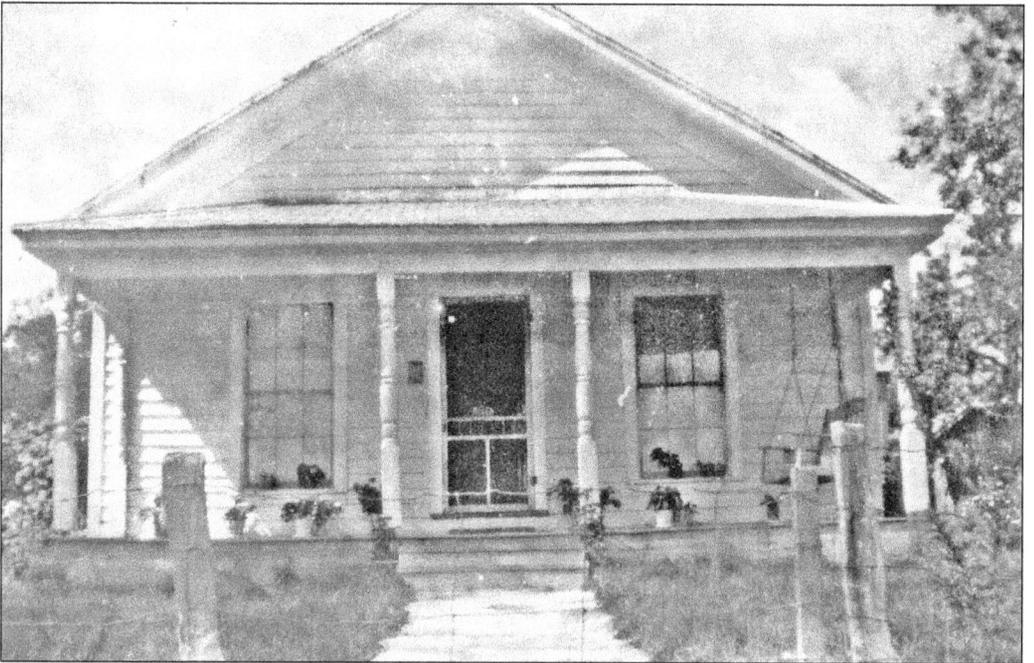

John and Helen Boling lived here in 1947. As a schoolteacher, Helen educated elementary students in Burke's Garden and Tazewell during her career. This house, one of the oldest in the Garden (exact date unknown), was the residence of John's parents, Lena Mae and Steve Boling. (Courtesy of Helen Boling.)

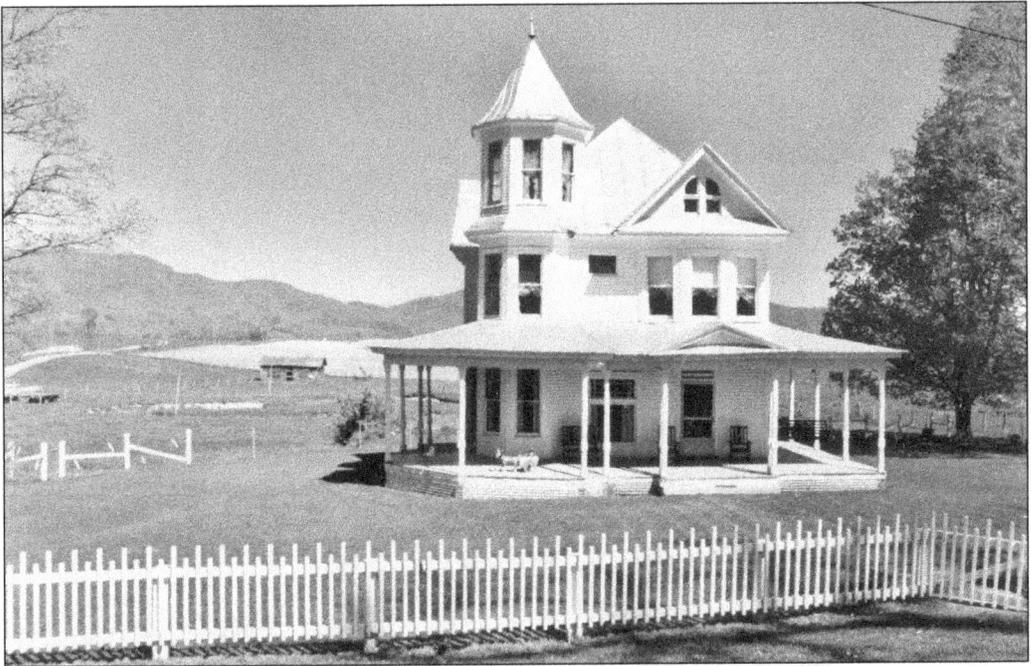

This beautiful home was designed by Anna Miller Snapp and built in 1903. Francis Snapp, the son of Anna and Landon, was born in 1906. He had one sister, Reba Ludwick, and a half-sister, Lucille Fracker. Following Landon's death in 1936, Francis became the home's sole owner in 1940. Before returning to Burke's Garden, he worked a year at Virginia Tech's experimental farm and at the Radford power plant. When he came home in the early 1940s, Francis started a dairy farm that continues today. Francis and his wife, Hattie Gregory, had one daughter, Louise St. Clair, and three sons: Francis Dulaney Jr., Otha Richard, and Phyl Du. While Francis was in Blacksburg and Radford, the farm was operated by Otie Wilson. (Courtesy of Ruth Snapp.)

Shan Leedy built this house, which was later remodeled by owners Joe and Mary Elizabeth McGinnis. Note the beautiful flowers that have long been a trademark of this home on the main road into the Garden. (Courtesy of Mary Elizabeth McGinnis.)

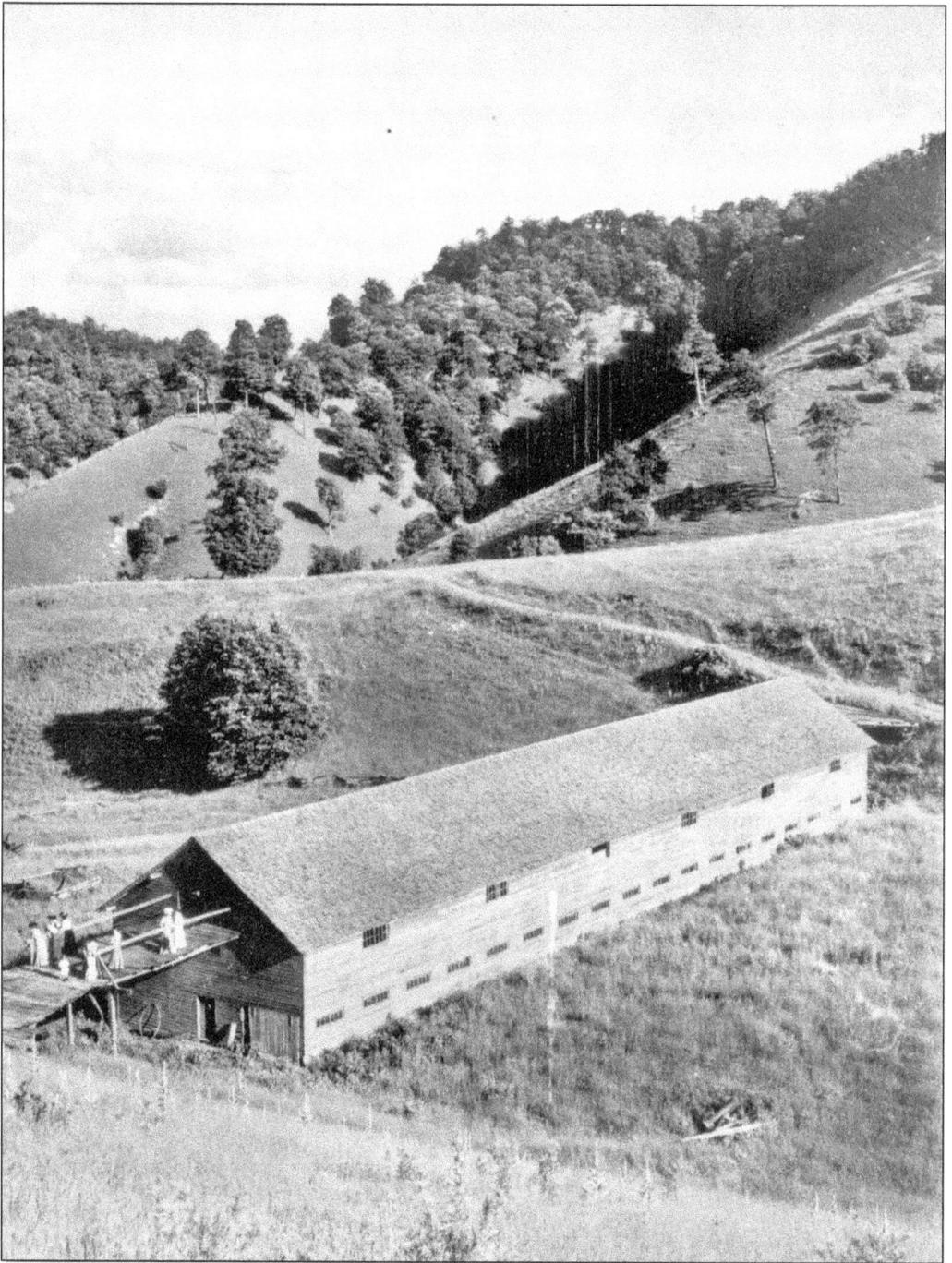

Sam Heninger's long barn stood on the rolling hills of Chestnut Ridge, and his big white house was built close by. Heninger connected several of the nearby ridges with bridges. Neighbors still remember the sound of his horses and wagon as they crossed over these bridges. (Courtesy of A. S. Greever.)

Dr. James H. Moore, whose home is shown here, was a well-known early physician who delivered many Burke's Garden babies. His practice in Burke's Garden was valuable in the days when medical services were scarce. James was born in 1885. His wife was the former Sally Mae Moss. (Courtesy of the Burke's Garden Community Association scrapbook.)

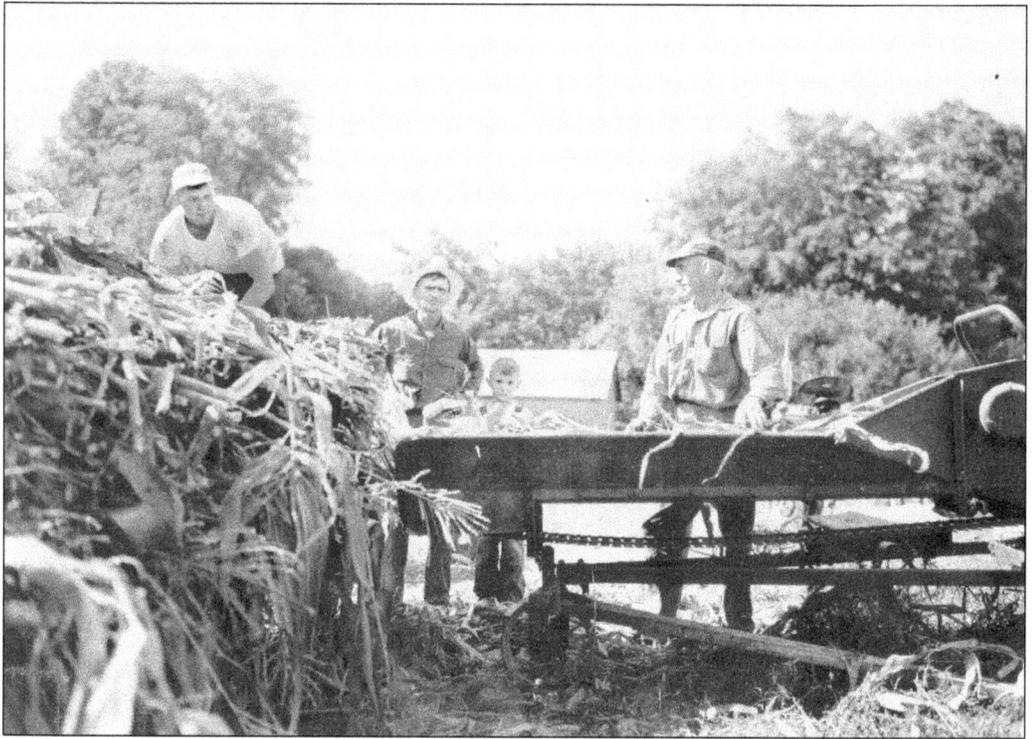

Silo filling meant a hard day's work for these Burke's Garden men. Here, from left to right, Dulaney Snapp, Alex Meek, Phil Snapp, and Francis Snapp gather corn stalks and other silage crops. (Courtesy of the Burke's Garden Community Association scrapbook.)

Still standing today, this house was built by Sam Heninger in 1830 and later became the residence of Lula May Dutton. The home is among the oldest in the Garden. (Courtesy of Betty Vanhoozier.)

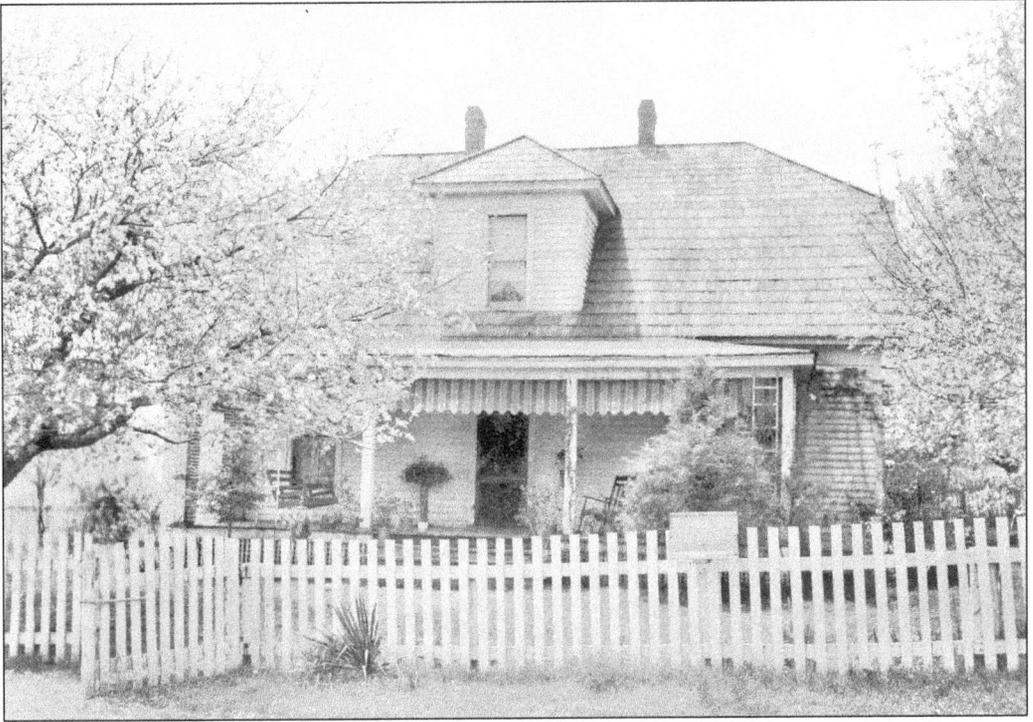

The Tilden Short home was a pretty scene around 1938, with the property's blooming trees and flowers. Burke's Gardeners encounter a short growing season due to the valley's elevation. Nevertheless, they also enjoy a variety of colorful flowers and shrubs during the late spring. (Courtesy of Bobby Short.)

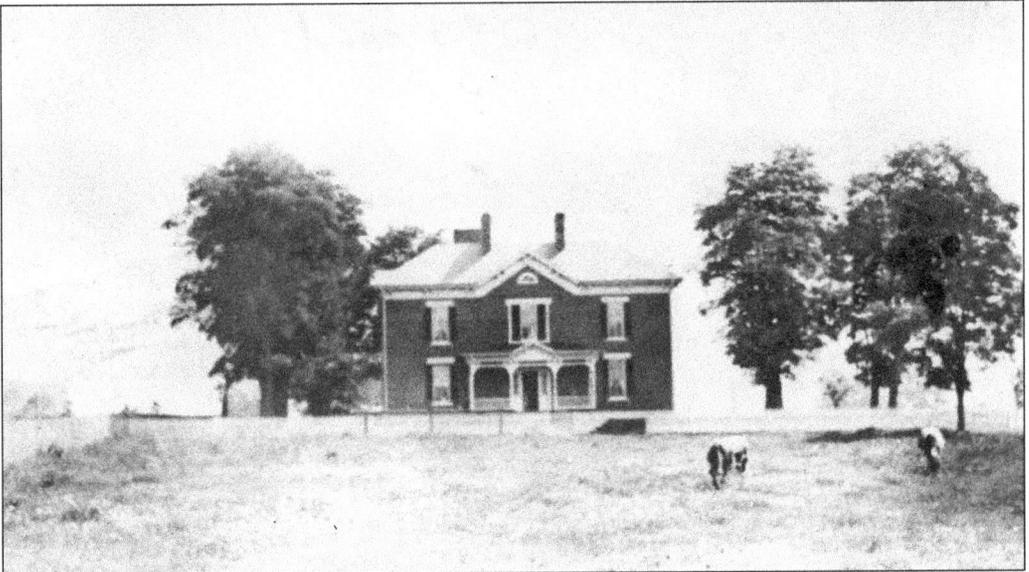

The original 1890 home of James Robert and Josephine Brenda Groseclose Meek is pictured before the beautiful tower addition was built. The Meeks used carbide lights. The first house on the site was made of logs. (Courtesy of Ben Lineberry.)

The Henry Branstetter Groseclose and Mary Elizabeth Kelly Groseclose home was an early Burke's Garden house where Meek, Kelly, and Groseclose cousins visited their grandparents on warm summer days. (Courtesy of Ben Lineberry.)

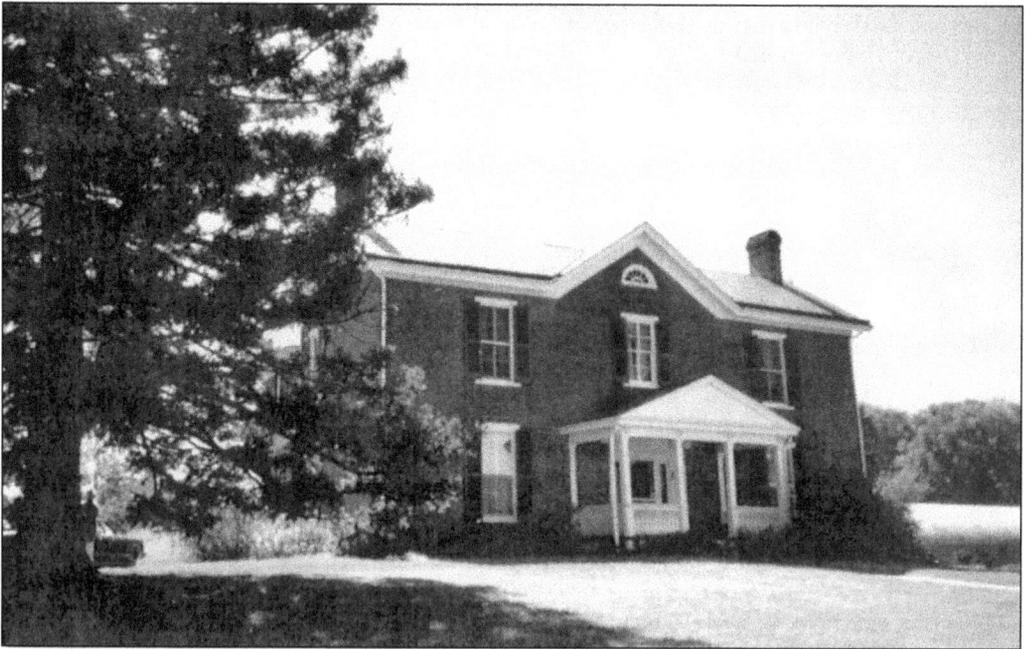

The home of Jim and Louise Hoge (aptly called Lovely View by its first residents) was completed in 1883 by Jim's grandfather James Meek Hoge. Its 260,000 bricks were handmade on the banks of Blue Spring Creek. The house stands on land first granted to James Patton in 1749. (Courtesy of Jim and Louise Hoge.)

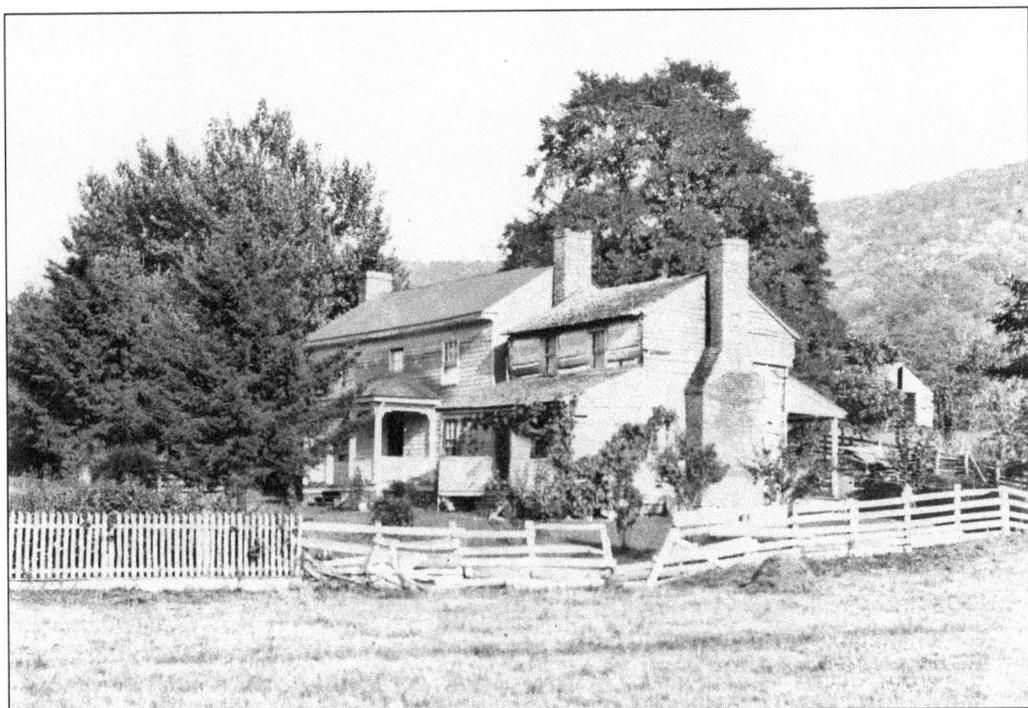

The Charles H. Greever home, pictured here in the 1800s, adjoined the Philip Greever house. Both were torn down in the late 20th century. (Courtesy of A. S. Greever.)

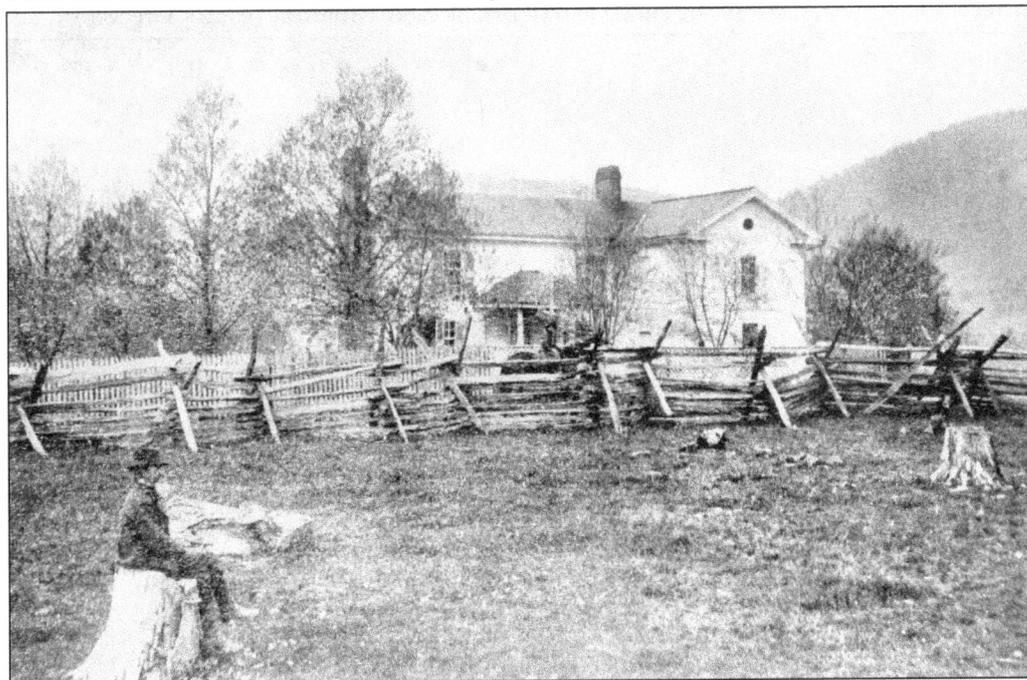

This image provides another perspective of the Groseclose home, located in Little Town on Route 623, about 200 yards south of Litz Lane. H. B. Groseclose rests on the stump in front of the house. (Courtesy of Ben Lineberry.)

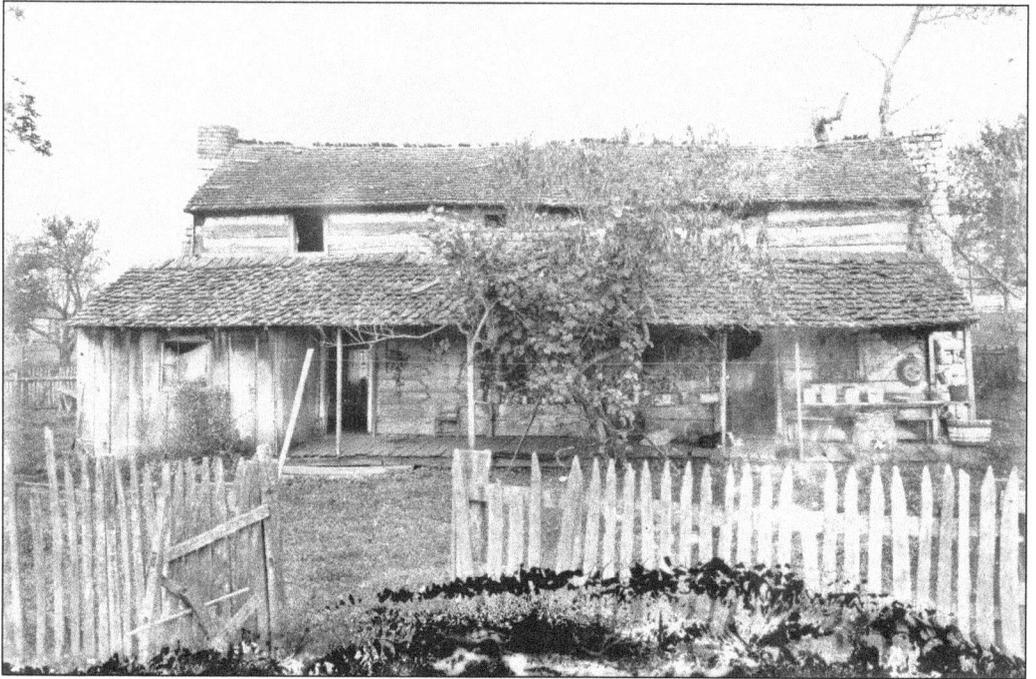

The Nancy Ritter home was constructed of logs in the early 1800s. When the first Ritters came to Burke's Garden from Wytheville, no roads had been built into the southwest side. They had to unhitch their wagons and, with ropes, chains, and hickory logs, ease the wagons down the mountain. After the Civil War, many of the family moved to Colorado. (Courtesy of A. S. Greever.)

The John Dudley Greever home was built after the Civil War, likely about 1870, and later burned. In this image, the front porch is lined with plants, and a picket fence and gate greet visitors. (Courtesy of Faye Cuddy.)

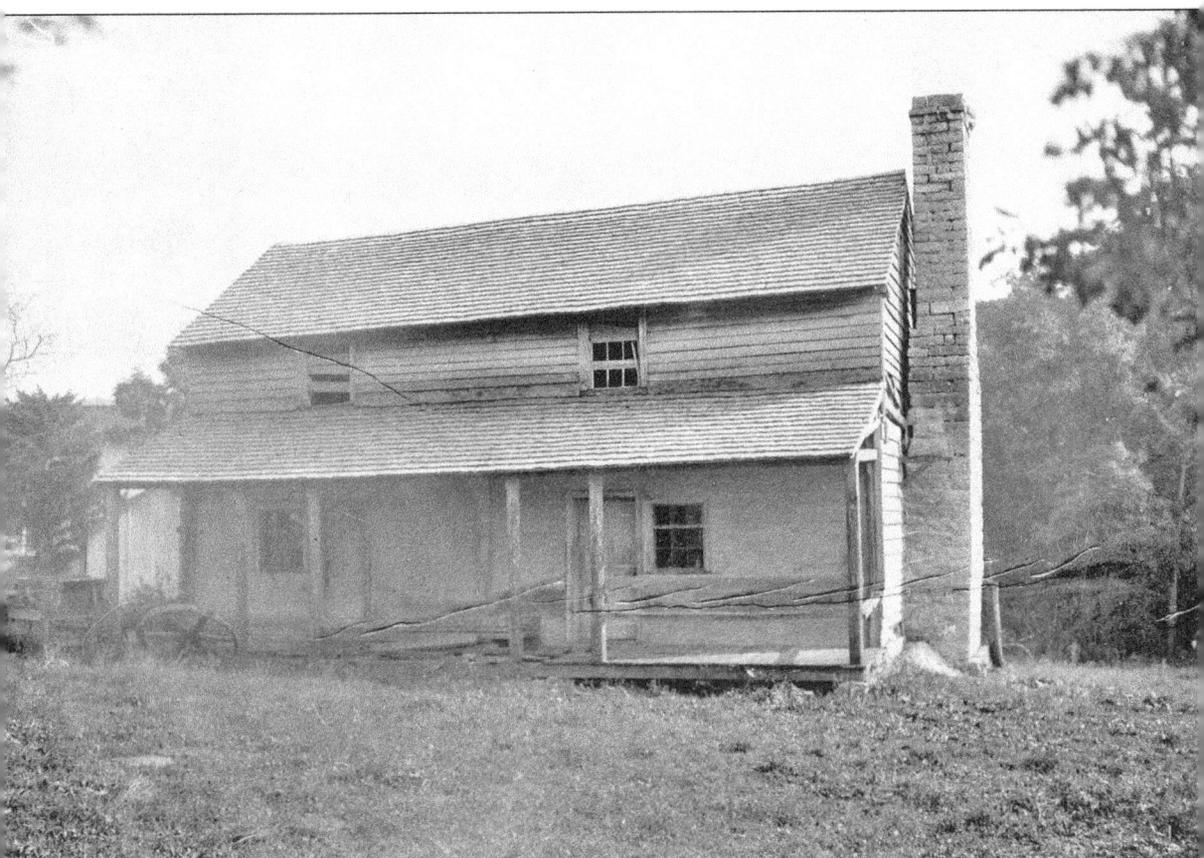

One of the first to settle in Burke's Garden, the Spracher family built the Stephen Spracher home in the early 1800s. Following the Civil War, Mary Spracher married John D. Greever. (Courtesy of A. S. Greever.)

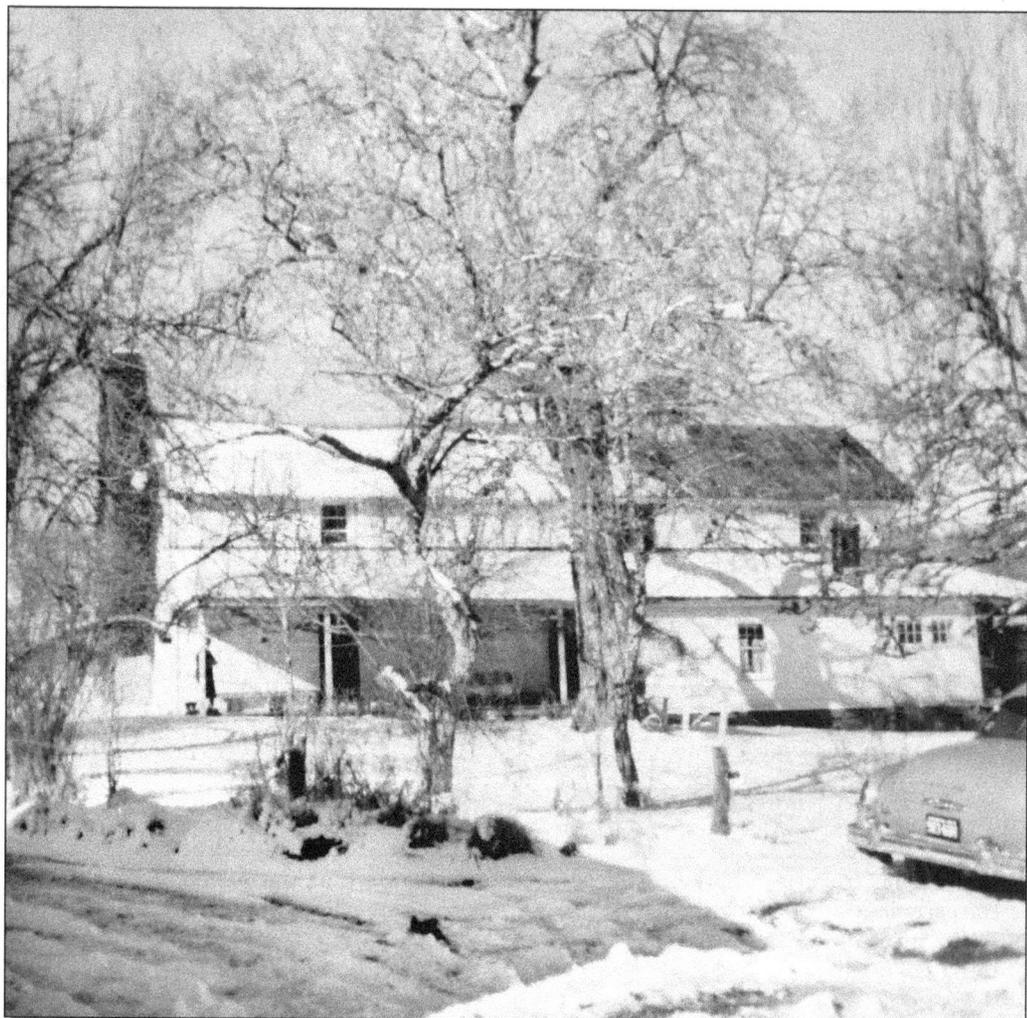

The Ira and Ethel Boling home is remembered by relatives and friends for its big cherry, pear, and peach trees and the Sunday dinners with food fit for royalty. (Courtesy Juanita Boling.)

The home of the Lee McMeans family is among the oldest Burke's Garden dwellings, but its exact date of construction is unknown. The surname beginning "Mc" is typical of the many early settlers in the area who came from Scotland and Ireland and lived in the mountains. (Courtesy of Marie Sheets.)

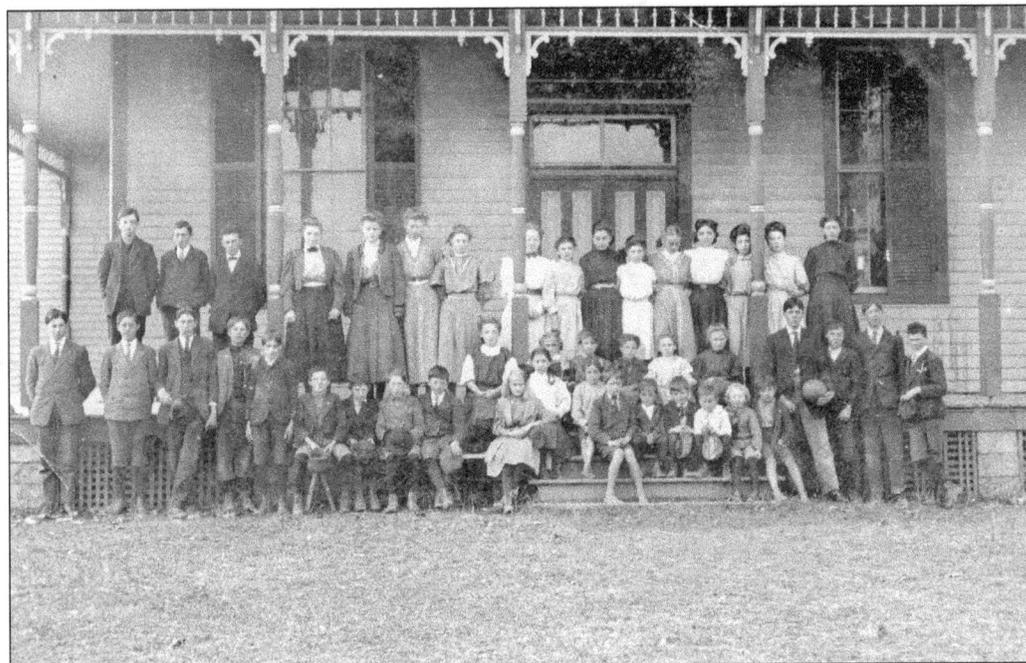

The Burke's Garden Academy, during its heyday, had students from first grade through high school. It was in operation from 1895 to 1910. (Courtesy of A. S. Greever.)

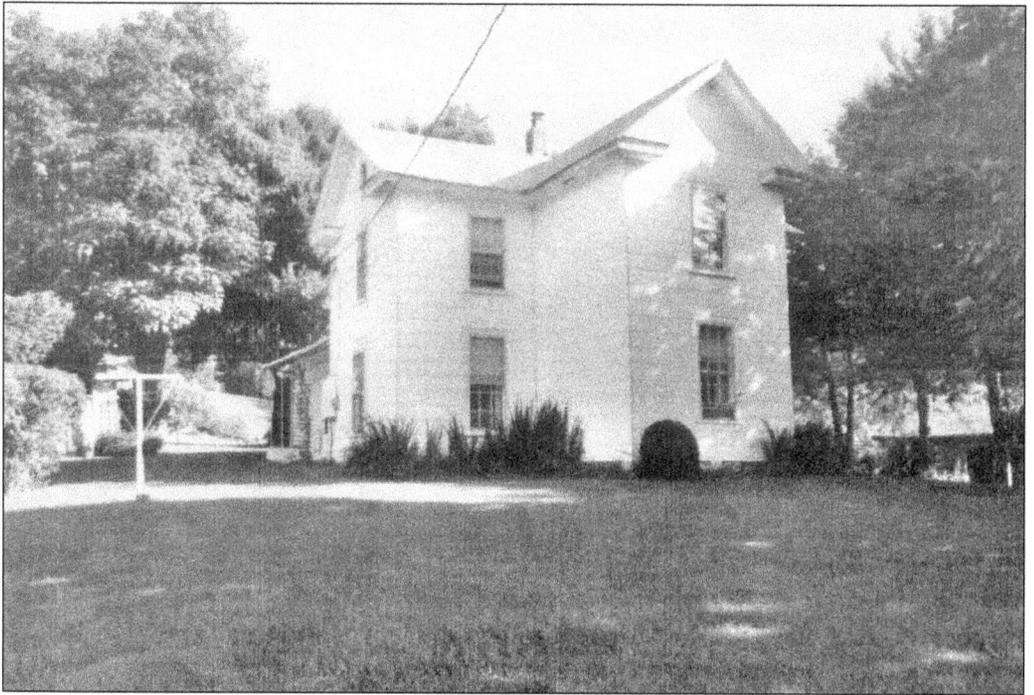

Located at the southern tip of Burke's Garden, the Repass home was built by the Wynn family in the early 1900s. Early landowner Marvin Eagle purchased the property and later sold it to a Mr. Compton. In the late 1940s, Frank E. Repass bought the house and 46 acres, which remain in the Repass family today. (Courtesy of Betty R. Felty for the Repass family.)

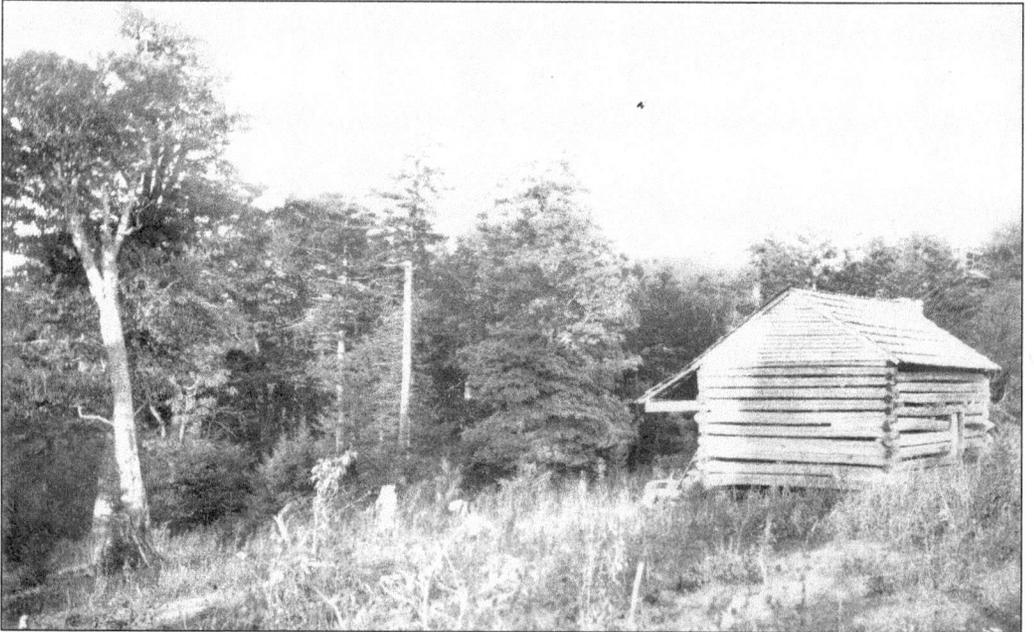

The Moss cabin used to stand on Beartown. At one time, several families lived on the mountain and many others had hunting cabins there. Today most of the structures are gone, as no people permanently reside on the mountain. (Courtesy of A. S. Greever.)

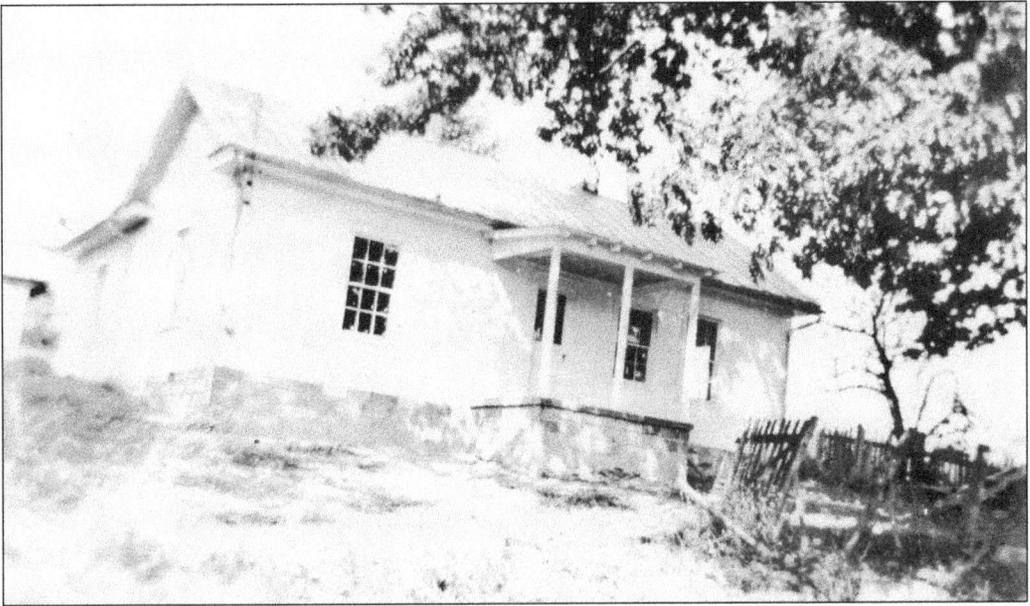

Many smaller homes dotted the Burke's Garden landscape as large landowners brought tenant farmers to the area to work on their expansive farms. One such house was on the Alex L. Meek farm. In this home, John Henry Mullins Sr. and Mary Katherine Peak Mullins raised a family of one girl and four boys. For decades, there were two or three times as many long-term tenant families as there were landowning families in Burke's Garden. Although the population of the valley is now less than 300, in the late 1800s and early 1900s it reached nearly 2,000. (Courtesy of Marvin Meek.)

The front yard of the H. H. and Mildred Lineberry home is pictured in April 1958. The James Robert Meek home can be seen in the distance. Late spring snows are not unusual in the high elevation of the "Garden Spot." (Courtesy of Ben Lineberry.)

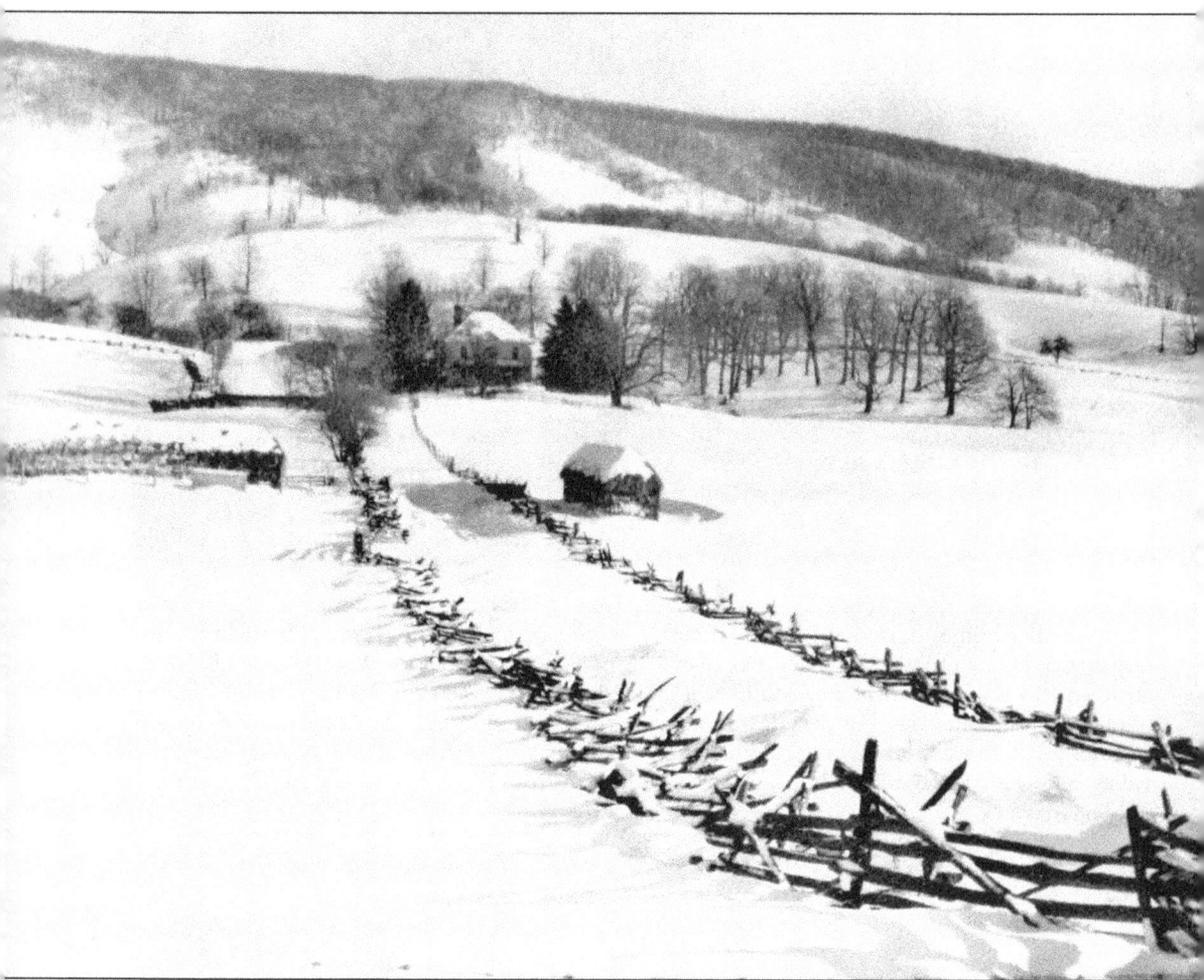

The John and Mamie (Davis) Fox home, with its picturesque lane lined with stake and rider fencing, is often photographed. In 1909, it was constructed close to David Spangler Fox's log cabin. Edward L. and Gracie Bowman purchased the farm and house in 1941. The property is now owned by Henry R. Glenn. Methias Fox and his wife, Barbary, the daughter of Peter Spangler, first bought property in Burke's Garden in 1804. (Courtesy of Elizabeth Ann Fox Martin.)

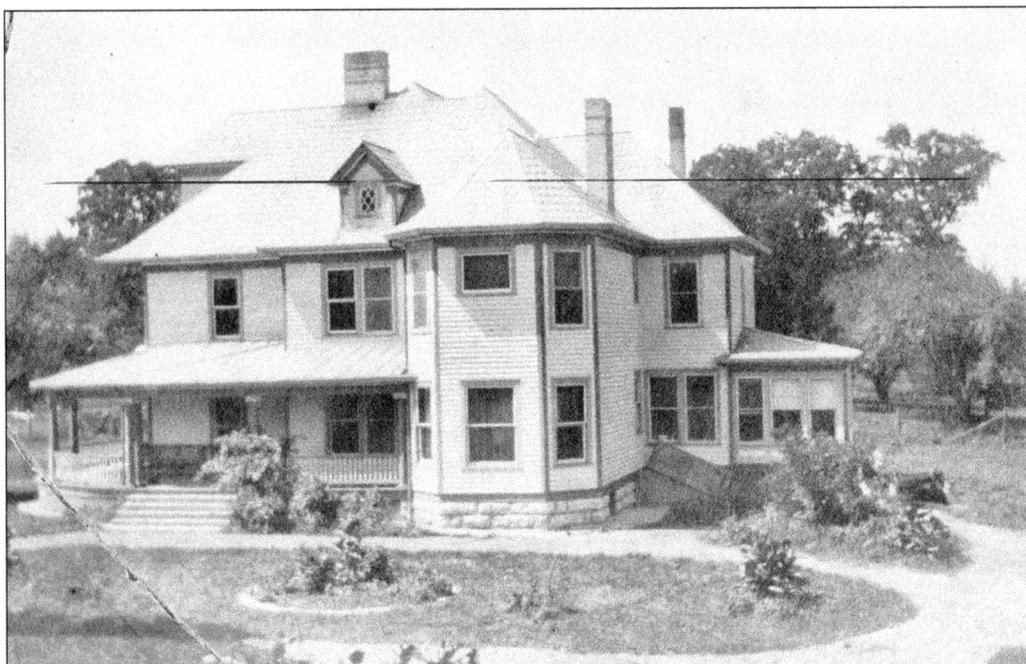

The Lawson-Moss house was built by the well-known Duncan Brothers of Bland. From this large farm, R. M. Lawson shipped the first heavy grass-fattened steers to England about 1850, beginning the profitable export steer business, which lasted until the early 1900s. (Courtesy of the Moss scrapbook.)

Alexander and Margaret C. Fox Mahood lived here in Burke's Garden before moving to Natural Bridge. The Mahoods are listed among the first landowners in the area. (Courtesy of Mary K. Lotts.)

The Clint and Hattie Moss house was constructed near the center of Burke's Garden in 1904. The Moss family played a prominent role in much of the history of the community. (Courtesy of J. C. McCann.)

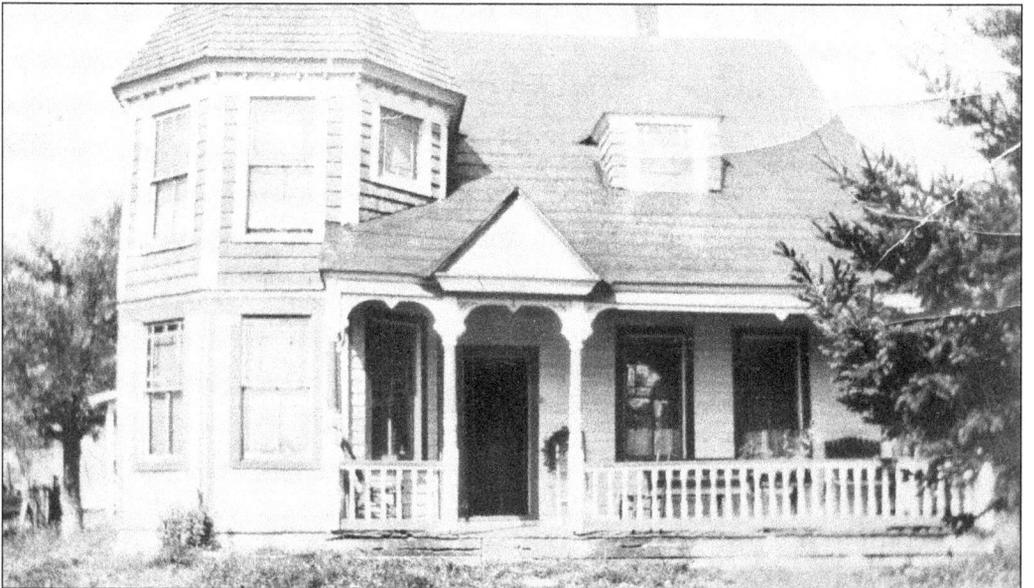
Situated in the Little Town section of Burke's Garden, the Hoback home was built in the late 1800s and burned in 1932. (Courtesy of Mary Lambert.)

Five

CULTURE AND
TRADITIONS

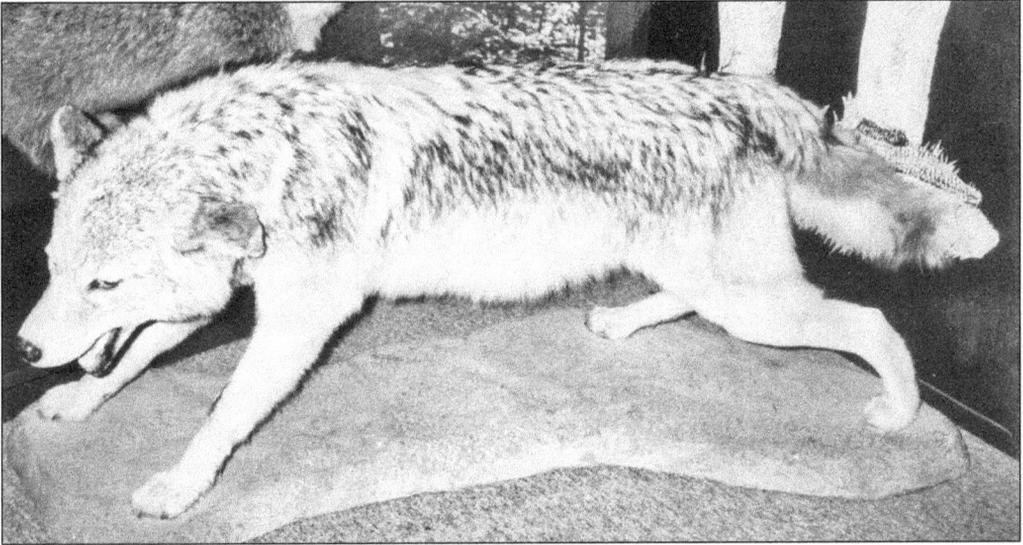

"The Varmint," Burke's Garden's famous coyote, was killed on Valentine's Day in 1953 after it had destroyed at least 410 sheep, approximately $25,000 in value. Several local hunters, state trappers, and even a federal worker tried to trap the animal. Finally the Tazewell County Board of Supervisors commissioned two of the best-known big-game hunters, Clell and Dale Lee of Tombstone, Arizona, to take down the culprit. Clell was available, and he soon identified the Varmint as a coyote. Accompanied by farmers, hunters, and even the county sheriff, Clell and his hybrid "Lee Strain" hound dogs soon found the scent. When news of the kill was broadcast, approximately 3,000 people crossed the mountains to see the Varmint as it hung in the schoolyard. Later more then 7,500 people came to view the dead animal hanging from a tree at the Tazewell County Court House. It was nearly 4.5 feet long with 1-inch fangs. The stuffed coyote is now on display at the Historic Crab Orchard Museum. (Courtesy of the Historic Crab Orchard Museum.)

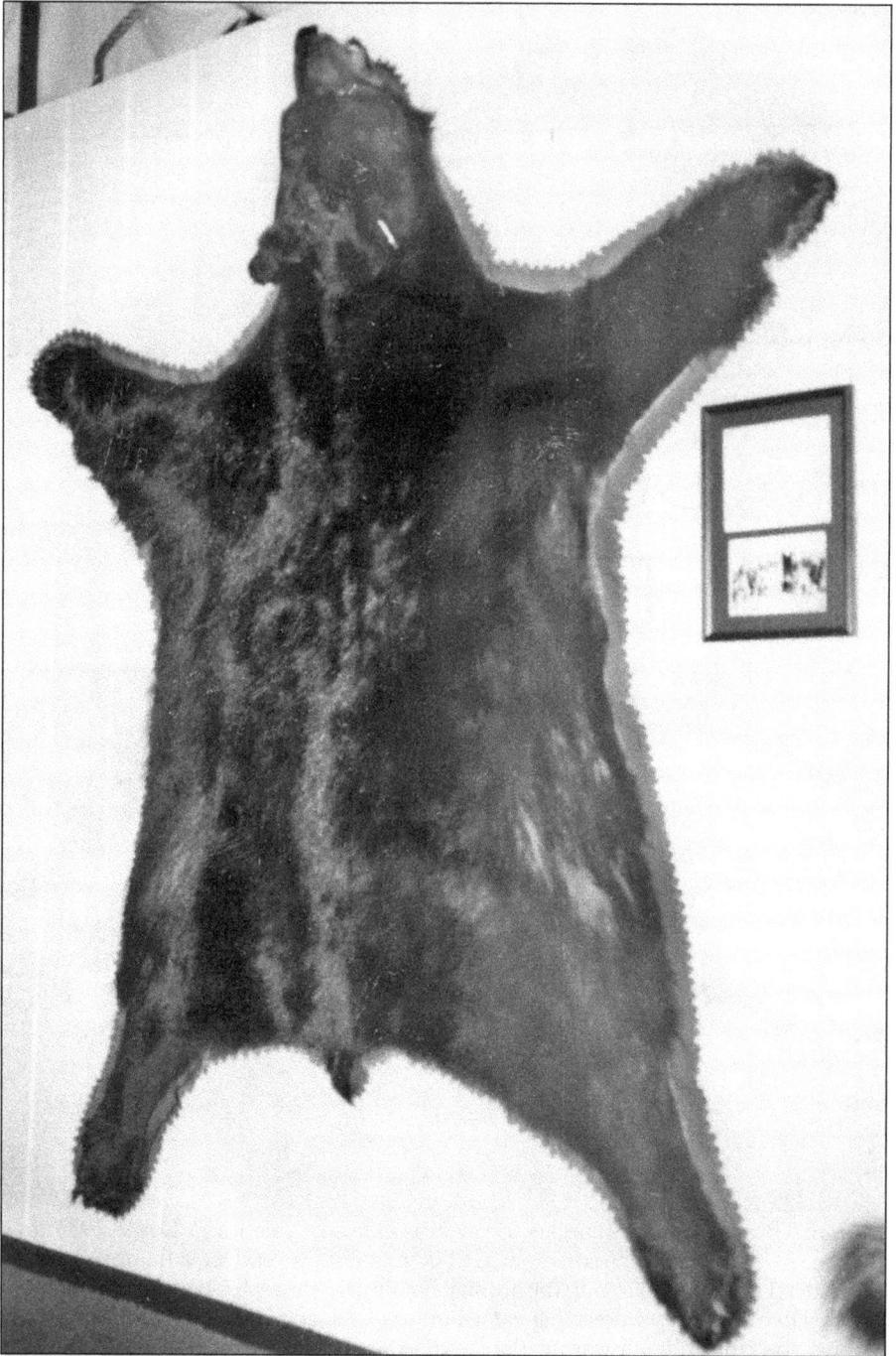

Bears still roam the mountains around Burke's Garden, and as a result, the Beartown area was named for those that have often killed the area's prized sheep. The most famous of these animals was the 500-pound "Old Hitler," which was killed in 1940 after ravaging sheep for 25 weeks. The size of this bear can be seen at the Historic Crab Orchard Museum. Beartown is the tallest point in Tazewell County and the third highest mountain in Virginia, at 4,710 feet. (Courtesy of the Historic Crab Orchard Museum.)

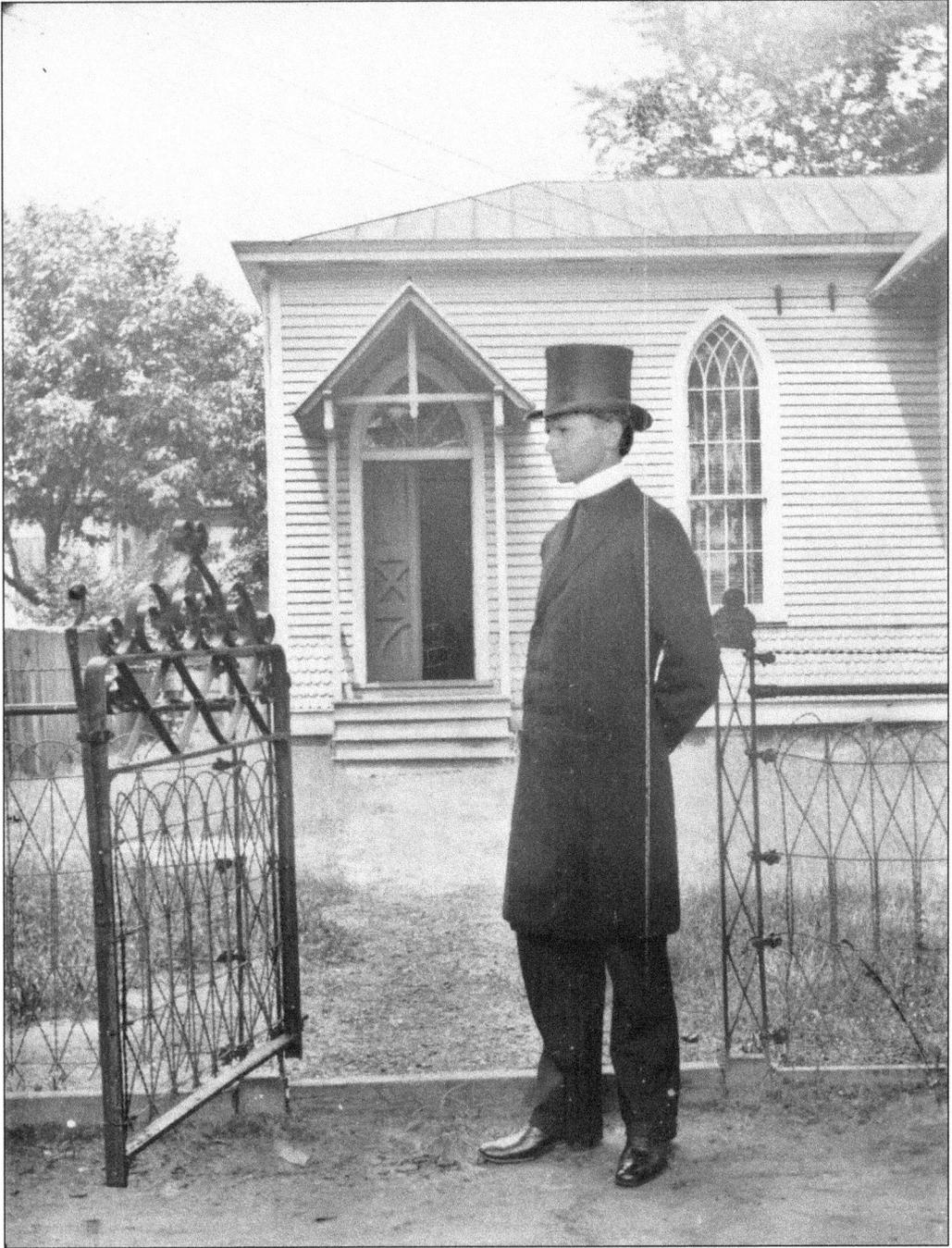

The Reverend Walton Harlow Greever, a Burke's Garden native, became the national leader of the Lutheran Church, following in the footsteps of his Burke's Garden family, who were leaders in the local Lutheran denomination. Dr. Greever served as secretary of the United Lutheran Church in America. (Courtesy of A. S. Greever.)

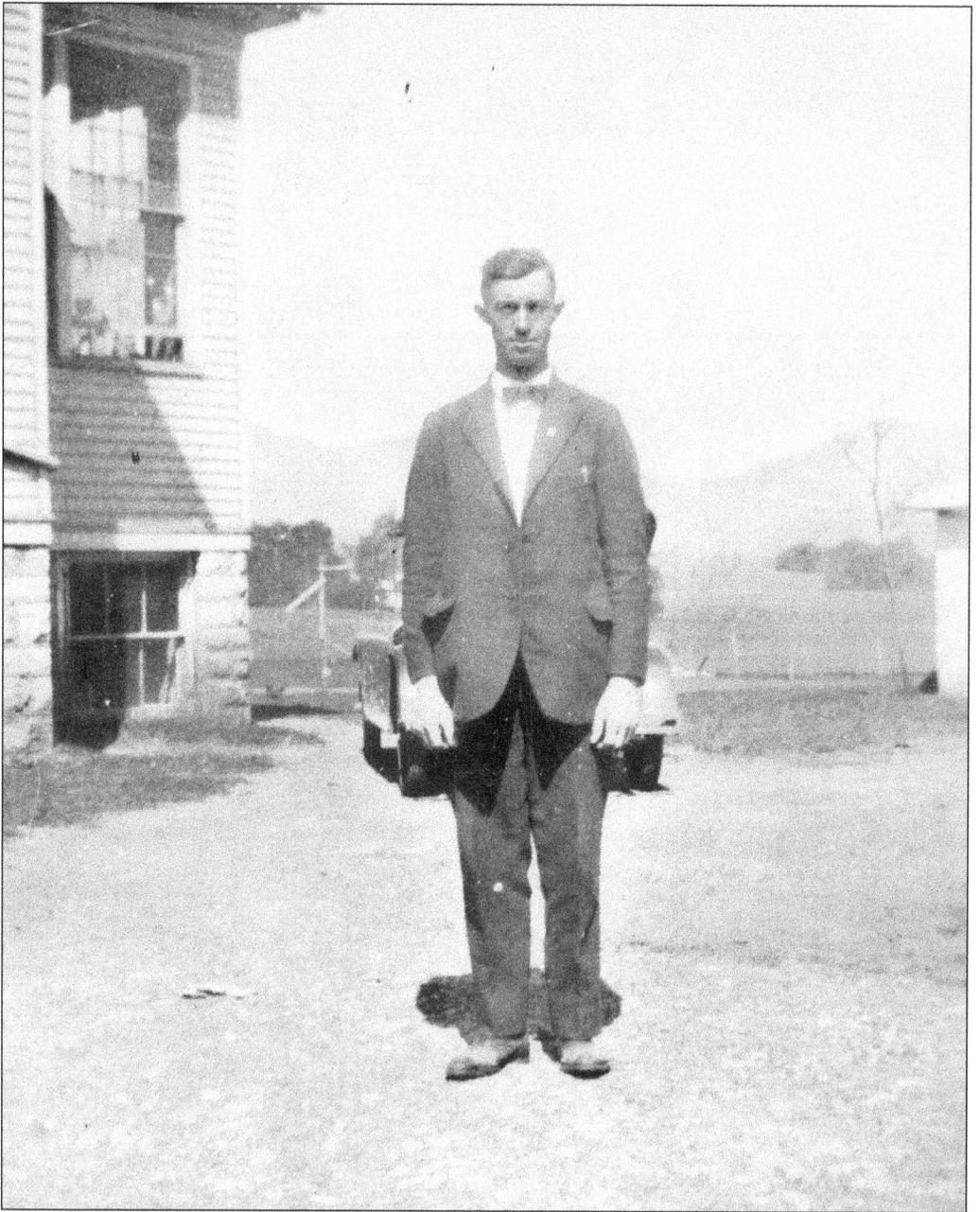

Thomas Perry Goodwin, who operated the Goodwin Store for many years, stands in front of the Burke's Garden High School in 1927. The Tazewell County School Board relinquished its ownership of the school in 2002. (Courtesy of Ben Lineberry.)

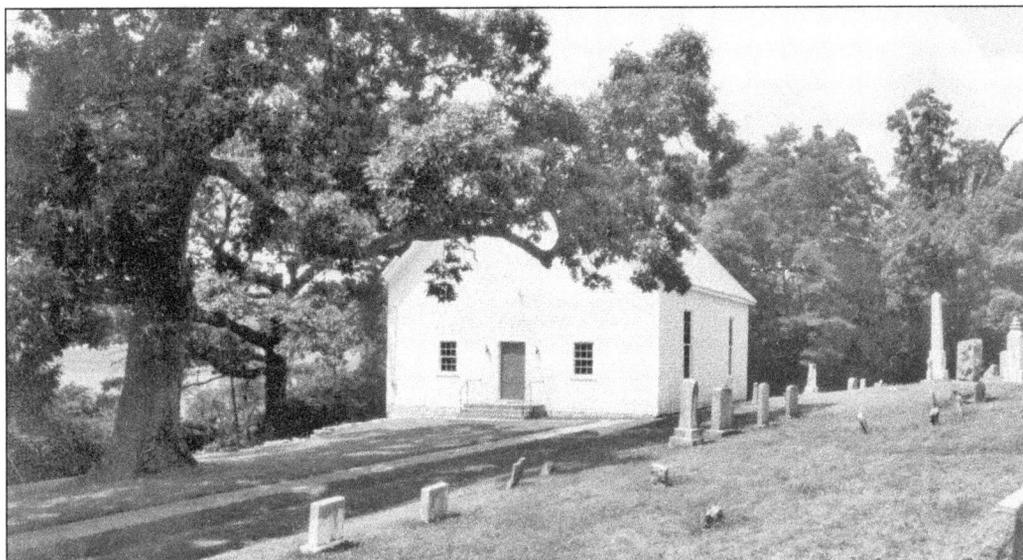

The Burke's Garden Lutheran Church (sometimes called Central Church) was constructed in 1880, the third building in the community erected by Lutheran settlers. The first Lutheran congregation was organized in 1828. Both the cemetery and church are listed on the Virginia Historic Landmark Registry. The old German gravestones in the cemetery are made of sandstone and are beautifully decorated with flowers, hearts, stars, trees, and other ornaments. The oldest grave marks the resting place of a Lutheran pastor, Rev. Christian Bergmann, who died in 1827. (Courtesy of Colleen Cox.)

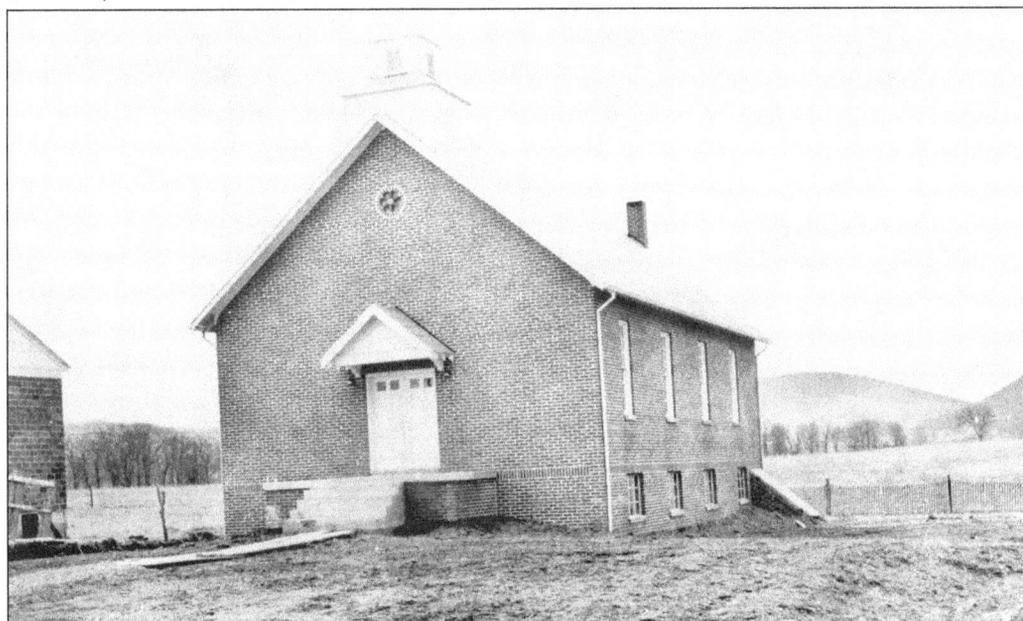

The Methodists have been among Burke's Garden residents since 1826, when a log structure was built for a "House of Religious Worship." Other buildings have been used through the years, but the present church, adjacent to the school, was completed in 1951. Despite changes in the area's population over the past two centuries, the Methodist congregation has remained a steady influence in the community. (Courtesy of the Burke's Garden Community Association scrapbook.)

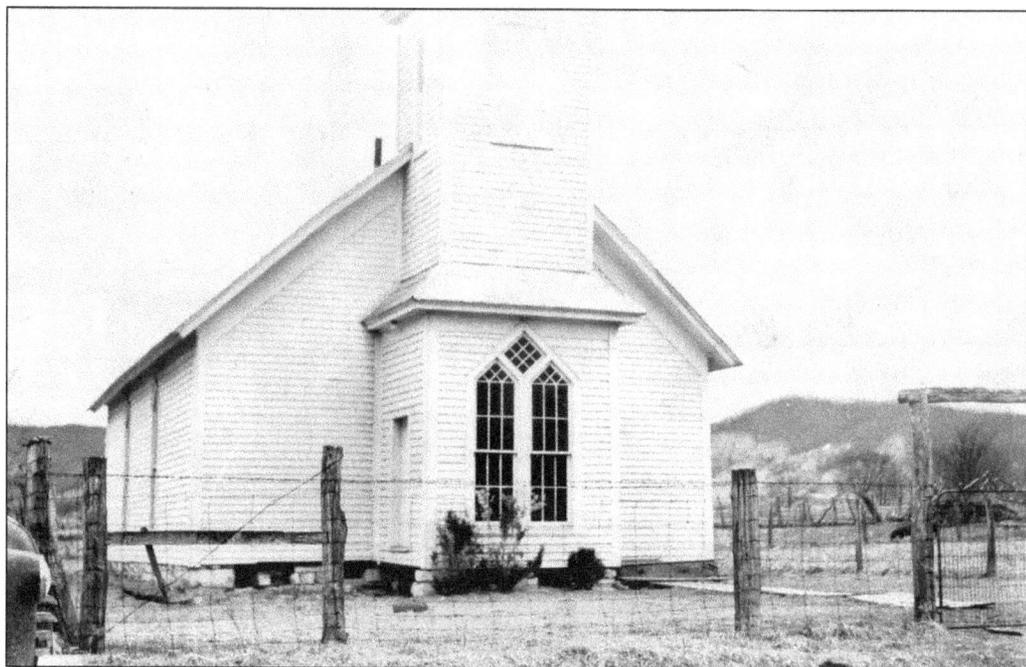

The Burke's Garden Presbyterian Church started with a small group of interested members in 1828 but was not formally organized until after 1838, when seven charter members are listed. In 1876, records note renewed interest in the congregation. At the same time, T. E. Howell was elected ruling elder, a post he held for 55 years. The church closed in 1971. (Courtesy of the Burke's Garden Community Association scrapbook.)

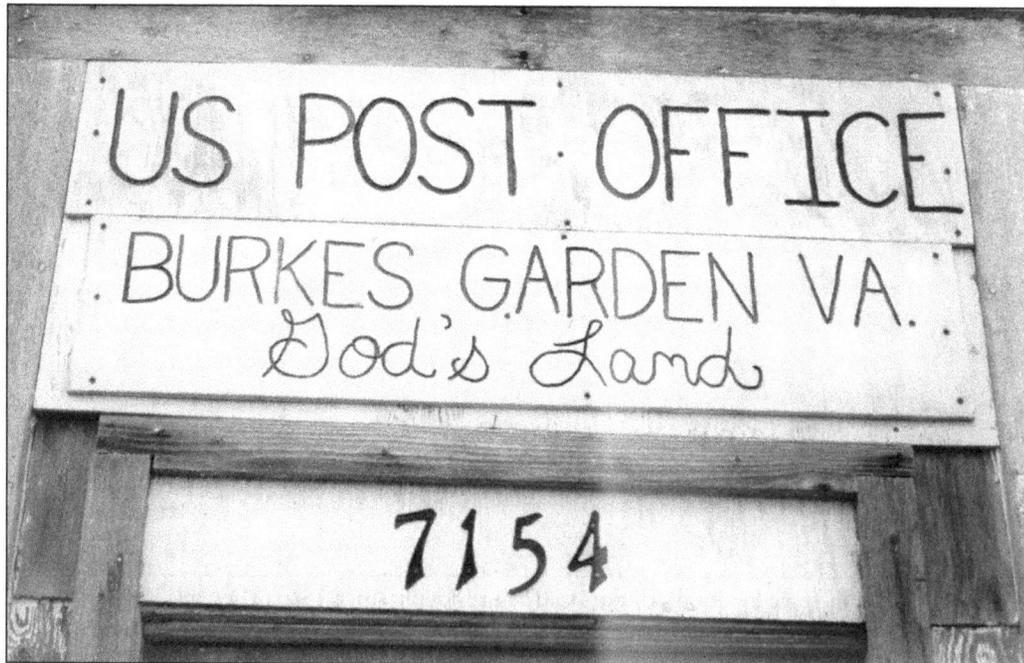

The Burke's Garden Post Office, one of the smallest in the nation, is proud to proclaim the location of "God's Land." (Courtesy of Mullins files.)

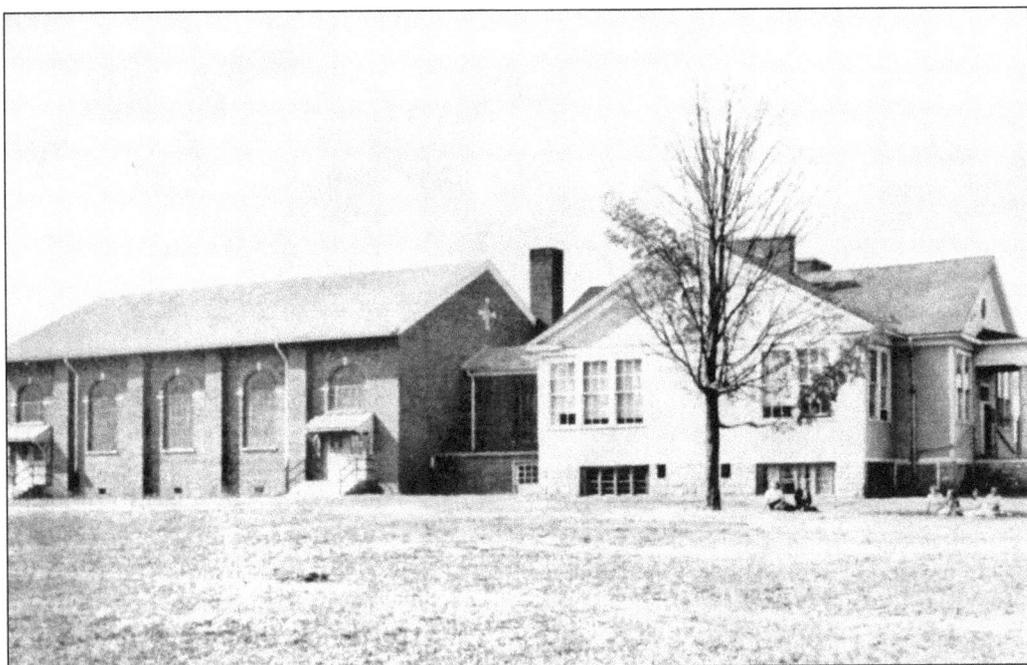

Built around 1910, the Burke's Garden Public School served the community until 1960, when high school students were sent to Tazewell High. The elementary school was closed in 1971, when the younger students were also sent to Tazewell. The building is now used as a community center. (Courtesy of Alex Chamberlain and the *Garden Gate*.)

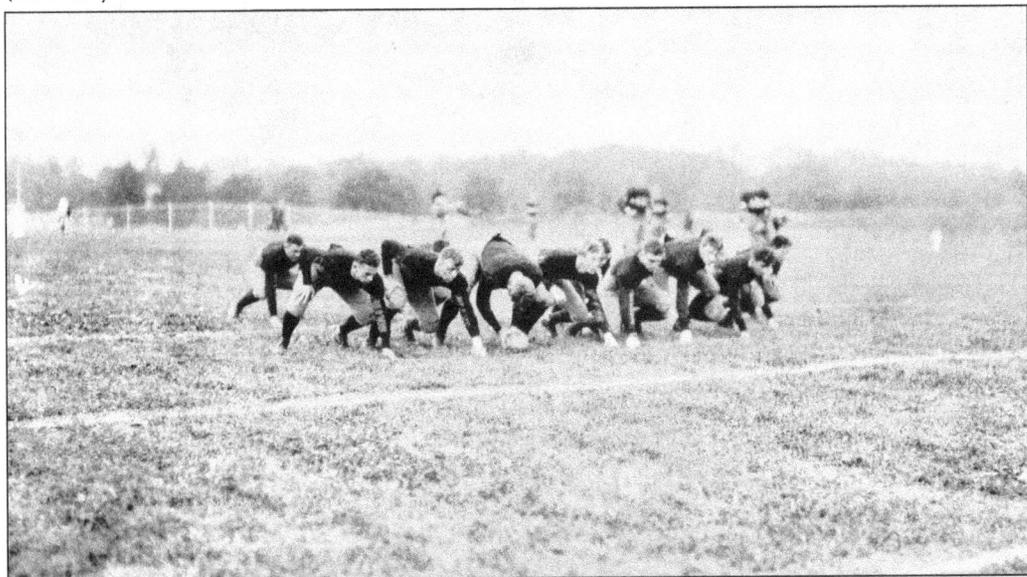

Burke's Garden fielded its own football team in the early days. In this photograph, members practice in the field beside the Burke's Garden School in 1935. The team consisted of Gurdes Young, Bud Meek, Ralph Lotito, Bill Rosenbaum, quarterback Edgar Greever, Joe Frank Meek, John J. Meek, John Nicewander, Bill Altizer, and Ed Harrison. The Wildcats played several area schools including Tazewell. During the 1935 season, the Burke's Garden 11 lost to the Tazewell Bulldogs by a score of 19-6. (Courtesy of Alex Chamberlain and the *Garden Gate*.)

113

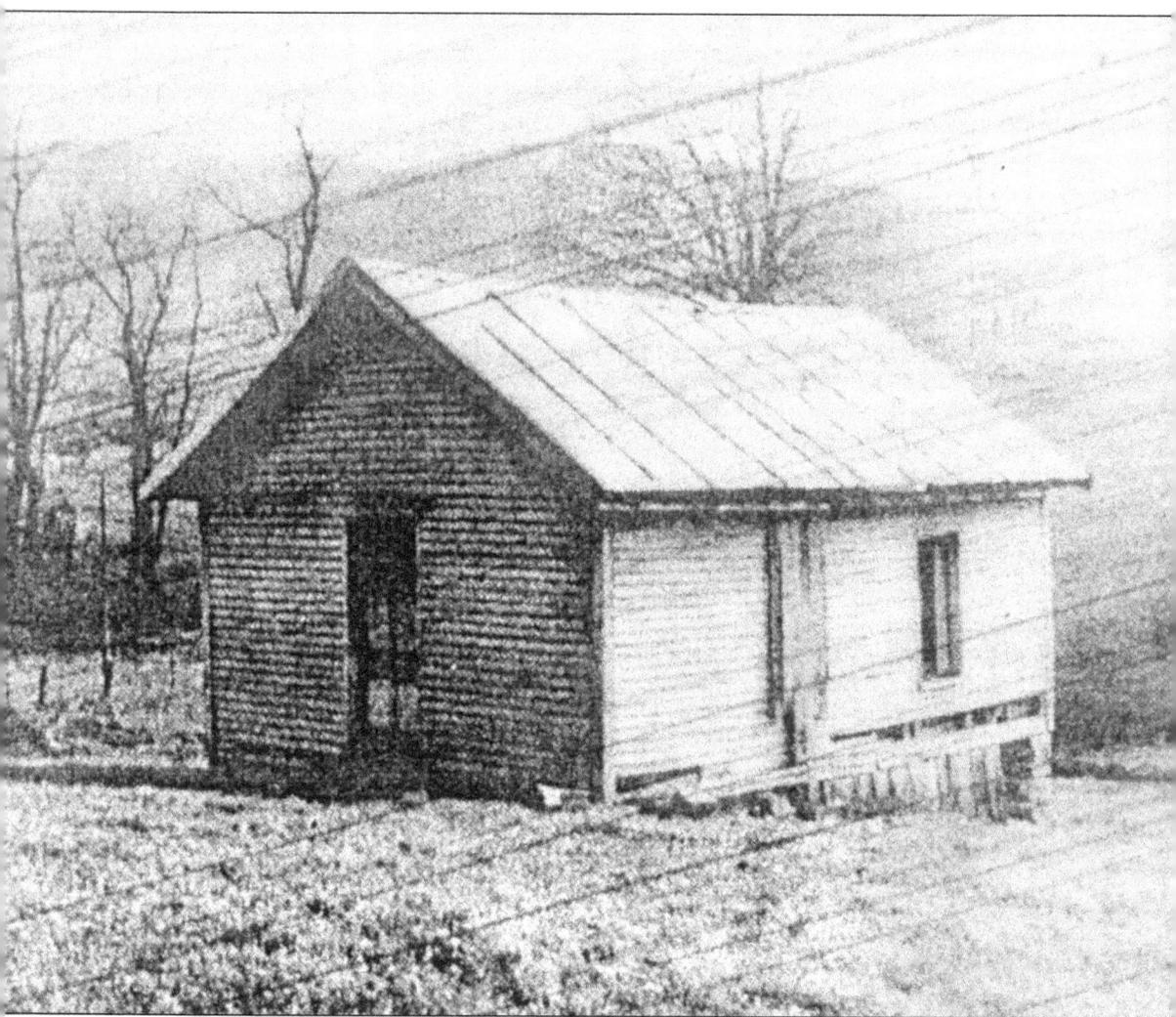

The Rhudy School was one of seven community schools usually operated by different Burke's Garden neighborhood families. In March 1908, there was a program at the Rhudy School with these students taking part: Lula Davis, Billy Brown, Tate Felty, Fred Felty, Robert Mahood, Earl Mahood, Mattie Margie Mahood, Mattie Felty, Nannie Heninger, Sarah Davis, Dewey Short, Willie Heninger, Robert Mahood, Allen Brown, Nita Mahood, Willie Henry, Luther Wynn, Ruth Davis, Walter Rhudy, Bertha Burkett, Irene Brown, Joe Kitts, Luther Wynn, Frank Kitts, Jesse Kitts, Allene Brown, and Irene Brown. (Courtesy of Margaret C. Rhudy.)

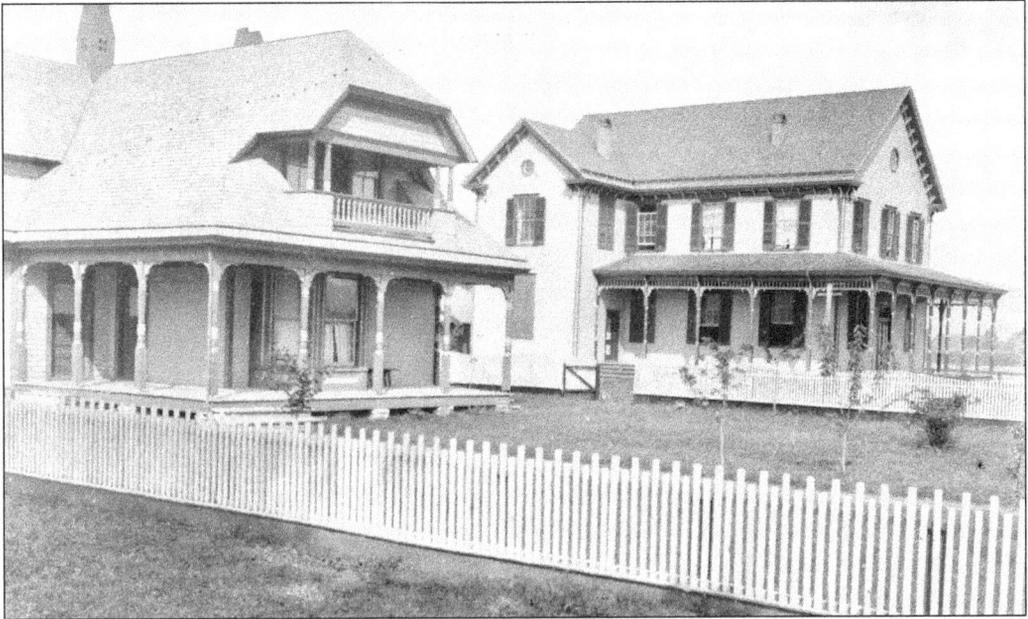

Burke's Garden was reportedly the best-educated rural community in the state. The Greever cottage and the Burke's Garden Academy, seen here, are well remembered. The academy, an outstanding school that prepared students for college and beyond, operated from 1895 to 1910. According to Ida Greever's *Sketches of Burke's Garden*, it included "the Upper Branches, Intermediate Department, or upper section of public schools, the Primary Department of the first four grades of public schools and a Music Department." (Courtesy of A. S. Greever.)

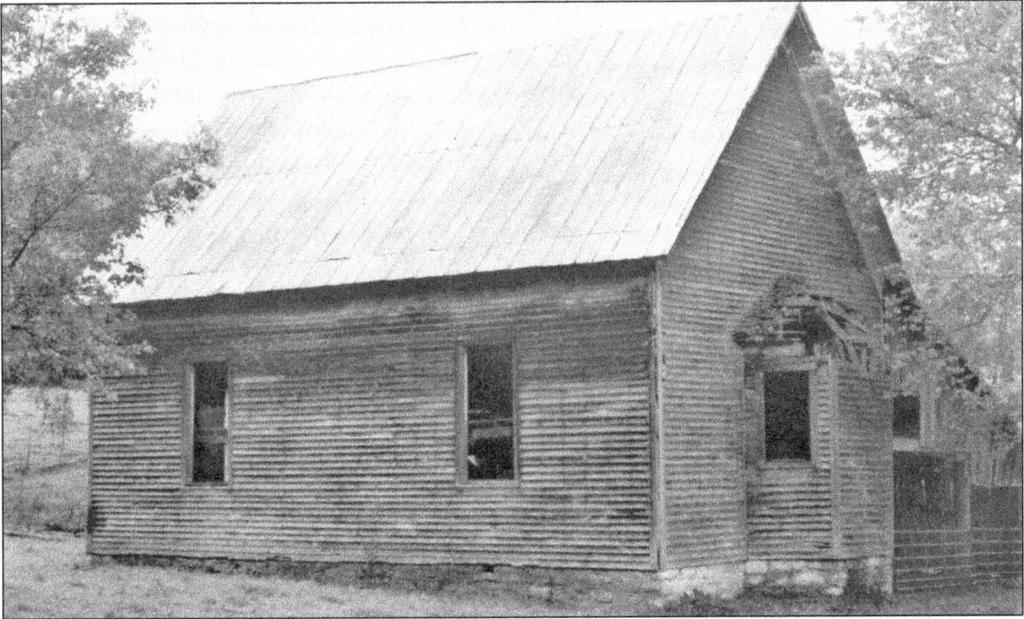

The Glade Church and School were once active places for Burke's Gardeners, who had a choice of attending seven different community schools and several churches in the early 1900s. The area around this site is still known as the Glade, with the frame church structure still standing. The Glade School, though, burned to the ground in 1920. (Courtesy of the Mullins files.)

The maple sugar at the Bob Davis farm was known far and wide for its excellence. Shown here are his sugar house and some of the trees that produced the fine product. (Courtesy of Elizabeth Bowman.)

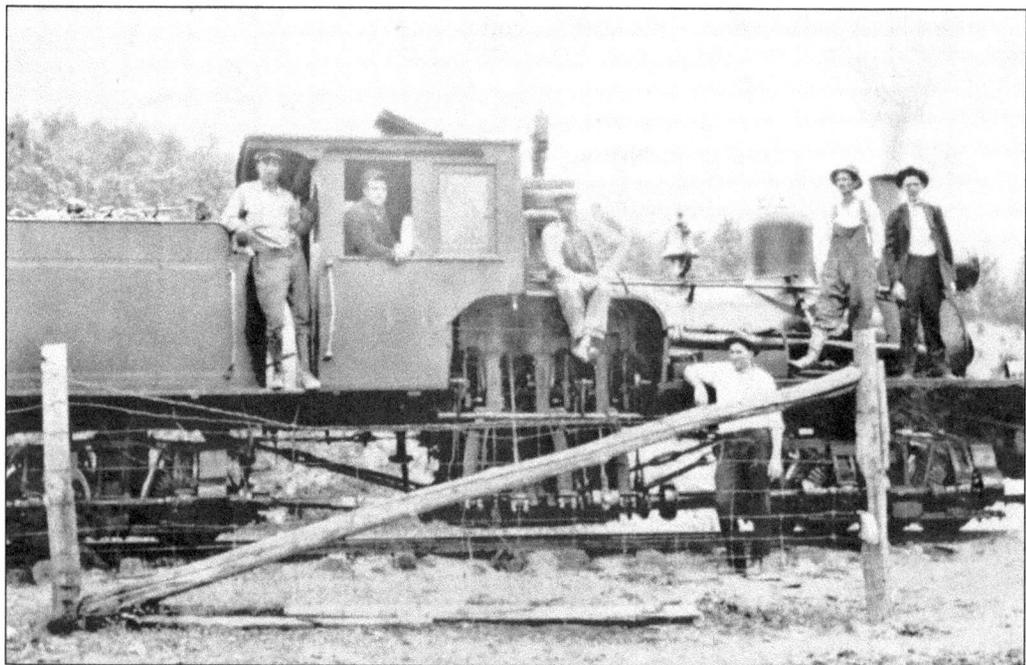

The dinky railroad came into the forest land surrounding Burke's Garden in the 1930s and 1940s, when vast timbering operations were underway in Bland County and the Beartown area. The workmen traveled on the "dinky train," and their families stayed in nearby communities or sometimes lived in the railroad cars. (Courtesy of Georgia Havens.)

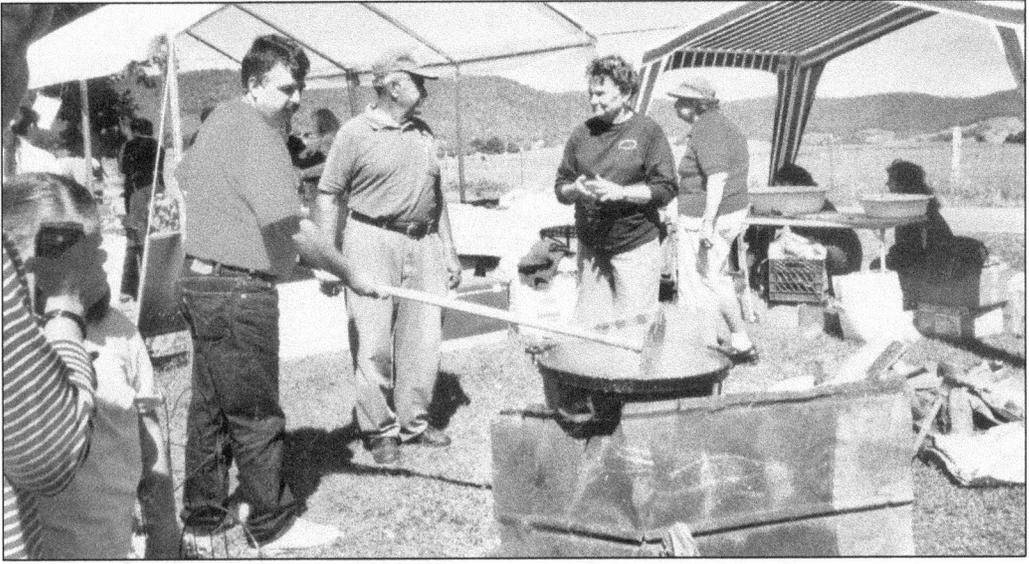

The Burke's Garden Fall Festival has been sponsored by the Burke's Garden Community Association on the last Saturday of September each year since 1988. No admission fee is charged, and home owners and farmers from all over the valley participate. Activities include apple juice pressing, sheep shearing, woodworking, quilting, spinning, blacksmithing, and pony and wagon riding. Residents also sell country hams, honey, molasses, apple butter, vegetables, eggs, lamb, chicken, pumpkins, cider, and other home-cooked foods. From left to right, Jeff Holmes, J. L. Rhudy Jr., Janice Gates, and Margaret Rhudy stir off apple butter for the annual celebration. (Courtesy of Margaret Rhudy.)

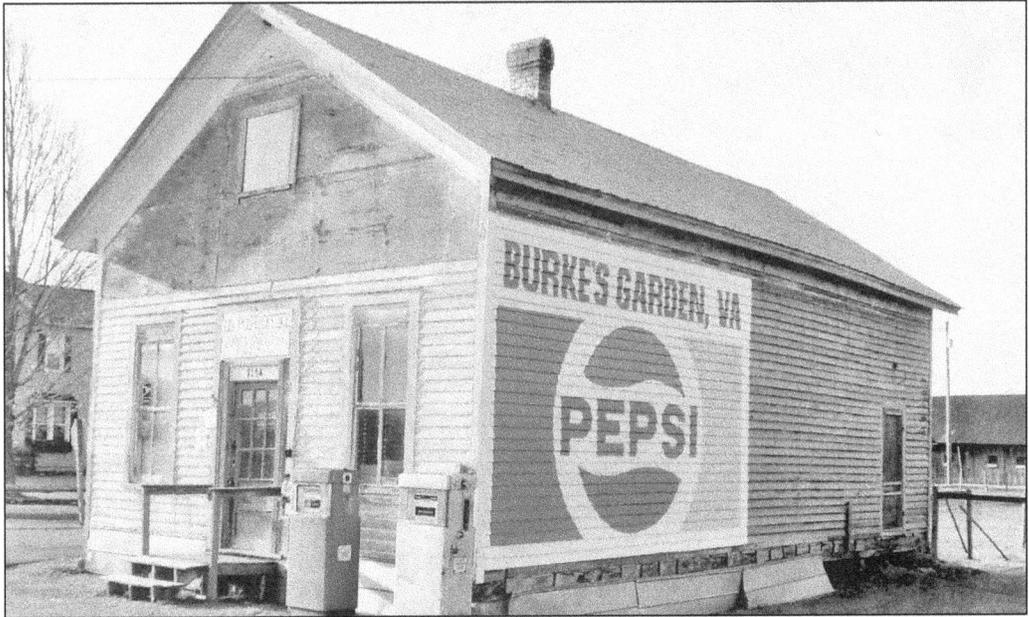

The Burke's Garden Post Office has been an integral part of the community since Peter Litz served as the first postmaster. In the early days, mail came two and sometimes three times a week via horse and rider from Wytheville. The sign in front of the post office proclaims the valley as "God's Land." Colleen Cox has managed the post office since 1972. (Courtesy of G. Michael Alford.)

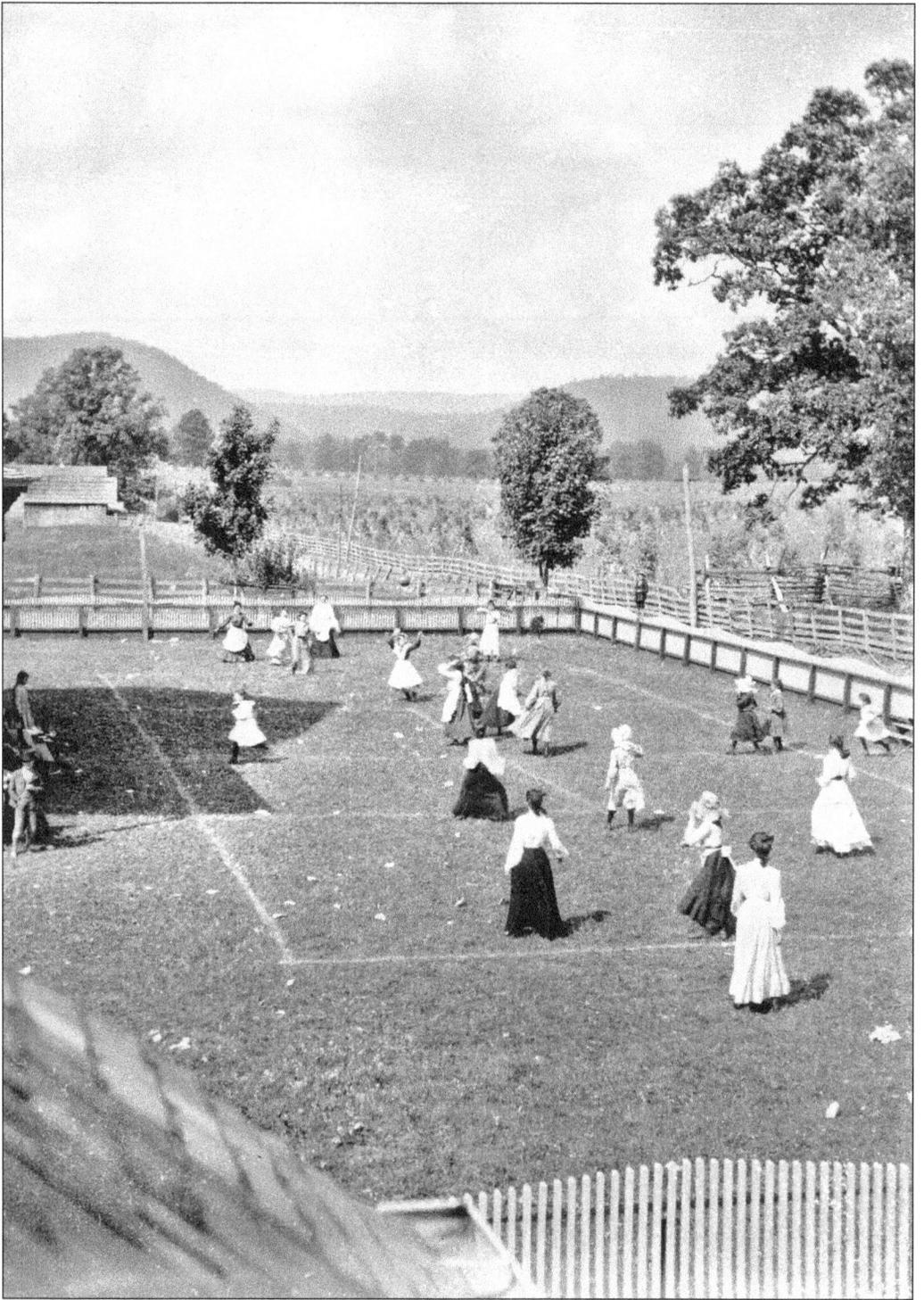

Students play in the yard of the Burke's Garden Academy, likely on a spring day when the hills and valleys were warm and green. This photograph was taken during the high point of the academy's existence, between 1900 and 1910. (Photograph by A. S. Greever.)

The Groseclose Store was located in Little Town at the intersection of Route 623 and Litz Lane. The first telephone from Burke's Garden to Pobst's Jewelry Store in Tazewell was in this store. The Burke's Garden Telephone Exchange was chartered in 1899 with the principal office in the store of Greever and Goodman. J. B. Meek was president, G. W. Moss was vice president and treasurer, and A. G. Greever was secretary. In 1976, it was incorporated as Burke's Garden Telephone Company with the following directors: J. P. Buchanan, E. P. Greever, R. L. Moss, W. H. Moss Jr., W. J. Rhudy, and Dulaney Snapp. The company had the first automatic dial system in Tazewell County. Today it operates with state-of-the-art equipment as the state's smallest private telephone business. The directory consists of half a page listing all the company's subscribers. (Courtesy of Ben Lineberry and E. P. Greever.)

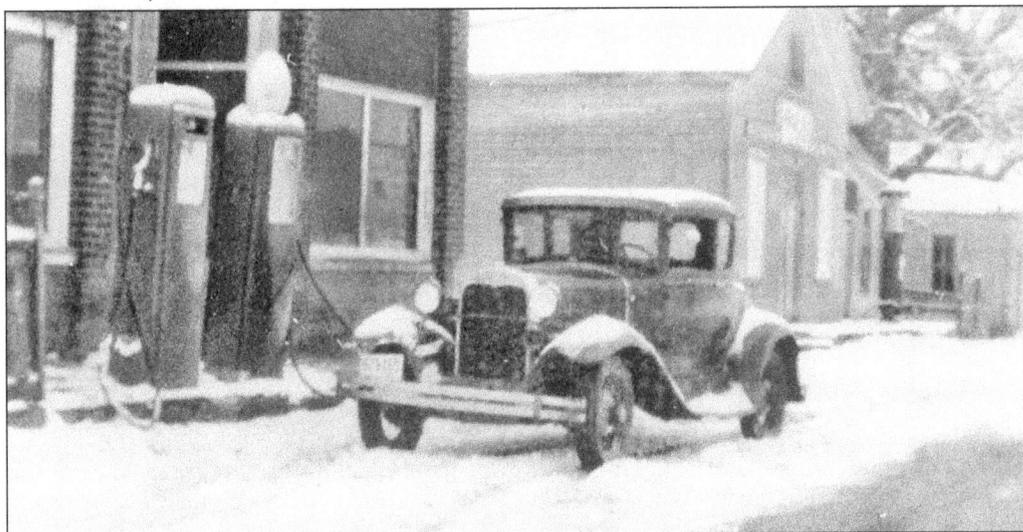

In the early 1900s, the Perry Goodwin Store (left), the Goodman Store (center), and the post office provided residents with most of their daily needs. The car was likely a 1932 Ford V8 Coupe. (Courtesy of Francis Felty Smith.)

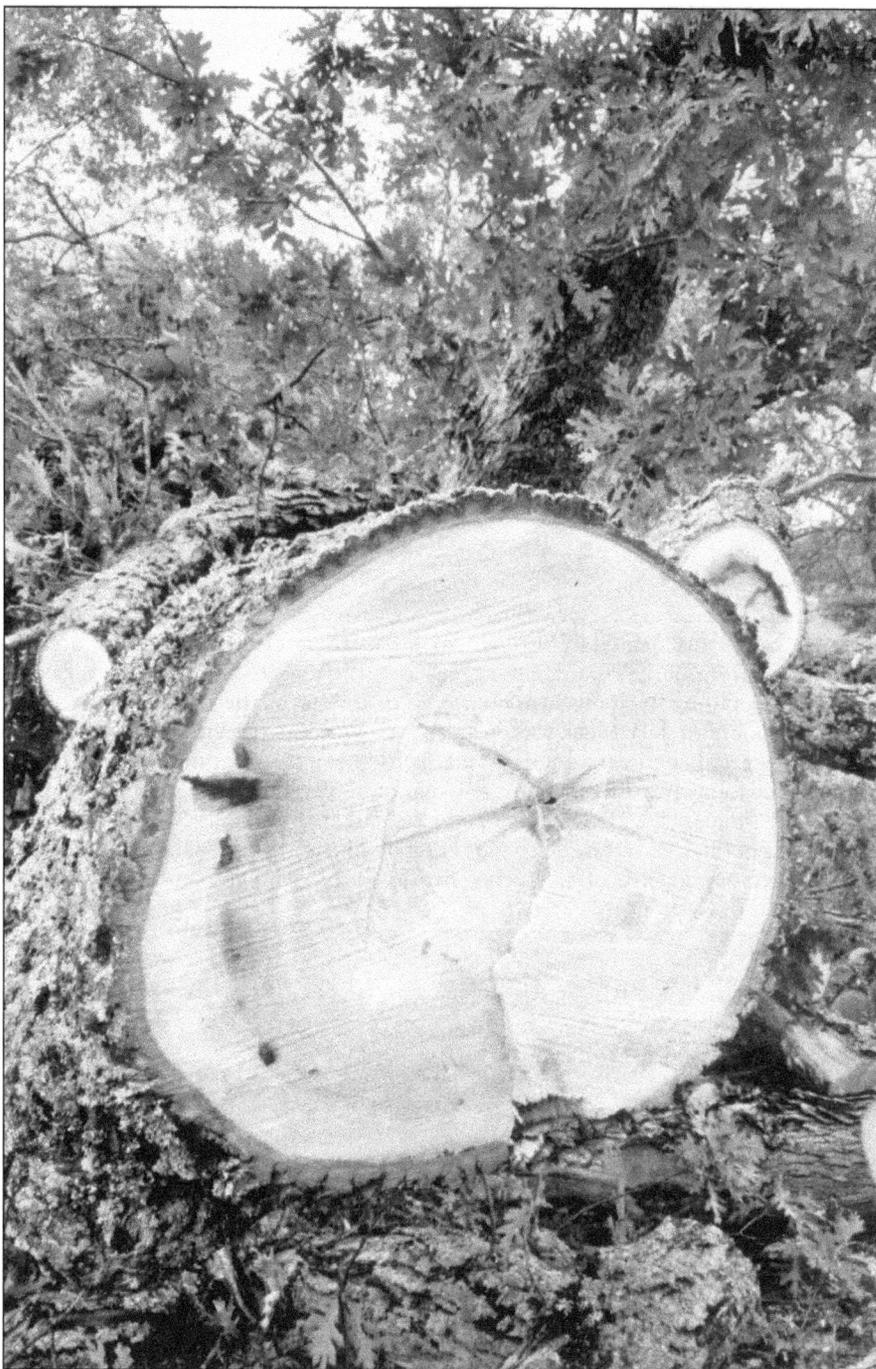

This giant white oak fell during a windstorm in September 2006 and was removed from the roadway by Joey Claytor and Fred Lawless. With at least 371 rings, it was estimated to be nearly 400 years old. The tree was a sapling about the same time that Jamestown was being established as the first permanent English settlement, on the opposite side of the present commonwealth of Virginia. Burke's Garden is noted statewide for its champion trees. This white oak and many other similar specimens of record dimension are several centuries old. (Courtesy of the Mullins files.)

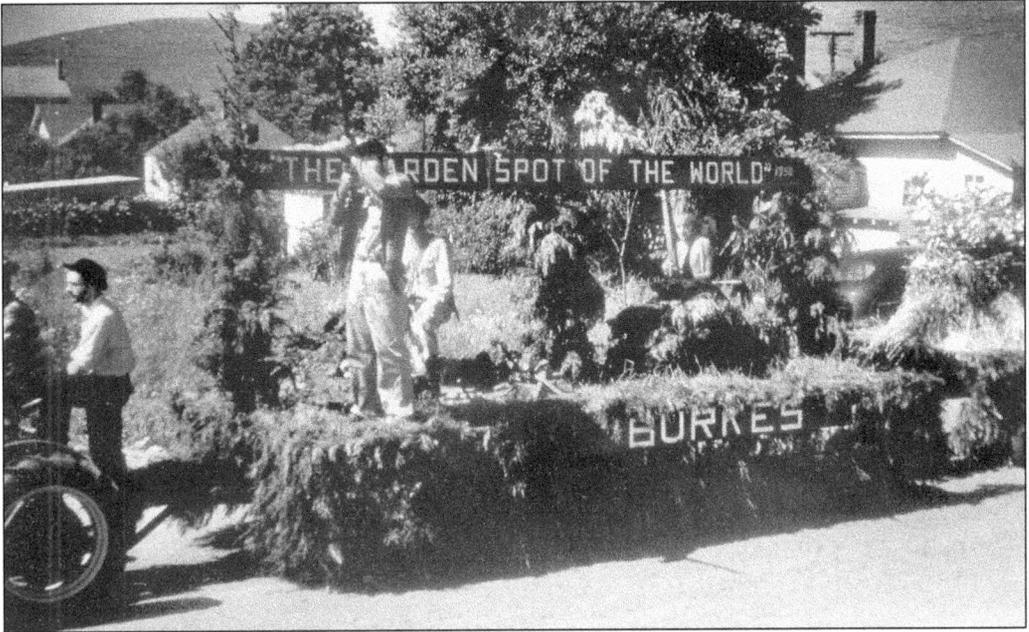

In 1950, the Burke's Garden community created one of the outstanding floats in the sesquicentennial parade in Tazewell, which marked the 150th anniversary of Tazewell County. Bill Moss drove the tractor while, from left to right, Marvin Meek, Edgar Greever, and J. L. Rhudy Jr. rode on the back. The Burke's Garden float emphasized the theme Garden Spot of the World. (Courtesy of the Nancy Ward files.)

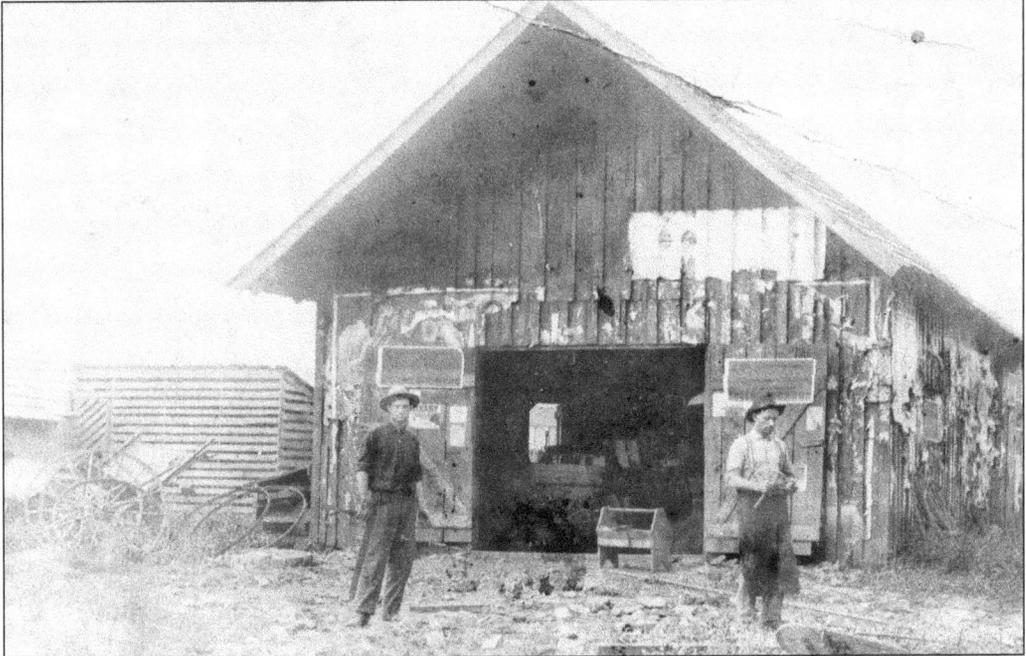

The blacksmith shop played an important part in early Burke's Garden, as the community blacksmith was noted for his skill and craftsmanship. The people pictured are unidentified, and the date of this specific shop is unknown. (Courtesy of Francis Smith.)

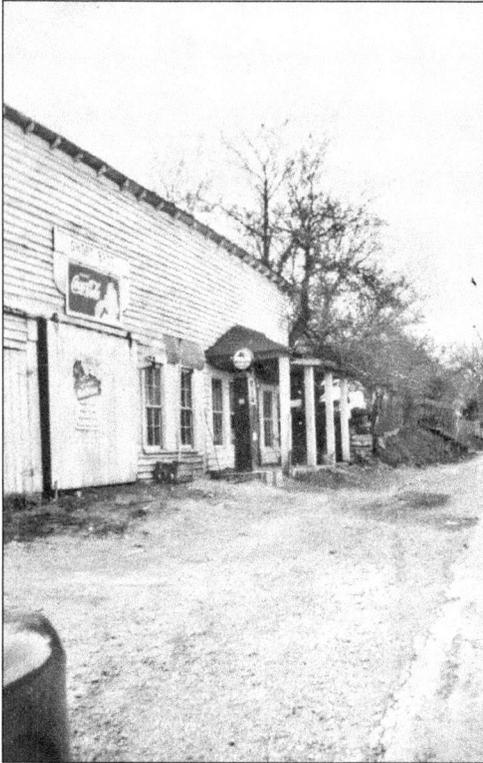

The Tilden Short Store and Garage are seen here. Short's grandson Jack Cox remembers, "Items were sold on the right side. On the left he had a single diesel engine that pulled a belt hooked to a grain grinder where he ground corn and made meal. The belt could also be hooked up to a saw for lumber." Grandson Bobby Short recalls the shop as one of several in Burke's Garden that allowed the community to be self-contained. (Courtesy of Jack Cox and Bobby Short.)

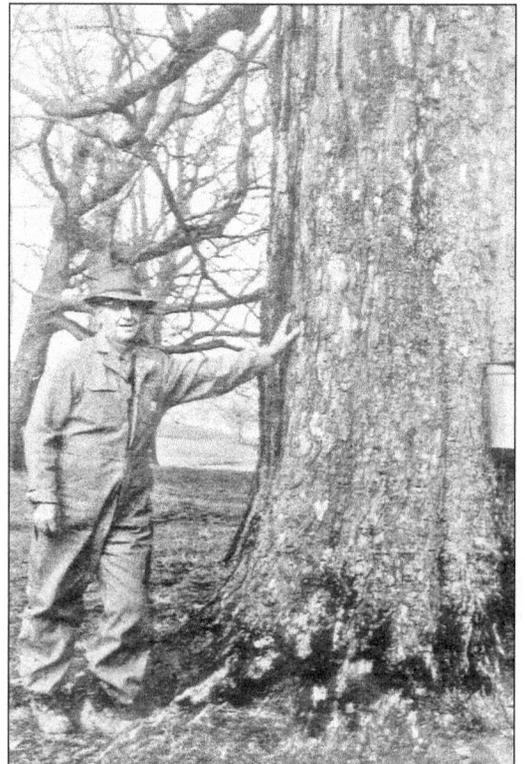

This giant sugar maple, located on J. R. "Bob" Davis's Sugar Grove Farm, has been called a "champion" and the "largest sugar maple tree in Virginia," according to the Virginia Forestry Service. Pictured in 1960, the tree had a circumference of 14 feet 6 inches, a height of 104 feet, and a spread of 37 feet. Bob Davis says it has created sugar water for seven generations of the Davis family. (Courtesy of Elizabeth Bowman.)

Around 1930, Leland Edwards (left, with a Felty family friend) owned a Chevrolet truck with tall racks that he used to haul children to the Burke's Garden School. The kids would climb up the racks into the back. The truck had no cover. About 1934, Edwards got a Studebaker truck and started transporting Grade C milk from Burke's Garden farmers to the Pet plant in Bluefield. Edwards charged 25¢ to drive people to Tazewell or to pick up necessary items while he was in town. (Courtesy of Elizabeth Bowman.)

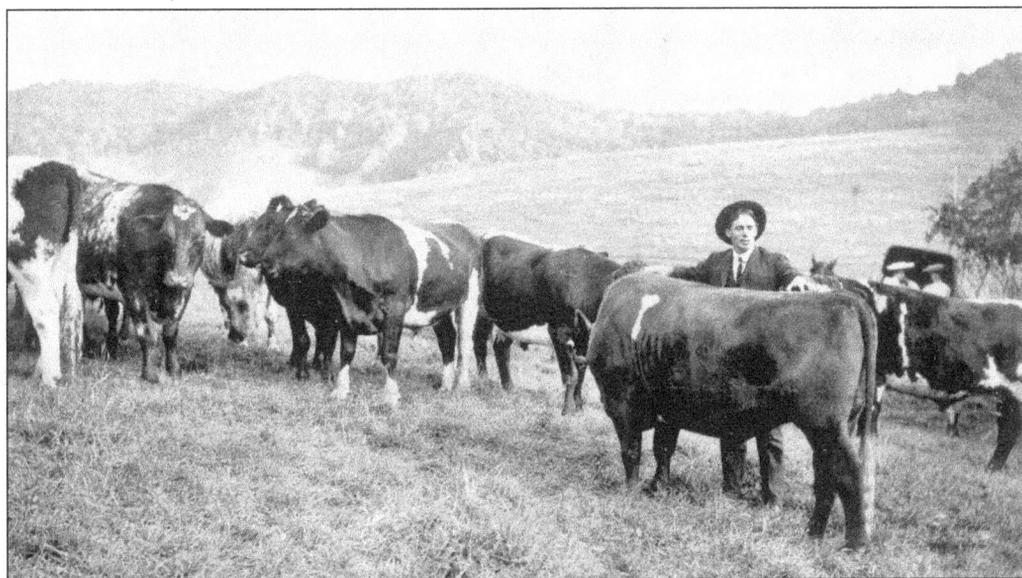

R. S. Moss's cattle joined the exports from other farms, making the name of Burke's Garden internationally known. This lucrative business began in 1840, when R. M. Lawson shipped the first load to Liverpool, England. Burke's Garden beef was once listed on the menus of restaurants in London. (Courtesy of A. S. Greever.)

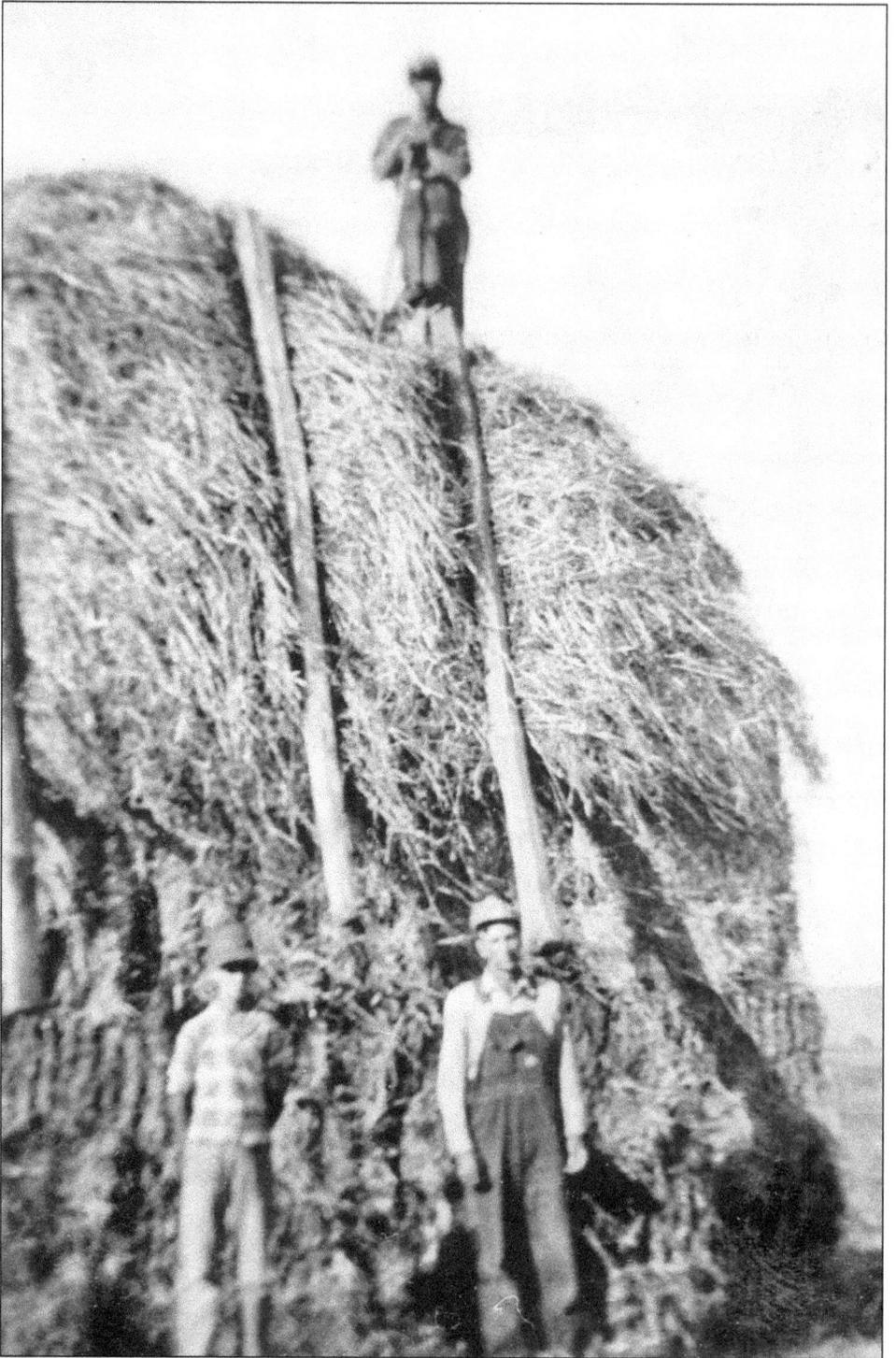

Henry Vanhoozier Sr. climbed to the top of this stack of baled hay on the R. O. Van Dyke farm in Burke's Garden in the mid-1950s. With him were Eugene Vanhoozier (left) and Charles Crutchfield. (Courtesy of Betty Vanhoozier.)

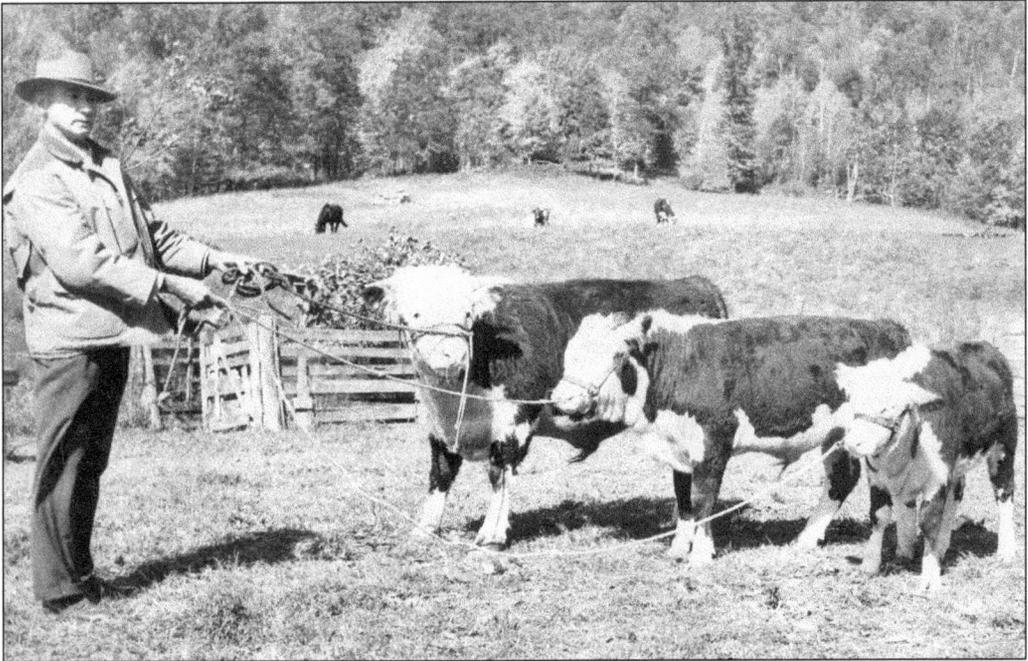

Harry Holland Lineberry directs his registered purebred Hereford bulls in the 1950s. Other cattle are visible in the background on land that Lineberry farmed for more than 40 years. According to Mildred Lineberry, the beef produced in Burke's Garden is not to be surpassed by any other in the country. (Courtesy of Ben Lineberry.)

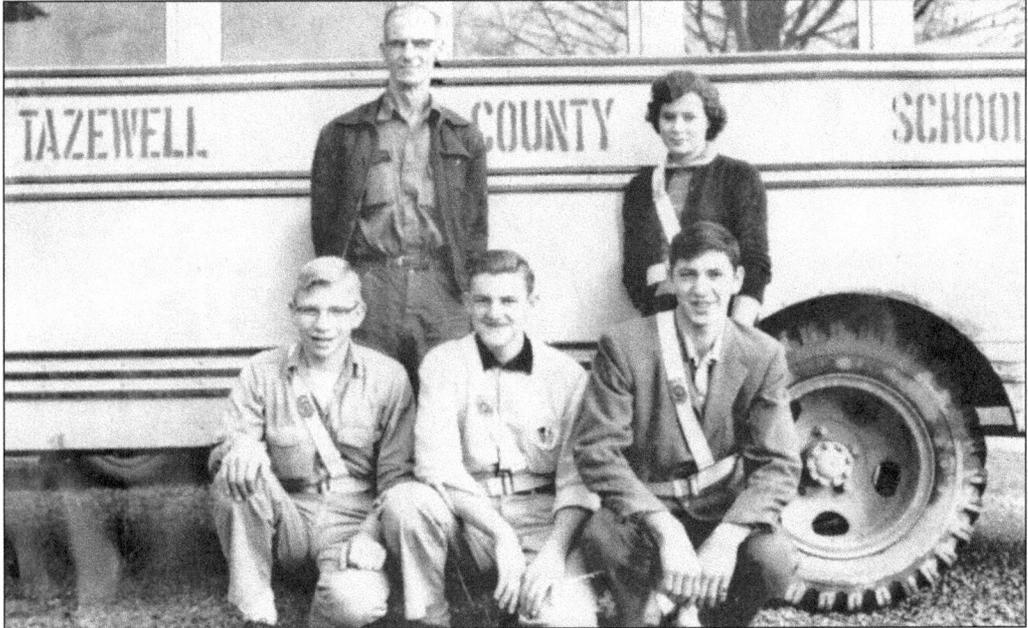

Tazewell County school bus driver Bill Lambert (back left) poses in front of the bus with safety patrol members (left to right) Charles Tibbs, Merle Howell, Kent Thomas, and Earnesteen McCann (back right) in 1957. Lambert drove the Burke's Garden bus from 1937 to 1960. (Courtesy of the *Garden Gate*.)

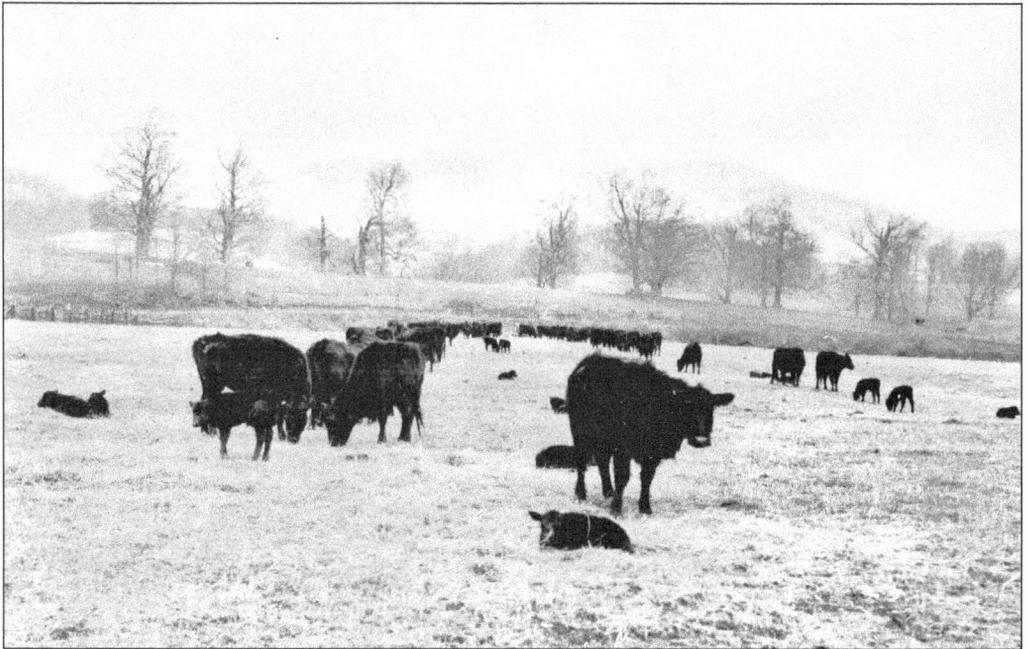

The cattle on the Lawson-Moss farm are typical of the rich herds found in the Garden since the first farmers realized the richness of the land. The area's products are noted far and wide for their outstanding quality and size. Burke's Garden cattle were moved by the hundreds to livestock markets throughout the region. Many were taken to the closest railroad connection: the Norfolk and Western, at Four Way in Tazewell. In fact, Norfolk and Western maps labeled this point on the old railroad as Burke's Garden Siding, which had the distinction of being the largest livestock shipping center in Virginia. (Courtesy of the Moss scrapbook.)

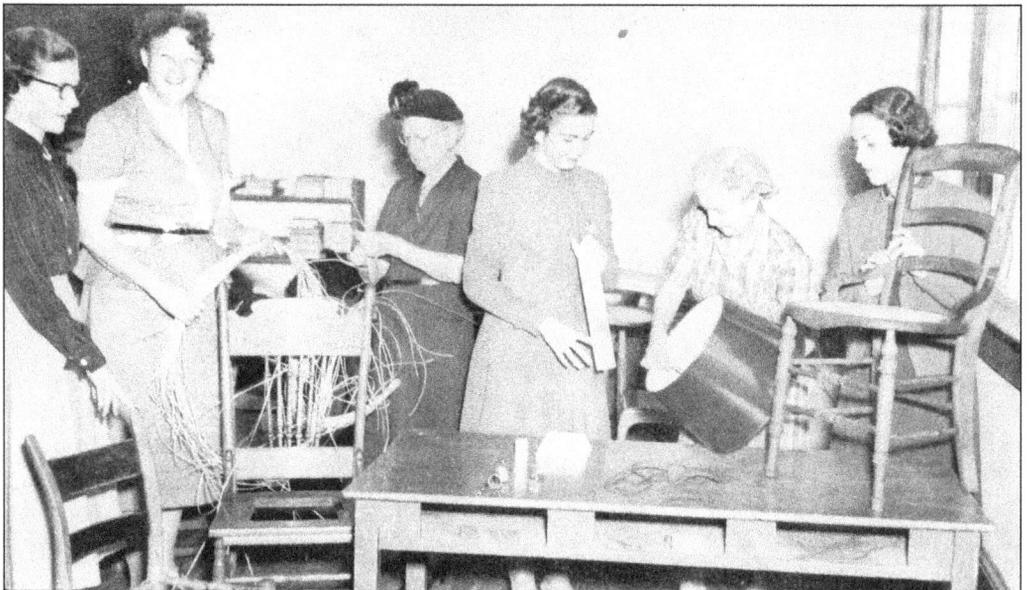

Here members of the community assemble straw-bottomed chairs. Burke's Garden residents have a tradition of preserving many of the old straw crafts and other skills that have long since died out in other parts of the country. (Courtesy of the Burke's Garden Community Association.)

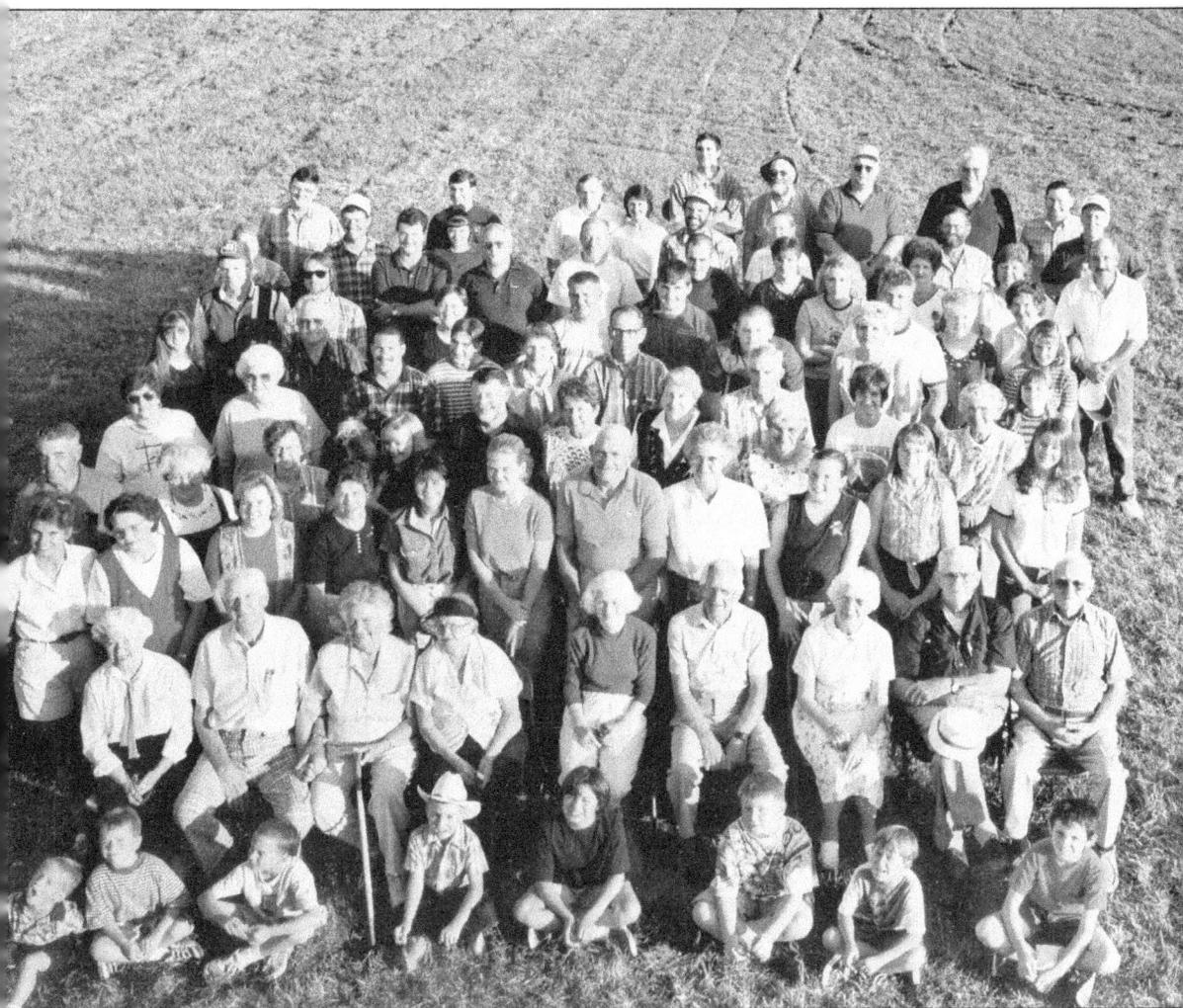

In the summer of 1998, the community picnic brought many people home. Among those attending were the following, from left to right: (first row) Bradley Rhudy, Andrew Rhudy, Calvin Hubbard, Thomas Claytor, Meredith Hubbard, Jarod Riddle, Joey Grygiel, and Paul Griebenow; (second row) Marie Roberts, Jim Hoge, Louise Hoge, Ruth Rhudy, Lucie Greever, Edgar Greever, Eleanor Jones, Mack Brown, and Joe McGinnis; (third row) Donna Shumate, Margaret Rhudy, Sharon Rhudy, Colleen Cox, Lynn Hurley, Cynthia Rhudy, Richard Snapp, Ruth Snapp, Zachlynn Blackburn, Jodi Lynn Claytor, and Lindsey Hurley; (fourth row) Junior Rhudy, Libby Bowman, Brenda McGinnis, Kayla McCann, Bridgett McCann, J. C. McCann, Eleanor McCann, Kathy Moss, Doris Thompson, Lenden Thompson, Angie Howell, Mary E. McGinnis, and Carrie Howell; (fifth row) Sharon Brown, Glenna Brown, Andy McCann, Michael Howell, Carol Chamberlain, Alex Chamberlain, Justin McGinnis, Tamara Blackburn, Lee Blackburn, Shirley Carson, and Kristina Cowans; (sixth row) Joni Stoker, Bernard Bowman, Rebecca Hubbard, Matthew Ray, D. J. Dillon, Leanne Blackburn, and Ella Meek; (seventh row) Joey Claytor, Tommy Dunford, R. B. Hurley, Jim Huffman, Mike Hubbard, Mark Lynch, Missy Lynch, Barbara Rhudy, Susan Brown, and Bill Brown; (eighth row) Betty Melvin, Doug Melvin, Eddie Rhudy, Lesley Rhudy, J. L. Rhudy, Ernie Coburn, Terri Coburn, Levi Rhudy, Robbie Glenn, Rick Griebenow, and Regina Griebenow; (ninth row) Rick Snapp, Jim Harman, Joe Howard McGinnis, Mickey Hoge, and Norman Howell. (Courtesy of Mel Grubb; submitted by Rebecca Hubbard.)

Visit us at
arcadiapublishing.com

www.ingramcontent.com/pod-product-compliance
Lightning Source LLC
Chambersburg PA
CBHW080604110426
42813CB00006B/1406